The TAB Guide to DIY Welding

About the Author

Jackson Morley pursued his interest in design and fabrication while studying industrial design at the University of Kansas, where he gained experience with MIG welding and fabrication techniques including working with sheet metal blacksmithing. Mr. Morley is involved at an industrial arts organization called the Steel Yard, which is best known for creating unique public art and offering courses in welding, blacksmithing, ceramics, and more. He teaches sheet metal forming, bicycle maintenance, and MIG welding courses that instill creative problem-solving techniques, work-smart practices, and efficient design principles using new and recycled materials.

Technical Reviewer

Randy Shapiro was born and raised in Rhode Island, and graduated from the Thielsch Engineering School of Welding in the spring of 2009 with his American Welding Society certifications in SMAW, GMAW, and GTAW. He currently owns and operates a full-service fabrication business in Cranston, Rhode Island.

The TAB Guide to DIY Welding

Hands-On Projects for Hobbyists, Handymen, and Artists

Jackson Morley

New York Chicago San Francisco
Lisbon London Madrid Mexico City
Milan New Delhi San Juan
Seoul Singapore Sydney Toronto

The TAB Guide to DIY Welding:
Hands-On Projects for Hobbyists, Handymen, and Artists

3 4 5 6 7 8 9 0 DOC/DOC 1 9 8 7 6 5

ISBN 978-0-07-179968-3
MHID 0-07-179968-0

This book is printed on acid-free paper.

Sponsoring Editor Roger Stewart	**Proofreader** Paul Tyler
Editing Supervisor Stephen M. Smith	**Indexer** Jack Lewis
Production Supervisor Pamela A. Pelton	**Art Director, Cover** Jeff Weeks
Acquisitions Coordinator Amy Stonebraker	**Composition** TypeWriting
Project Manager Patricia Wallenburg, TypeWriting	**Technical Reviewer** Randy Shapiro
Copy Editor James Madru	

Contents

Preface . xi
Acknowledgments . xvii

Part 1 Metalworking 101

1 Safety First . 3
General Shop Safety . 3
Shop Hazards . 4
 Sharp Stuff . 4
 Dirty Stuff . 4
 Heat and Fire . 4
 Intense Ultraviolet Radiation and Light 5
 Electricity . 6
 Chemicals . 6
 Gases . 7
Personal Protective Equipment (PPE) . 8
 Clear Safety Glasses and Face Shields 8
 Welding Helmet . 8
 Shaded Glasses and Face Shields (Shade Nos. 4–12) 12
 Gloves . 13
 Arm, Neck, and Head Protection . 15
 Boots . 16
 Long Pants . 16
 Hearing Protection . 16
 Dust Masks . 16
Shop Safety Equipment . 18
 Welding Screens . 18
 Fire Extinguishers . 19
 Covered Trash Cans . 19
 First Aid Kit and Eyewash . 19
 Ventilation . 19
Minimum Safety Equipment Review . 19
 MIG Welder . 20
 Plasma Cutter and Oxygen-Acetylene Torch 20
 Angle Grinder, Chop Saw, Bench Grinder, and Drill Press . . . 20

	Roller and Hand Tools	21
	General Shop Safety	21
2	**Welding 101**	**23**
	What Is Welding?	23
	What Isn't Welding?	26
	Welding	27
	Mechanical Connections	28
	Adhesives	28
	Soldering or Brazing	28
	How Welding Works	29
	Types of Welders	29
	Torch Welding	29
	Metal–Inert Gas (MIG) Welding or Gas-Metal Arc Welding (GMAW)	31
	Tungsten–Inert Gas (TIG) Welding or Gas-Tungsten Arc Welding (GTAW)	31
	Stick Welding (Shielded Metal Arc Welding)	32
	Types of Welds and Joints	33
	A Brief History of Welding	35
3	**Steel**	**37**
	What Is Steel?	37
	Plain-Carbon Steels	38
	Alloys	40
	Mild-Steel Properties	40
	Strength	40
	Conductivity	41
	Expansion and Contraction	41
	Corrosion and Rust	41
	Mill Scale	42
	Finishing	42
	How to Obtain Steel	43
	Buying Steel	44
	Finding Steel	52
4	**Metalworking Studio**	**55**
	Layout	55
	Safety Concerns	55
	Lighting	56
	Welding Table	57
	Cutting Table	58
	Cutting/Grinding Area	59
	Steel Storage	59
	Paint Area	59
	Buying Tools	60
	Cleaning and Maintenance	60

5 **Basic Hand Tools** .. **63**
 Clamps .. 63
 Vice-Grips ... 63
 Measuring Tape .. 65
 Wire Cutters ... 65
 Magnetic Angles ... 65
 Other Layout Tools 67
 Slag Hammer .. 67
 Files .. 68
 Scribe ... 68
 Soapstone ... 70

6 **Grinding and Cutting** **71**
 Angle Grinder ... 71
 Parts ... 71
 Types of Disks 75
 A Place to Grind 81
 Angle Grinder Safety 81
 Practice .. 82
 Bench Grinder ... 94
 Parts ... 96
 Safety .. 97
 Practice .. 97
 Chop Saw ... 99
 Parts ... 101
 Types of Disks 102
 Safety .. 102
 Practice .. 102

7 **Drill Press** ... **111**
 Parts ... 112
 Accessories ... 112
 Center Punch 112
 Deburring Tool 113
 Adjustable Vice 113
 Automatic Center Finder 114
 Drill Bits ... 114
 Twist Bits .. 115
 Center Drill Bits 115
 Unibit .. 116
 Speeds .. 116
 Safety .. 116
 Drilling Practice .. 117

8 **Roll Bending** ... **125**
 Parts ... 127
 Operation .. 127

Safety 128
Rolling Practice .. 128

9 Oxygen-Acetylene Torch **137**
Parts and Accessories 139
Torch and Tank Setup 139
Parts Detail 140
Torch Detail 140
Safety ... 142
Torch Cutting .. 142
Operation .. 143
Cutting Practice 156
Torch Welding .. 158
Filler .. 159
Flux ... 159
Operation .. 160
Welding Practice 167
Torch Bending 168
Operation .. 170
Bending Practice 172

10 Plasma Cutter .. **177**
Parts .. 179
Plasma Cutter 179
Plasma Torch 179
Accessories 180
Safety ... 181
Operation .. 183
Amperage .. 183
Travel Rate 184
Angle of Torch 184
Standoff ... 185
Preparing to Cut 185
Making a Cut 188
Shutting Down the Plasma Cutter 189
Practice ... 189

11 Metal–Inert Gas (MIG) Welder **193**
Parts .. 193
Power Source and Transformer 193
On/Off Switch 193
Voltage and Wire-Feed Settings 194
Negative, or Grounding, Clamp 194
Welding Lead and Gun 195
Shielding Gas and Regulator 195
Weld Chart 195

MIG Gun .. 195
 Gun ... 195
 Trigger .. 195
 Gas Nozzle .. 196
 Gas Diffuser 196
 Contact Tip 196
 Electrode/Filler 197
 Gas Line .. 197
Inside a MIG Welder 197
 Spool of Welding Wire 198
 Feed Rollers 198
 Electrical Connections 198
MIG Welder Consumables 198
 Shielding Gas 198
 Filler Wire and Contact Tip 199
MIG Welder Adjustments 200
 Wire Speed/Feed 200
 Voltage ... 200
You Are in Control 202
 Distance from Weld Area (Stick-Out) 202
 Speed ... 203
 Angle ... 206
 Pattern of Motion or Weave 207
 Steadiness .. 207
Weld Vision .. 208
Weld Orientation 209
 Flat .. 209
 Horizontal .. 210
 Vertical .. 210
 Overhead .. 212
 Safety .. 212
Operation .. 213
 Setting Up Your Work Area and Welder 213
 Get Comfortable 215
Practice ... 216
 Flat-Position Bead Making 216
 Flat-Position Weaving 220
 Flat-Position Tee Joint 222
 Making a Tee Corner 223
 Breaking a Weld 225
 Cutting Your Weld 226
 Visual Inspection 229

12 Finishing .. **231**
Steel Preparation 231

Muriatic Acid . 232
 Application . 233
Paint . 233
 Brush Paint . 234
 Spray Paint . 235
Clear Finish . 238
Wax . 239
 Application . 240
Powder Coating . 240

Part 2 Projects

13 **Project Preparation** . 245
Materials . 246
Studio Access . 247
Time . 247

14 **Start from Scratch** . 249

15 **Cube** . 253

16 **Plant Stand** . 261

17 **Candelabras** . 267

18 **End Table** . 275

19 **Fireplace Log Holder** . 287
Finishing . 296

20 **Garden Cart** . 297
Finishing . 309

21 **Barbecue** . 311
Finishing . 333

Resources . 335
Education and Studio Resources (Listed West to East) 335
General Welding and Online Resources 336

Index . 337

Preface

Welding is a process that is responsible for the creation of much of our modern world but is shrouded in mystery and I think generally misunderstood. This is not all that surprising, really—after all, it's only been around in its current form since the advent of electricity. Welding's mysterious status is only enhanced by the required safety equipment; it can make just about anyone look quite intimidating. (But isn't that part of the appeal?) Without welding, the modern car, skyscraper, airplane, bridge, and ship wouldn't be possible. It's pretty amazing to think about how recently welding technology has evolved and that now just about anyone can create a decent weld in less than a few hours.

People who want to learn to weld come from all walks of life. At the Steel Yard, where I got my start teaching metal–inert gas (MIG) welding courses as an assistant to Howard Sneider, our classes consisted of students ranging in age from 15 years old into their seventies. Enrollment was split right down the middle of the gender line, occasionally with more female students. These students became interested in welding in every way imaginable. Some had a specific project in mind, such as a skateboard grinding rail or a musical instrument; some wanted to learn welding as a possible career choice; and others wanted something fun and creative to do in retirement. Some students were looking for a memorable way to spend the Mother's Day weekend (at our "Welding with Mom Workshop"), and other students with an arts background just wanted to add welding to their repertoire. However, I'd say that the majority of students shared one thing in common: They had at some point become fascinated by welding and were looking for a way to get behind a MIG welder to see what they could do.

In those classes, I learned how to make welding accessible. I learned how to communicate the trickier aspects of welding in simple terms that made the whole process "click" for my students. I learned a lot about the difficulties first-time welders face and how to help my students overcome these challenges. I also created a number of small projects that introduce basic principles slowly and challenge the welder. My hope is that by following along with this book, your understanding of welding and metalwork will greatly improve, enabling you to think about the world in new ways and create freely.

One of the best things I've ever done was to get involved in the metalworking community at the Steel Yard. Besides having great shop space and equipment, the

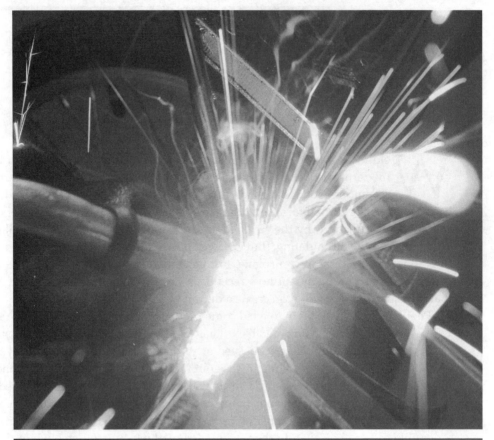

FIGURE I.1 A welding project underway.

Steel Yard allowed me to become involved in a community environment that has been rewarding on many levels. At the risk of sounding cheesy, the people I've met, the experiences I've shared, and in general, the creative environment at the Steel Yard are without a doubt some of the best things of my life. I encourage the readers of this book to seek out metalworkers and metalworking communities in their area to find out about shop access, local resources, and other like-minded people (you'll be surprised by how many exist).

Setting up your own shop can be a big undertaking, and I frequently urge new metalworkers against it. Therefore, this book isn't going to cover every step involved in shop setup. My biggest advice to people interested in starting metal-work is to try it out somewhere with an already up and running metal shop. As I mentioned earlier, there are accessible metal shops all over the country. Among many other reasons, I feel that supporting this industry helps to maintain our ability to create and build. At the end of this book is a short list of creative-minded metal shops and organizations from almost every corner of the United States.

Please get in touch with one or several of these shops to find out more about classes and studio space in your area. After a few years of metalwork in a shared space, the time may come to set up your own studio, but at that point you'll know exactly what types of tools and layout your work requires.

This book will cover everything you need to know about MIG welding in order to start creating your own work. I am going to go over essential hand and power tools that will help you to prepare, modify, and finish your projects. I'll introduce tips and tricks for starting out with a MIG welder and how to rate your first welds. Of course, I'll break a few welds, too. As your welding improves, you will start some more advanced home, garden, and shop projects that I hope will be fun and useful and maybe even give you bragging rights among your friends. By the end of this book, you'll be able to grind, cut, drill, bend, and weld steel for use in your own projects. If you want to delve deeper into welding, you may want to consider trying out another form of arc or torch welding or possibly becoming a certified welder for structural jobs. I should emphasize that this book is directed toward sculptural and artistic welding. That isn't to say that your welds aren't going to be strong. However, when structural welds are required, every detail must be considered to leave no room for mistakes. This requires specific training and practice.

Who Is This Book For?

Do you find yourself wandering around city streets staring as various joints and connections, wondering how they are made or how they could be made better? Do you find yourself daydreaming about the inner workings of today's high-tech cars, planes, buildings, and more? Do you want to be able to build and realize some far-out metal sculpture lurking in the back of your mind? Maybe you want to be able to repair things that break? I could go on, but if any of these questions have crossed your mind at some point, this book is for you.

This book is for artists who are new to or already know some form of metalworking but want to add MIG welding and metalwork to their repertoire or artistic toolbox. I use the term *artist* loosely. Everyone has a bit of the artist in him or her somewhere; it just takes the right form of expression to make it appear. I don't define an artist as someone who can draw or paint. Drawing and painting are great forms of expression, and we owe a lot of the art of today to these forms, but to be an artist, you don't have to be comfortable with a pencil and paper. To be an artist, you must think independently and have a desire to create.

I wouldn't say that there has always been a connection between art and welding, but with creation comes design, and with design comes artistic freedom. Inevitably, as welding is practiced and becomes more popular, the artistic side follows closely behind. Welding started out as a process to make tools and weapons. If we look at blacksmithing in the Middle Ages, where forge welding was practiced as an early form of welding, quite elaborate tools and weapons were made and held in high

regard. In history, as people got more skilled with certain fabrication techniques, the products of those techniques became more artistic.

This book is for anyone with a curious mind who seeks a slightly better understanding of our world. The many forms of modern welding that exist today help to make up nearly everything around us, yet the basics of welding aren't widely understood. For home owners, gardeners, and furniture lovers, this book will cover how to create some unique pieces for your home or garden. The skills taught here also will be applicable to all sorts of hobby and repair projects. Unfortunately, the day of steel tools for the home and garden has nearly passed, and a lot of what you see today is made from plastic. However, being able to fabricate and weld reinforcements for broken pieces of hardware may just save you some serious dough.

What's in This Book?

In the following pages, I'm going to start with the very basics of what exactly defines a *weld* and build on that by covering the basics of steel characteristics. I'll start off with some tools that are slightly more common, but the simple practice lessons in each of these chapters will help you to prepare material for your first few welds. There are lots of unique safety items to consider with welding and performing metalwork. This book is a review of much of what I've picked up over the years in metal shops and is therefore based on my particular experience. If you have different opinions than mine on any safety material or any of the processes covered in this book, double-check with the Occupational Safety and Health Administration (OSHA) or with one of the resources at the end of this book.

There are many different ways to manipulate steel, a number of which will be covered by the chapters in this book. I'll start off by providing a look at some of the important hand tools required for basic metalwork, some of which you'll surely already have in your tool kit. You'll learn about and practice using various grinders and cold-working tools such as a roller. Before you start MIG welding, you're going to learn how steel responds to heat using a plasma cutter and oxygen-acetylene torch to make cuts, bends, and welds. Next up, you'll learn about the MIG welder and practice making a variety of welds. As far as I'm concerned, there is no sense learning to weld unless you consistently are aiming to make the most structural welds you can. To test your welds, you're going to, well, break some!

The idea is that by the end of this book, you can find (or build, if necessary) a place to do metalwork, buy steel and tools, and know how to manipulate steel in a number of useful ways. From there, where you decide to take it is up to you. If you enjoy welding so much that you want to make a career of it, maybe a course in structural welding to become certified is for you. If you want to continue making functional and sculptural projects, get involved in a local or online community to share ideas. Maybe the most fun you'll have in this book is using the oxy-torch to

bend steel (I know, it is a lot like being Superman). For you, maybe taking a course or checking out another book on blacksmithing would be the best way to advance your skills. Whatever you decide to do with your new skills, I hope that the basics covered in this book help you to get there.

What's Not in This Book?

This book will not talk specifically about structural welding; rather, it will focus on making strong sculptural welds. Structural welders are required to take advanced courses in very specific types of welding that apply to the welds they will make. Welders in trades such as the automotive and construction industries are certified in structural welding. This isn't to say that I'm not going to cover how to make a strong weld; you will make welds that could pass structural quality tests. However, your welds are *not* going to be tested for structural quality, so only you can be responsible for the strength of your welds.

This book is going to deal exclusively with the welding and manipulation of *low-carbon steel*, also called *mild steel*. There are lots of other types of metal and steel out there. Each has a set of unique characteristics that need to be considered when designing and building with them. You will learn how to identify steel and how many alloys are formed. One of the great things about the MIG welder is that with the same machine and some different accessories, you can weld different steel alloys, including stainless steel and even aluminum.

Although I am here for you to learn and guide you along in the process, I am not able to look over your shoulder or critique your work or safety habits. If you're just starting out with metalworking, again, I strongly recommend that you begin in a shared studio with someone who can give you feedback and advice. Each chapter in this book is really just the tip of the iceberg when it comes to what's possible with each tool. I wish I could squeeze everything into one book, but in the interest of presenting everything you want to know to create your own projects, I've had to omit various subjects.

How to Use This Book

The way I've structured this book is to be read from the beginning through to the end. Most chapters are concluded with short practice lessons to review what was covered, and you'll be putting all those lessons to work in the project chapters. If you feel the need to skip ahead at any point, I would ask you to thoroughly read the safety chapter and any safety notes along the way. If you've already learned some of the tools in this book, keep in mind that every instructor or metalworker has different tips and information relating to each tool. You never know, you might learn something new!

Something I'm always happy to share with new metalworkers, and I feel is an area where I have a lot to offer, is project planning. Each project you make I will have planned from the initial sketch to the completed project. This includes types of materials needed, lengths of each and any special hardware, construction details, and possible finishing options. I'll share as much of this information as I can so that when you are ready to plan your own projects, you'll know where to begin.

Most important, have fun, keep an open mind, and be safe!

Jackson Morley

Acknowledgments

There are a great many people to whom I owe everything I know today about metalwork and design. My parents always encouraged and supported me in pretty much anything I chose to do, and for that I am grateful. I grew up surrounded by art created by generations on both sides of my family in a variety of media, from architecture to portraiture to automotive repair and more. To say "The apple doesn't fall far from the tree" in this case I believe would be an understatement. My parents clearly inherited some of those genes and passed them on to us kids. Even though I had a hard time sticking with some projects when I was younger, thank you Mom and Dad for teaching me the value of creative work.

Thank you to the entire crew at the Steel Yard, especially Nick Bauta, Alma Carrillo, Brian Dowling, Drake Patten, Clay Rockefeller, Dave Sharp, and Howie Sneider. Also thank you to my technical editor Randy Shapiro for helping with the production of this book, Louis Gitlin at Mid City Steel for his advice, and Miller Electric for their support.

Metalworking 101

CHAPTER 1
Safety First

CHAPTER 2
Welding 101

CHAPTER 3
Steel

CHAPTER 4
Metalworking Studio

CHAPTER 5
Basic Hand Tools

CHAPTER 6
Grinding and Cutting

CHAPTER 7
Drill Press

CHAPTER 8
Roll Bending

CHAPTER 9
Oxygen-Acetylene Torch

CHAPTER 10
Plasma Cutter

CHAPTER 11
Metal–Inert Gas (MIG) Welder

CHAPTER 12
Finishing

Safety First

Welding and metalworking have many inherent risks. Anytime you're working with high heat, bright light, electricity, heavy materials, loud noises, and rotational tools, there is a chance for injury. By keeping a handful of tips in mind, you will be able to work safely for many years to come. Whether or not this is your first time in an industrial studio, the following basic safety rules are practiced in many artistic and industrial shops and are great habits to adopt. When working around industrial tools, safety should be your number one priority. It only takes a small mistake or lapse in attention to cause serious and permanent damage to yourself or someone around you. I encourage you to take your own safety seriously and make it your first priority.

General Shop Safety

A metal shop can be a fun creative space that gets used for everything from the dirtiest of projects to your very first art gallery opening. By keeping safety at the forefront, you can avoid many accidents.

Know your limits. I find metalworking to be so much fun that sometimes I'd rather work through lunch than take the 45 minutes to relax and grab a snack. I can tell you from experience that pacing your workday properly is crucial. Take frequent breaks to admire your work, plan the next steps, and hydrate. This isn't a race, so take your time and enjoy the ride!

Metalwork doesn't mix with alcohol or drugs. Being in the proper state of mind when working will help you to avoid accidents.

For more safety information and guidelines, check out the manuals that come with each tool. They will tell you what specific type of protective equipment should be worn and if there are any special considerations. The U.S. Occupational Safety and Health Administration (OSHA) is a good resource for questions relating to material and workplace safety. Although it is intended for employers and

employees, much of the information is relevant even for a small home shop. Try a computer search for "welding" or the name of a specific tool or material to view full OSHA regulations.

Every shop should have a number of safety items and first aid available. There should be a number of functioning fire extinguishers readily accessible and at least one first aid kit with Band-Aids, eyewash containers, antiseptic, and burn ointment. Some shops will have a plumbed eyewash station that should be used if any chemical finds its way into your eyes. You'll learn more about fire protection later in this book, but if your shop is a shared space, there should be an emergency plan. A phone for emergency calls should be available as well.

Shop Hazards

Sharp Stuff

The metal shop you're working in will without a doubt have lengths of metal somewhere in it. These can be sharp and frequently have a burr on the cut edge. Sharp metal such as this can cut, poke, tear, and cause serious injury. Taking care to store material in a safe place is critical.

Dirty Stuff

With grinding and welding going on, some serious metal dust will be created. This dust collects on just about every surface it can, so if you wind up with a cut or wound, make sure to clean it out immediately with running water and antiseptic. Cover it with a bandage for the rest of the time you are in the shop.

If you feel like there could be something in your eye, wash it out with eyewash immediately. Do not rub your eye because that could cause the particle to become embedded and would require a trip to the doctor or emergency room.

Metal shops always should have available an eyewash station or eyewash containers. If while working you feel *anything* start to irritate your eye, *do not scratch it*; rather, make your way to the eyewash area, and flush out your eye or eyes for a minute or two. Scratching a potential foreign object will, nine times out of ten, cause it to become embedded and require a trip to the eye doctor or emergency room.

Heat and Fire

Nearly every tool you are going to use in this book creates some sort of heat. The metal–inert gas (MIG) welding arc and plasma arc both create heat well over 10,000°F. An oxygen-acetylene torch burns at over 6,000°F. Friction from grinding wheels and cutoff disks can create heat up to 1,000°F. Since steel is a good conductor, as soon as heat is introduced, it begins to spread out quickly. For this reason, you should always wear insulated gloves and be aware of areas that were welded

recently so as to not rest tools or place any exposed skin near them. Long after steel has stopped glowing red or orange, it still may be very hot to the touch, enough to cause serious burns.

A good practice in metal shops is to put any recently heated metal in a special place, such as directly under the worktable or against a certain wall. The work can stay there until it is cool to the touch. Particularly in blacksmith shops, a bucket of water is kept handy for quenching hot work. This has special applications for blacksmithing and isn't as useful in a welding shop except for cooling work (only occasionally). Mild steel doesn't respond to quick cooling like steel containing more carbon. If you quench mild steel in cool water, the steel is not going to become harder. Rather, the rapid cooling can add stress to a recently welded joint, potentially jeopardizing its strength.

CAUTION: Never put a heated tube into water to cool. The water will instantly turn to steam inside the pipe and can shoot out toward you.

The sparks caused by welding, plasma cutting, torch cutting, and grinding have the potential to start a fire. Don't let this happen—keep the workplace free from flammable items such as rags, sawdust, paper goods, and other fuel sources. Sparks tend to "dance" across the floor and can travel quite far. If a stray spark lands on any of the materials just listed, you could very quickly have an emergency on your hands.

Clothing items for metalworking should be made out of natural fibers. Wool, cotton, and leather are just about the only acceptable materials for metal shop work wear. Never wear anything synthetic! The heat and sparks can cause synthetic material to burn and/or melt, introducing the risk of serious injury.

CAUTION: Never keep a lighter in any of your pockets while metalworking. The plastic casing on the lighter can melt when it comes in contact with a hot surface, causing an explosion.

Intense Ultraviolet Radiation and Light

One of the most unique safety issues to keep in mind when welding, plasma cutting, and working with an oxygen-acetylene torch is the ultraviolet (UV) radiation such processes produce. Ultraviolet radiation is what comes from the sun and is responsible for giving you a nasty sunburn, not to mention that the bright light causes light spots in your vision if you accidentally look at the sun. For safety sake, you must treat your arc and flame just like the sun—only this "sun" is much, much closer. Just like sunburn, a burn from a welding light gives no advance warning. Spend even a short time welding with exposed skin, and a burn can appear. When welding and plasma cutting, cover your face, neck, torso, arms, and

hands at all times. The same rule of "never look directly at the sun" goes for your arcs and flames as well. You should never look directly at them unless you are looking through the proper filter or shade.

With that said, if you get "flashed" by a neighbor's welding arc or even your own, quickly look away and/or move away from the welding light, and you shouldn't suffer any serious damage. If after being flashed you notice light spots in your vision, take a quick break to make sure that those spots go away completely. On occasions when I've been flashed, I always notice feeling a little distracted or even dizzy, and I choose to take that chance to grab some water or take a rest. Longer exposures can result in a condition known as *arc eye* and is described as a sensation of having sand in your eyes. If you ever notice changes in your vision that do not go away, contact your eye doctor immediately.

To keep the risk down of accidental flashing, you should always erect welding screens around your worktable. Depending on your workspace, you may need four screens to go all the way around your space. These screens also help to keep any sparks from traveling too far away.

NOTE: *Wear dark colors when welding because even indirect reflected light off of clothing can cause damage to your vision.*

Electricity

Electric tools such as a MIG welder and plasma cutter run on a 110- through 240-V circuit. The higher voltage, usually used in shops and industrial areas, has much more power than a household circuit and must be taken very seriously. Again, the conductivity of steel can be a problem if an electrical cord shorts out on a length of steel on which you are working. If a hot piece of your work rests on an extension cord for long, it will melt through the shielding and can cause a shock. Inspect all electrical connections regularly, and replace any damaged cords or plugs. Always use caution when plugging and unplugging tools, and never remove coverings or the guards from a tool in use.

Fortunately, the risk of electrical shock while welding is very low because electricity looks for the path of least resistance when completing a circuit. Steel is a much better conductor than your skin or leather gloves, so the current will flow easily through the metal. However, loose electrical connections in the welder and working in a damp environment can increase the risk of shock greatly. For these reasons, make sure that all your electric tools are in good shape and that you are not welding in wet conditions or when your clothing is damp. Always wear rubber-soled shoes, insulated gloves, and protective clothing to help minimize the risk.

Chemicals

Most metal studios have some sorts of lubricants, paints, solvents, and other common chemicals nearby. Many of these chemicals are flammable and/or

combustible. Chemicals always should be labeled and stored properly where heat, sparks, and flame can't come in contact with them. Usually the best option is a fireproof locker or cabinet.

Gases

For welding and torch cutting, compressed-gas cylinders are required. The handling of compressed gases should be taken very seriously because these cylinders are big, heavy tanks with an internal pressure that can be around 2,000 lb/in^2. If one of these tanks gets knocked over or develops a hole, a lot of force is unleashed very quickly. Oxygen gas and carbon dioxide and argon gas mixtures are not flammable on their own, but the acetylene gas you use for torch cutting is extremely flammable. More storage techniques will be covered when I talk about the workshop, but here you're going to learn the basics of compressed-gas cylinder handling:

1. *Compressed-gas cylinders always must be secured.* This means that when stored, transporting, and in use, all gas cylinders should be secured in the vertical position. If they are not secured properly, damage could occur to the valve, allowing gas to escape. When not in use and for transporting, cylinder valves should be covered properly with their valve cap. A handcart with restraint strap or chain must be used when moving gas cylinders around the shop space. Transporting gases in a vehicle that isn't designed to do so can be dangerous. To keep yourself and others safe, always have your gases delivered by a supplier. If for some reason this is impossible, follow the link at the end of this section to read about proper transportation of gases in your vehicle.

2. *Keep your regulator and valve assembly clean.* Particulates lodged in the valve assembly can create leaks in the fittings or regulator, which may lead to an explosion. Since oxygen lowers the combustion temperature for materials, even the most everyday contaminate can become flammable in an oxygen environment. Make sure to blow out the fitting area before attaching a regulator. The brass fittings on gas cylinders and the regulators will form a tight seal as long as nothing is trapped along the threads.

3. *Never go above 15 lb/in^2 on an acetylene regulator.* Acetylene gas is combustible above 15 lb/in^2. If acetylene gas gets compressed over 15 lb/in^2, it will likely cause an explosion. Always use extreme care when opening an acetylene valve to make sure that the pressure does not increase rapidly.

4. *Never use an acetylene cylinder that has been laid down.* Thus, if the other gas cylinders are filled to 2,000 lb/in^2 and acetylene is combustible at 15 lb/in^2, how do they compress the gas in a cylinder? This brings me to the final gas cylinder-handling note. Acetylene cylinders contain a mixture of acetylene gas that's been dissolved in acetone, all of which is suspended in a porous

structure inside the tank. When an acetylene cylinder is laid on its side, the acetone can flow into the valve, which would cause regulator failure.

If you are working in a shared metal shop, make sure to check with the shop manager about gas safety. If you are setting up your own workspace, you'll need to arrange a gas rental plan with a local supplier.

Most important, read all safety warnings and labels that come with the specific tools and equipment you use so that you understand how best to use them.

NOTE: *For more information on compressed-gas cylinder safety, download the "Cylinder Safety" .pdf from BOC World of Welding (www.bocworldofwelding.com/).*

Personal Protective Equipment (PPE)

Clear Safety Glasses and Face Shields

Whenever you are in a metal shop, whether you're working or just passing through, wear safety glasses. No matter what. Wear safety glasses. One more time, *wear safety glasses*. Given the presence of tools that rotate at high speeds, long lengths of metal, sharp objects, sparks, metal dust, and a plethora of other dangerous things, there are many ways in which your eyes could be in danger. By simply putting on eye protection, most injuries can be avoided. Even if you wear regular glasses, find a pair of safety glasses that fit over them and cover the top and both sides. I highly recommend spending some time to find a pair of safety glasses that fit comfortably and that you keep those in good shape. If you have an extra eyeglass case around the house or an old sock, devote it to the protection of your safety glasses, and they will be with you for a long time!

For angle grinding and chop sawing, you may want to increase protection over your whole face. For this I recommend using a clear acrylic face shield. These shields should be worn over your safety glasses because they don't protect your eyes as well as safety glasses alone (Figure 1.1).

CAUTION: *Remember that safety glasses do not offer protection from the extreme light produced by welding or plasma cutting. For those processes, you will need to wear protection that is rated at the proper shade (see Tables 1.1 and 1.2).*

Welding Helmet

MIG welding creates UV light and radiation that is bright enough to cause serious eye damage within seconds and will dry out and burn any exposed skin. For this

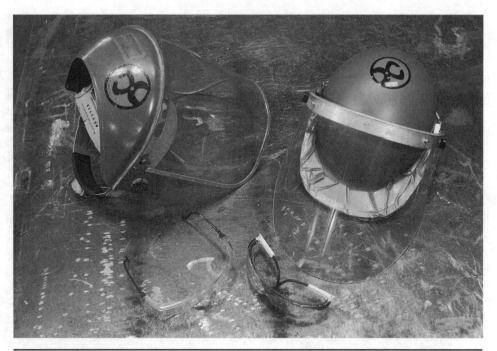

FIGURE 1.1 Examples of clear safety glasses and face shields.

reason, never look at a welding arc for any amount of time without proper eye protection or stand near an arc with exposed skin.

Welding helmets provide protection against this extreme UV light, heat, and sparks (Figure 1.2). They feature a hard shell that wraps about halfway around your head and covers some of your neck. The shell should pivot on an adjustable cradle that conforms to your head. In the middle of this shell is a rectangular window called the *shade* or *filter*. Shades are rated in darkness numbers 1 through 14 (14 being the darkest). The required darkness of your welding shade will depend on the type of welding or cutting you are planning to do (see Table 1.1). For general MIG, tungsten–inert gas (TIG), and stick welding, a shade rated between 11 and 14 is recommended. To give you an idea of how dark these filters are, if you were in a normally lit room looking through a shade no. 10 helmet, it would seem as though you were looking into pitch black. Only if you look directly at a halogen bulb or the sun will you see any light through it. If you were looking through a no. 8 or 9 filter, you would start to see normal light bulbs and some reflected light around the room. A no. 4 to 5 filter will allow you to see most everything, but it would be like looking through dark-green sunglasses. The key to these filters is that when the welding arc, plasma torch, or oxygen-acetylene flame is created, it produces enough light to illuminate your work area. It won't look like "normal" lighting conditions, but it will be enough that you can see the weld pool and surrounding material. It is this

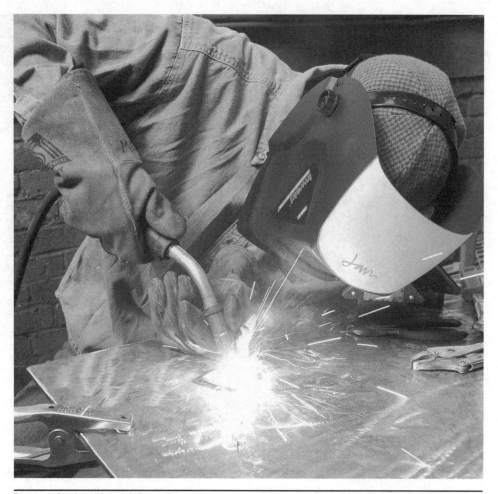

Figure 1.2 A welder working safely.

environment that will surprise and frustrate most new welders. The first projects in this book are designed to help you overcome this hurdle, and I strongly recommend that you take your time with these and move on only when you are comfortable maintaining a constant arc.

As recently as 20 years ago, there was one main type of welding helmet on the market. This helmet had a shade that was fixed at a specific darkness and required the user to "flip" the helmet down just before starting to weld. These helmets are called *fixed-shade, flip-down,* or *non-auto-darkening helmets* and are shown in Figure 1.3. They are still available today and are very inexpensive, have fewer parts, and require little maintenance. The main disadvantage is that between when you flip the helmet down and strike a continuous arc, you're basically left in the dark. To use one of these helmets, you must remain very still for this split second so as to not

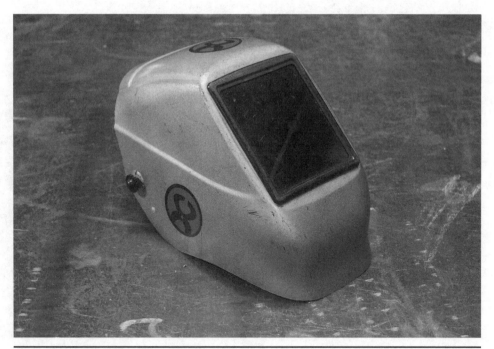

Figure 1.3 Fixed-shade welding helmet.

move your electrode and accidentally weld off-target. The other type of helmet that is very popular today is called an *auto-darkening helmet*, as shown in Figure 1.4. These helmets have a window that changes between a lighter shade (around nos. 3–5) to a shade that is appropriate for welding (nos. 10–14) immediately when exposed to welding light. These welding helmets are battery powered and have a solar panel that charges the battery when you are welding (genius!). They also have a sensor that triggers the shade to darken as soon as a welding arc is detected. These helmets are very convenient because you can see your work environment between stopping and starting the welding arc. For projects in this book, your maximum welding current will be less than 200 A. Take a look at Table 1.1 to see the range of possible shades required for MIG welding.

Steel Thickness	Arc Current (A)	Minimum Shade No.	Suggested Shade No.
>22 gauge	>60	7	8
20 gauge, $\frac{3}{16}$ in	60–160	8	10
$\frac{3}{16}$–$\frac{3}{8}$ in	160–250	10	12
<$\frac{3}{8}$ in	250–550	11	14

Table 1.1 Shade Number Guide for MIG Welding

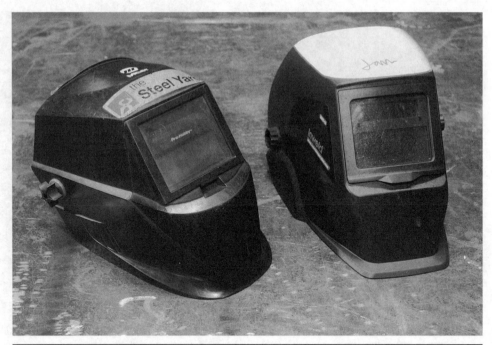

Figure 1.4 Auto-darkening welding helmets.

Every day when you strike your first arc, check to make sure that your auto-darkening helmet switches to the proper shade immediately. If it doesn't, try charging the battery by leaving it in direct sunlight. It's a good practice to leave your auto-darkening helmet in direct sunlight for short times when it's not in use so that it remains fully charged.

Two other types of welding eye protection exist, but I don't recommend either to beginning welders. The first type is a shield with a fixed-shade filter that you hold between your face and the weld area. For the techniques I'm going to cover in this book, this type of protection isn't acceptable because you'll be using both hands to brace the MIG weld gun. It also doesn't provide as consistent protection as a helmet to the rest of your face and neck. There are also shaded glasses intended for welding use (you've probably seen them in old movies), but these provide no protection to your face or neck and aren't used commonly with today's welding techniques.

Shaded Glasses and Face Shields (Shade Nos. 4–12)

For plasma cutting, a shade nos. 4–12 pair of glasses, goggles, or face shield always should be worn. Just as with welding, plasma cutting produces intense UV light, extreme heat, and sparks, so proper coverage and eye protection like that shown in Figure 1.5 is crucial. In Table 1.2, the full range of shades is listed for plasma cutting in relation to the machine's selected arc current.

FIGURE 1.5 Shaded glasses and a face shield.

A face shield also will provide protection against the sparks that inevitably bounce off the surface of the workpiece and toward your face. When you begin plasma or torch cutting, I suggest that you wear a full-face shield until you are accustomed to the sparks. When you are welding, cutting, or bending with an oxygen-acetylene torch, always wear a no. 4 or higher shade facemask or glasses. The exact shade number depends on your personal preference, but anything over a no. 4 shade will prevent injury from UV light produced by the flame.

Gloves

Mild steel melts at around 2,600°F. This is over 2,000 degrees hotter than if you accidentally reached into your oven to grab a pie tin while the oven is still hot.

Arc Current (A)	Minimum Shade No.	Suggested Shade No.
<20	4	4
20–40	5	5
40–60	6	6
60–80	8	8
80–300	8	9
300–400	9	12

TABLE 1.2 Shade Number Guide for Plasma Cutting

Needless to say, touching any piece of steel with your bare skin shortly after you've welded it will cause a serious burn.

There are a few types of gloves that you will want to use when working on a welding project; most importa is a nice pair of insulated welding gloves such as those shown in Figure 1.6. These gloves will protect you from flying sparks, heat, and UV light. Although they are well insulated, heat can—and will—transfer through them if your hand is on or near a hot surface for an extended period of time. If you start to feel heat on the inside of your glove, chances are that within a few seconds that heat is going to get much hotter. This is why MIG welding gloves are slightly loosely fitting. With one or two quick shakes of your wrist, the glove should slide completely off your hand. It will take some getting used to working in these clumsy-feeling gloves, but stick with it and you'll soon adjust. Wear these gloves when MIG welding, plasma cutting, and torch cutting. They also will come in handy when you need to remove a wire wheel from your angle grinder.

Many metalworkers will have another pair of noninsulated work gloves to use when handling metal projects before and after the welding stage. I find it more comfortable to handle steel with such gloves, and they also help grip dirty or oil-soaked materials.

CAUTION: Never use welding gloves that are greasy or oily.

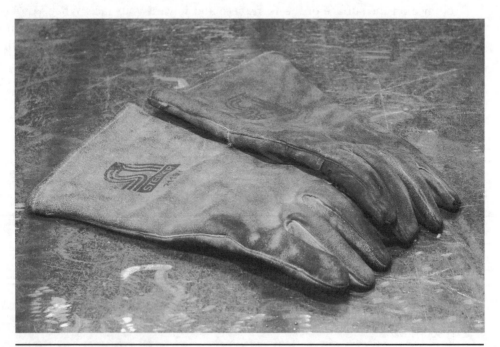

FIGURE **1.6** Insulated welding gloves.

Keep in mind that you should never wear any gloves when working with rotational tools such as a drill press, angle grinder, chop saw, or bench grinder. If your glove were to get snagged by one of these tools, the rotational inertia is enough to pull your whole hand into the "danger zone." I make an exception to this rule only when I am using a wire wheel on the angle grinder. The small shards of steel wire that come off the wheel will become embedded in your hands if they aren't covered.

Tip: Apply hand lotion liberally before you start working in the shop, and most grease and grime will wash right off your hands at the end of the day.

Arm, Neck, and Head Protection

Protection for your upper body can come in many forms. Many welders prefer to wear a long-sleeved work shirt with a collar to protect their arms and neck. Sometimes welders also wear a scarf or bandana around their necks to give more protection from the extreme welding light. It's easy to cover up for welding when it's cool out, but in the summer or in warmer climates it may be tempting to dress down to stay cool. In such situations, I suggest wearing welder's sleeves such as those shown in Figure 1.7, which are long sleeves attached to a button-up crop top

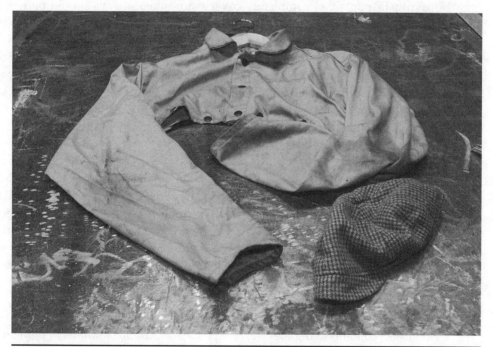

Figure 1.7 Welding sleeves and cap.

that usually has a collar. They should be made out of leather or other nonsynthetic material.

With your welding helmet and collar or scarf on, the only part of your head that is exposed to sparks is the top. For this I recommend wearing a wool or cotton cap with a short bill either to the front or back of your head. This will prevent sparks from singeing your scalp and hair.

In general, make sure that none of your clothing is too loose fitting so that you can avoid having it snag on your work or a tool. This also goes for hair and jewelry. If you have long hair, make sure that it is secured neatly to your head or tucked into your shirt collar, and any long, dangly jewelry should be removed.

Boots

Boots or sturdy leather shoes are essential in a metal shop. Most metalworkers recommend steel-toed work boots for added protection in the event of a heavy object falling from the workbench and landing directly on your foot. Shoes or sneakers made from synthetic materials can melt when they come into contact with a hot object or find their way into the path of falling sparks. Any type of footwear that leaves part of your foot exposed should never be worn in a metal shop. Find a quality pair of work boots, and you'll be working in comfort for years to come.

Long Pants

Nonsynthetic pants that completely cover your ankles always should be worn in the shop. Again, synthetic materials can melt when exposed to heat and can to stick to your skin, worsening the burn. Any pants that have frayed material should be thrown out or, better yet, turned into a rag. Frayed natural fibers can burn if they come into contact with a stray spark. Cuffed pants also can pose a risk because sparks that otherwise would bounce off could become trapped in the cuff and start to burn through to your skin. Pants should not be tucked into boots but rather should be left outside to help keep sparks and debris from falling into the boots.

Hearing Protection

There are two main types of hearing protection commonly worn in metal shops: foam earplugs and earmuffs such as those shown in Figure 1.8. Each style has a range of decibels that it can block out if worn correctly, but generally, the foam earplugs block more sound. Earmuffs are great if you take them off and put them on frequently, whereas foam earplugs are a little more challenging to put in correctly and so are better for longer applications. Each will come with proper use instructions, which I strongly suggest you follow.

Dust Masks

Carbon steel contains manganese, and exposure to extreme amounts of manganese can cause Parkinson's disease, especially when inhaled. When steel is welded,

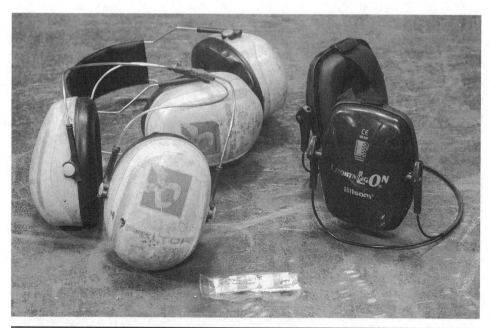

FIGURE 1.8 Earmuff- and earplug-style hearing protection.

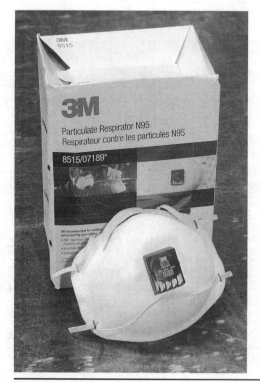

FIGURE 1.9 Dust masks.

some of this manganese is turned into gas. Many shops are equipped with air circulators or ventilators to direct these fumes away from the welder. For shops that don't have these, personal respirator systems are available that deliver a supply of fresh air directly to the welder. However, if you're not spending 40 hours a week welding, an N99 or N95 dusk mask (Moldex or 3-M brand, as shown in Figure 1.9) is more than adequate and much more affordable. When grinding and sanding steel, one of these masks also should be worn to minimize dust inhalation. At the end of a workday, you'll be thankful when you come home and find that your nasal mucus isn't black!

Shop Safety Equipment

Welding Screens

To protect the people working near you and in an effort to keep your sparks controlled, every welding shop should be outfitted with a number of welding screens. These screens can either be tabletop or go all the way to the floor, as shown in Figure 1.10. They will prevent accidental "flashing" of anyone working nearby or passing through your area. Depending on your work environment, you may need up to four welding screens to keep your workplace safe (one for each side of

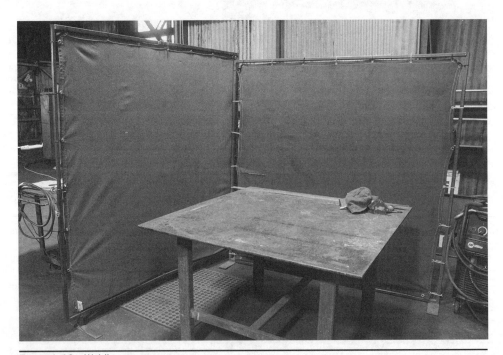

FIGURE 1.10 Welding screens.

your table). Screens can be made out of either canvas or amber-colored polyvinyl chloride (PVC). They should be used to prevent sparks from traveling across the shop space or onto others who are present in your work area.

Fire Extinguishers

As I mentioned earlier, every shop should be equipped with a number of up-to-date, functioning fire extinguishers. They should be accessible in an emergency, and everyone who has access to your shop should be trained on how to use them. Remember the acronym PASS—pull, aim, squeeze, and sweep. This stands for pull the pin, aim the hose at the base of the flames, squeeze the handle, and sweep the spray across the base of the flames.

Covered Trash Cans

To further avoid fire hazards, trashcans should be covered. An old pizza box or rag, when introduced to a welding spark, can go up in flames very quickly. Keeping lids on trashcans will not allow as much oxygen into the can, thus preventing anything from combusting. This is especially true when dealing with oily rags.

First Aid Kit and Eyewash

At least one fully stocked first aid kit should be easily accessible in the shop. This should contain bandages, eyewash, antiseptic, and burn ointment. If possible, a plumbed eyewash station should be built in the shop as well.

Ventilation

Metalwork creates noxious fumes and dust, so many shops are outfitted with a ventilation system near work areas. These systems help to keep the work area clean and also protect your health. Sometimes these are hoods that pull air up and away, and other times they are table-type ventilators that pull air and debris down to be filtered. Depending on the type of work you do, a ventilation system may be required. For example, if you're frequently welding or grinding steel that has paint or another finish on it, you'll want to make sure not to breathe those fumes.

NOTE: Direct breeze to your MIG welding area can cause inferior welds by blowing the shielding gas away. For welding in windy environments, you may need to use flux-core welding wire. A breeze also may make it more difficult to control the heat when you are torch welding.

Minimum Safety Equipment Review

To review, I've included the following lists of minimum safety items that should be worn during each of the procedures covered in this book, and I head each list with

some of the safety hazards to keep in mind. This chapter is not meant to scare or intimidate. If there is one thing you take away from this, I hope it's that with some forethought and planning, it is quite easy to keep yourself safe while working in a metalworking environment. If any procedure covered in this book leaves you feeling a little worried or unsafe, please find someone who can take you through the procedure in person and give you pointers.

Review all safety warnings and guidelines that come with your specific tools and safety gear. Most important, make safety your number one priority.

MIG Welder

Intense UV Light, Extreme Heat, Sparks, High-Voltage Current, and Gases
- Welding helmet (with proper shade)
- Safety glasses
- Insulated gloves
- Long sleeves, pants, boots, hat, and neck protection
- Dust mask (N99 or N95) when welding for extended periods
- Welding screens

Plasma Cutter and Oxygen-Acetylene Torch

Lower-Intensity UV Light, High Heat, Sparks, and Gases
- Proper shaded glasses or facemask (no. 4 and up)
- Insulated gloves
- Long sleeves, pants, boots, hat, and neck protection
- Dust mask (N99 or N95) when welding for extended periods
- Welding screens

Angle Grinder, Chop Saw, Bench Grinder, and Drill Press

High-speed rotating tools may cause your workpiece to be jerked out of your hand and launched into your work area. If an item of clothing or dangling jewelry gets caught in one of these tools, it can pull your body into the tool, causing serious injury.

Rotational Blades, Sparks, Flying Particulates, and Heat
- Face shield and/or safety glasses
- Long sleeves (not loose at wrists), pants, and boots
- Hearing protection
- Dust mask (N99 or N95)
- *Do not wear gloves.*

Roller and Hand Tools

Sharp Edges, Flying Particulates and Grit/Grime
- Safety glasses
- Work gloves (not when working on a roller)
- Long sleeves, pants, and boots
- No loose-fitting clothing or dangling jewelry

General Shop Safety

Sharp Objects That Can Poke or Snag, Electricity, General Grit, and Others Working in Your Vicinity
- Safety glasses
- Work gloves
- Long sleeves, pants, and boots
- No loose-fitting clothing or dangling jewelry

Welding 101

What Is Welding?

At its most basic, *welding* is a process of joining materials so that the result is a continuous solid. It seems silly, but I find it helps to look at the definition of *continuous*; it means "an unbroken whole (solid) without interruptions." This means that if you have two pieces of steel and you weld them together, the result is one uniform piece of steel without interruptions. People generally think of welding metals such as steel, aluminum, titanium, cast iron, or copper, but welding even can be used to join plastics and synthetic fibers. Because of the diverse properties of these materials, welding takes on many forms in terms of tools and procedures used.

To weld steel, you first must be able to bring the steel above its melting temperature of around 2,600°F. When the steel melts, it then can combine with a neighboring piece of steel or filler steel, both of which also must be melted. The properties of steel allow it to cool and re-form into a solid without any other steps, so really the welding process is, in theory, very easy. For electrical welding, one other element is needed to create a solid weld, and that is shielding gas. An inert or semi-inert gas must be directed around the weld area to promote the electric arc and keep impurities out of the finished weld.

All of the welding processes I will discuss in this book have these things in common: a controllable heat source, a method of adding filler material, and some type of gas welding environment. It is the way in which these various elements are controlled that gives the different types of welding their own advantages and disadvantages and also determines how "easy" they are to learn. For this book, I am going to focus on welding steel using two methods. The first is a process that is roughly a century old, and it uses a 6,000°F flame to bring an area of steel to its melting point, at which time you manually introduce a filler rod to blend the two pieces together (Figure 2.1). You'll also learn an electric-arc welding process called

FIGURE 2.1 Handwritten "welding" using a weld bead.

metal–inert gas (MIG) welding, a gas-metal arc welding (GMAW) process, where you use an electric arc to melt the steel and automatically add filler material. With this narrow focus, I can redefine welding as the process of joining together steel pieces by heating them to their melting temperature and adding steel filler to take up any voids.

The first method, *oxygen-acetylene (oxy-acetylene) torch welding*, is a great way to understand the principles that make MIG welding work. While torch welding, you are in complete control of the heat and filler material. In this way, you get instant feedback when adding too much or too little heat: Add too much heat, and your material starts to burn away; add too little heat, and the filler won't melt properly. The MIG machine does so much automatically (exactly why it's great for beginners) that if you don't take time to understand the process, it's easy to get it wrong. I also find oxy-acetylene welding to be somewhat relaxing and therapeutic. It's relatively quiet and requires your complete attention. At the same time, oxy-acetylene welding is a bit more challenging, so if you struggle with it, I don't want you to give up hope. Just move onto the next chapter, where you'll learn about MIG welding, and then come back to it later.

Welding has a number of advantages over other joining techniques. Being able to combine multiple pieces into one uniform piece is a big one. This has a clear advantage for engineering purposes; when you understand the characteristics of a material, it is easier to predict how a complex shape will perform when stressed.

Steel and other metals are very workable; you can cast, forge, bend, draw out, and manipulate them almost endlessly. When these processes are combined with welding, the possibilities are even greater. Figure 2.2 shows a typical welded steel connection. Welding lets you free yourself of a lot of the work that would go into preparing a strong connection of a different type. For example, if you wanted to securely attach a ½-in-diameter round steel stock on end to a flat 1-ft square of ¼-in steel plate without welding, as shown in Figure 2.3, the process would involve drilling, cutting threads in both materials, and fitting them together. The result would be a strong, removable connection, but lost are many hours of shop time. If you can weld this connection, all you have to do for preparation is to clean both surfaces, and you can make a strong, permanent connection in a matter of minutes.

With welding, you are able to connect parts in ways that make sense even to a non–mechanically minded person. If you want to "stick" a piece of steel on another piece of steel, weld it! Upside down? That's okay. Sideways? Of course. Almost any way you can imagine putting two things together, you can achieve through welding.

Another advantage to welding is that it's quick enough to let us prototype a design in full size and also strong enough to be used permanently and safely as the

FIGURE 2.2 A welded connection.

Weld or connection

FIGURE 2.3 A ½-in piece of round stock attached to ¼-in plate.

final connection method. You can quickly answer design questions or problems and try the result out in the real world. Say that you are curious what height a stool you're designing should be. Why not weld a simple mock-up together and try it out by putting it to use?

Welding also can fit a number of aesthetic design choices. If you want your project to have a clean, joint-free look, there is no better way than welding; if desired, you could grind away all your welds until they nearly disappear. If you want the final product to look rough, natural, or decorative, welding lets you add decoration to the material infinitely. The look of a weld bead is unique, and some artists choose to leave the beads visible, grind them away, or even build sculptures completely from weld bead. Depending on your artistic vision, you can achieve anything from Mad Max gnarly to Martha Stewart chic.

What Isn't Welding?

So welding sounds pretty great, but there are a number of other connection methods that you see in everyday life, such as adhesives, nails, screws, bolts, and even rope. Why don't you just weld everything? One answer is that not everything can be welded. A solid must melt into a liquid when heated as opposed to sublimate to a gas. For example, if you try to heat wood with your oxy-acetylene torch, it just

burns away. As you learned at the beginning of this chapter, welding is mostly limited to metals and some plastics. In terms of joining, any joint between two or more materials that interrupts the material is not a weld.

Another answer is that other joining techniques actually have a lot of advantages. There is a wide array of fasteners, all of which are designed to join material in a particular way. Whether to weld or fasten a joint should be determined by the demands of the specific application. For example, welded joints are as permanent as joining gets. If there is the chance that you'll need to remove or adjust something on your workpiece, it may be better to fasten that part with bolts or screws.

Let's take a look at different ways of joining materials to better understand what makes welding unique. For projects later in this book, you'll return to some of these techniques as needed.

Welding

Figure 2.4 shows a cross section of a welded joint. This weld, if performed correctly, has at least the same strength as the material surrounding it, and it didn't require any brackets to be fabricated or expensive hardware.

Figure 2.4 A cross section of a successful weld.

Mechanical Connections

Mechanical connections are those where the joining force is applied through mechanical fasteners such as screws, nails, rivets, bolts, clamps, or even a simple string or some type of glue. Mechanical connections are very useful because they can be strong, are very versatile, usually don't require expensive tools, can be permanent or temporary, and can allow for movement. Although some mechanical connections may be uniform in material, the resulting piece is not a continuous solid, such as steel rivets on sheet steel or a bolted steel connection. These two examples may seem to meet the rules of welding, but just because they are composed of the same material does not mean that they are a continuous solid.

Adhesives

An *adhesive* is a material or chemical compound that bonds items together. Adhesives harden after they have been applied through evaporation or a chemical reaction. Adhesion occurs either by mechanical means, where the adhesive works its way into small pores on the surface of the object, or by a chemical method, where the adhesive reacts with the material. Adhesives can be very strong and easy to work with and can bond many dissimilar materials. An important consideration when determining the strength of an adhesive connection is the surface area to be bonded. If you were gluing two sheets of paper together face to face, the result would be incredibly strong. However, if you wanted to attach the two sheets edge to edge, it would be nearly impossible to create a bond. However, edge-to-edge connecting is possible through welding.

Soldering or Brazing

Much like welding, *soldering* is a form of connection that also involves heating a parent material and adding filler. The difference is that the filler is the only material to melt in the soldering process. That is, the object requiring connection does not reach its melting temperature. *Brazing* is a type of higher-temperature soldering that occurs when the filler metal has a melting point of over 842°F.

It is possible to solder or braze many of the same materials that can be welded. For example, for a lugged steel bicycle frame, steel tubing and castings are brazed together using brass filler, and in many houses, the plumbing is mostly copper tubing and fittings joined by a silver-alloy solder. It is often easy to identify a soldered or brazed connection because there will be a metallic material of a different color along the seam or joint. Soldering is very useful when working with small pieces such as jewelry because less heat is generated than with welding, and therefore there is less metal distortion.

How Welding Works

You learned that in order to weld steel, you need a controllable heat source, a filler material added in precise amounts, and usually some type of shielding gas to keep your weld clean. The ways in which either the user or the machine controls these variables determine the advantages and disadvantages of each welding process. Now I'm going to provide a look at four specific types of welding to show you how they control their variables: torch welding, which uses a flame to create heat, and metal–inert gas (MIG), tungsten–inert gas (TIG), and stick welding, all of which use an electric arc to create heat.

Before I get into specifics, let's review a basic principle of electricity and how it applies to MIG welding. We know that opposite charges attract electrons thanks to research by Charles Augustin de Coulomb and Georg Simon Ohm. When a medium is provided to allow the exchange of electrons, an electric current is produced. For electrical welding, the opposing charges are a positive electrode and a negative clamp connected to your work (also called a *ground clamp*). In electric welding, however, the medium is a little unusual. The high-amperage output from a welder causes an electric arc to jump between the electrode and the base material, ionizing the air (essentially this is plasma). From this point on, the medium required to aid in the exchange of electrons is this arc. When you're welding, you won't feel the electrode actually touch the base material because it has already turned into a liquid at that point. Because ionized air isn't a perfect conductor, some of the electron energy is converted into heat and light energy. This is where the arc gets its bright light and extreme heat.

Types of Welders

There are many types of metal welding used by artists and industry today. MIG welding is one of the most common, versatile, speedy, and easy-to-learn methods of welding. A few other common forms of welding that you may encounter while shopping for tools or in a shared work environment are TIG welding (a type of GTAW), stick welding (or shielded metal arc welding [SMAW]), and of course, torch welding. As you develop your metalworking skills, there may be applications where one of these other welding methods is preferred. For example, for very precise welding and for welding thin materials, the TIG process is usually used over MIG welding. For structural welding, although MIG welding is common, stick welding may be required or specified in construction documents.

Torch Welding

Torch (or gas) welding was one of the first industrial welding methods and is still used today. Figure 2.5 shows an oxy-acetylene torch forming a weld along a corner

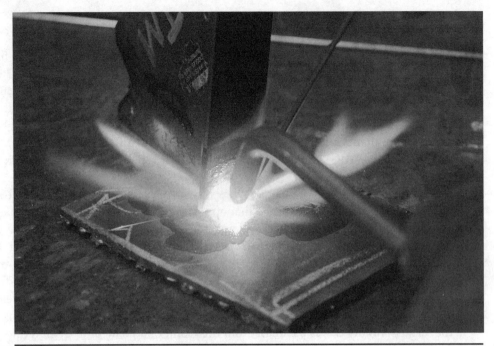

Figure 2.5 Torch welding.

joint. The flame created by the burning of oxygen and acetylene gas is over 6,000°F, which is more than enough to bring steel to its melting temperature of around 2,600°F. Still, it takes some time to bring the temperature up enough to weld. The thicker the material, the longer it will take because the heat is absorbed into the steel. As the metal gets hotter, it will change from dark red, to orange, to yellow, until a shiny pool of molten metal is formed. Both materials here should be brought to this molten point before adding filler. Once they are ready, gently "stir" the pools together using the tip of the flame and bring the filler close enough so that it starts to melt. Dab the filler rod into the molten pool as the torch slowly moves along the seam, making sure to keep both sides molten as you go. The quickly spreading heat will make the molten pool form more quickly as you move along the joint. It should be noted that to weld with an oxy-acetylene torch, you don't actually have to add filler; swirling the metal together with the flame also forms a weld.

Of the modern welding techniques, torch welding has the most indirect heat source. The flame created by the burning of acetylene in oxygen is over 6,000°F, hot enough to bring steel to its melting point, but it requires more time than an electric arc. Over time, the heat at the source of the flame is dispersed over the steel and can cause the steel to warp or bend. Clearly, a small flame is an improvement over using an open fire to heat steel, but it is not nearly as precise as an electric arc.

Controlling the addition of filler material with your hand is not the easiest way to add filler, but with practice, exceptional welds can be achieved. An experienced welder will get feedback immediately from the weld area and can adjust the amount of filler to match.

No shielding agent is required for most torch welding, but when needed, it can be added before heat is applied in the form of paste flux.

Metal–Inert Gas (MIG) Welding or Gas-Metal Arc Welding (GMAW)

All the ingredients to form a weld with the MIG welder are pretty much the same as with torch welding but in very a different form. Rather than using a flame to create heat for melting the steel, a MIG machine uses a powerful electric arc. This arc reaches temperatures of over 10,000°F, enough to bring steel to its melting point very quickly. To create an arc, you need an electrical circuit. The steel workpiece is connected to the negative clamp on the welder, completely charging it. The tip of the MIG gun acts as the positive electrode, and the filler rod protrudes out of the tip. Once you pull the trigger on the gun, the filler rod is automatically fed through the tip and carries with it the positive charge from the machine. This type of electrode is called a *consumable electrode*. As soon as the positively charged electrode and negatively charged workpiece are within roughly $\frac{3}{16}$ in, they begin to arc. The arc continues as long as this distance is maintained and the trigger is held down. Figure 2.6 shows a MIG weld in progress.

The MIG welding machine automatically adds filler material, shielding gas, and heat, all with the push of a button. Before starting a weld, the user must dial in the correct voltage, select the right wire size and feed rate, and adjust the gas to the correct setting. Once that is done, however, all the user needs to do is pull the trigger and control the MIG gun's movement along the weld path. It is essentially a one-handed operation.

Tungsten–Inert Gas (TIG) Welding or Gas-Tungsten Arc Welding (GTAW)

A big advantage to using a TIG welder is the added control put into the hands (and feet) of the person doing the welding. The only "automatic" feature of a TIG welder is the delivery of shielding gas. Even the amperage is finely tuned by the operator's foot pedal. There is no automatic feed for the filler rod either, which is held in one of the welder's hands and fed manually, much as in torch welding. Because a smaller, more controllable heat source is used with TIG welding, there is more control and less risk of damaging the metal than with a torch. TIG welding can deliver quite a bit of electric current, so it too can be used for structural applications.

Another advantage to a TIG setup is its low noise and low mess. Because the user controls how much filler is added, as long as the proper amount is added, TIG welding has no sparks, spatter, or popping noise.

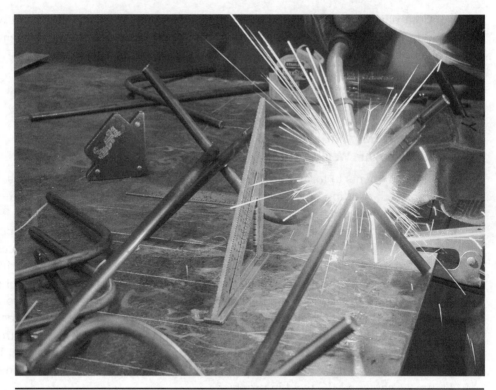

Figure 2.6 MIG welding.

Lastly, since TIG welding machines have added adjustability and put so much control into the hands of the welder, they end up being the most versatile welding machine in existence, able to weld many different types of metal. They can weld many types of steel alloy, titanium alloy, copper alloy, aluminum alloy, magnesium, and nickel. These various types of metals have uses from extremely specific and well-engineered aircraft parts to "pot-metal" gizmos and ornaments.

Stick Welding (Shielded Metal Arc Welding)

Stick welding has been around for over a century and was one of the first forms of electric arc welding. Like our other forms of electric welding, it has a positive electrode and negative clamp, but there is no separate shielding gas. The shielding gas is in the form of solid flux and coats the consumable electrode. As it and the electrode burn away, a gas environment is created around the weld area. Stick welding is great when a lot of heat and weld penetration are required and is a relatively easy tool to set up and use. It is slightly more difficult to learn than MIG welding and is fairly limited in its use. Only the most skilled welder would be able to weld any type of sheet metal using a stick welder, for example. Stick welding machines (Figure 2.7) often resemble tombstones and sometimes are called by that name.

FIGURE 2.7 Stick welder.

Another disadvantage to stick welding is the slag that is left behind on the surface of the weld. To weld over a previous stick weld and for finishing, the slag must be hammered off.

All these methods of welding are extremely important to today's artists and industry, but I think the most satisfying technique for beginners is the MIG welding process.

Types of Welds and Joints

The general name for the line of filler material that you lay down with each weld is the *bead*. A weld bead that is not used to connect two or more pieces together is referred to as a *surface weld* and is used mostly for decorative or labeling purposes, as shown in Figure 2.1 (i.e., surface design, labeling your work, etc.). Figure 2.8 shows other examples of welds that are used to hold one or more pieces of steel together called *butt joints, corner joints, edge joints, lap joints,* and *tee joints.* These welds all have applications depending on the types of connections you need to make.

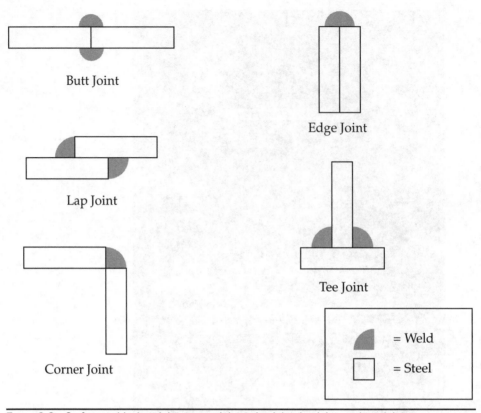

Butt Joint

Edge Joint

Lap Joint

Corner Joint

Tee Joint

= Weld

= Steel

FIGURE 2.8 Surface welds, butt joint, corner joint, edge joint, lap joint, and tee joint.

- *Butt joints.* Butt-joint welds are connections where two pieces are welded end to end (180 degrees). A square butt joint has no chamfer (a corner that's been ground at 45 degrees), and in a bevel butt joint, or v-joint, one or all corners have been chamfered.
- *Corner joints.* When two pieces are joined perpendicular to each other, it is a corner joint. Any joint that is between 180 and 0 degrees is a corner joint.
- *Edge joints.* An edge joint is like a butt joint, only the two pieces are parallel to each other, and the weld happens on the edge.
- *Lap joints.* Any time two pieces overlap each other and are welded edge to face, this is a lap joint.
- *Tee joints.* These are like corner joints, when the materials are situated perpendicular to each other, but with area for a fillet weld on either side.

As I stated earlier, almost any way you can dream of attaching two pieces together, you can achieve with welding. Fortunately, a lot of these connection styles are used regularly and have common names. What Figure 2.8 shows is how the two pieces are oriented to each other and where to grind away each material to allow

for the best heat penetration and weld strength. I am not going to go into how these chamfered edges are made quite yet, but this figure will prove very valuable when you put your grinding, welding, and fabricating skills to work.

A Brief History of Welding

The earliest examples of welding date back to the Bronze Age, but with no electricity, compressed gases, or power tools, it was quite different from the forms discussed in this book. Heat from a fire was used to bring materials up to nearly melting temperature, and then they were hammered or pressed together to form a continuous solid. This form of welding is actually still used today by blacksmiths and is commonly called *forge welding*. Tools discovered dating back to 1000 BC show signs of this kind of welding.

Techniques based on forge welding were used into the nineteenth century until advancements came in the form of the electric arc and the discovery of acetylene gas. Along with acetylene gas, advancements had been made in tooling used to control an open flame. This meant that rather than using an open fire as the heat source, heat could be focused to a smaller area for more efficient heating. The electric arc is really just another way of focusing heat to an even finer point.

It wasn't until the beginning of the twentieth century that the combination of pure oxygen with an acetylene flame and further developments in torch technology really made the oxy-acetylene welding technique more viable. It's wild to think that welding as we know it has only been around for a little over 100 years!

Just before the turn of the twentieth century, the first U.S. patent was awarded to C. L. Coffin of Detroit for an arc welding process using a metal electrode. This is the first record of welding using an electric arc to carry filler material into the weld pool. Around that same time, electrodes and filler rods were being developed with a coating that would provide a more stable arc. World War I added pressure to all industry around the world, including welding, and gas and arc welding were further developed through the war until 1919. Immediately after the war, the American Welding Society (AWS) was formed, and it is still one of the greatest welding resources today.

Soon after the end of World War I, the first type of automatic welding was introduced, and it fed filler at a rate determined by arc voltage. While advancements were being made to automatic welding technology, they were being paralleled by advancements to stick welding. New types of electrodes came into existence, and codes specifying the quality of welds raised the bar for production standards. Also during this time, research was being done into types of gas environments for arc welding. This research would directly affect the technology behind MIG welding.

In the 1940s, GTAW (TIG) and GMAW (MIG) processes were developed further and patented. At that time, GTAW was used primarily for nonferrous metals (e.g., magnesium and aluminum) and the ferrous alloy stainless steel. GMAW, although intended for use with nonferrous metals, saw its most effective use on steel. The

use of a carbon dioxide (CO_2) atmosphere with a consumable electrode was announced in the early 1950s. The CO_2 atmosphere increased the temperature of the arc, allowing bigger electrodes to be used. Since it could be used with the already popular GTAW and GMAW tools, it gained immediate favor.

Welding technology saw many more improvements in the 1960s. New forms of welding that were based on the already tried and true forms were invented. Flux-core welding wire, electroslag welding, and plasma arc and electron-beam welding all were introduced at that time.

The development of welding technology can be summarized by one main goal: being able to precisely focus the heat source. We've come a long way since using an open fire to heat material, probably the most indirect heat source available. As scientific research developed, we were able to control fire using torches and compressed gas to make a very precise flame. When electricity was discovered, the heat from an electrical arc then was focused even further and was capable of higher heat. The most recent innovation, using lasers to quickly heat material, is by far the most precise heat source to date.

Steel

What Is Steel?

For the beginning welder, steel is an ideal material (Figure 3.1). Steel allows you to weld, reweld, cut, bend, file, grind, drill, and more, all with fairly basic tools. It is strong, readily available, inexpensive, and relatively forgiving when welding and manipulating. For these reasons, it is used in many structural and artistic applications today from demanding feats of engineering such as the Golden Gate Bridge to someone's backyard garden art.

To understand steel, you must first take a look at its main ingredient—iron. By mass, iron is the most common element forming our planet, mostly owing to its high presence in the earth's outer crust and inner core. It can be found on and close to the earth's surface is chunks called *ore* or by mining. It has been used for thousands of years because of its availability and relatively easy workability through forging. Naturally occurring, iron is fairly soft, although not as soft as another common metallic element—copper. It was discovered that by adding carbon to raw iron, it would get significantly harder and therefore more useful for making tools and weapons. The addition of carbon actually was a by-product of early forms of smelting, where carbon-rich charcoal was burned as the fuel source, thereby contributing to the molecular makeup of the end product. When carbon is combined with iron in amounts between 0.2 and up to 2 percent, the result is steel, which can be up to a thousand times harder and stronger than pure iron. However, most steel contains less than 0.35 percent carbon. An advantage to steels with between 0.35 and 1.86 percent carbon content is that they can be hardened using a technique called *quenching*, where the material is heated and cooled in a particular way. The type of steel you are going to use in this book is a type of plain-carbon steel (<1.50 percent carbon) called *low-carbon steel* or *mild steel*.

FIGURE 3.1 Examples of steel.

Plain-Carbon Steels

Low

Low-carbon steel is the most commonly used type, and it has a carbon content of less than 0.30 percent. Low-carbon steels have relatively easy workability, meaning that they are ductile, can be machined, and weld very well. Note that because of the carbon content, low-carbon steel cannot be hardened by quenching. In fact, rapidly cooling mild steel can cause unwanted stress in the material.

Medium

Medium-carbon steels have a carbon content of between 0.30 and 0.45 percent. While this type of steel is harder than low-carbon steel, it also is more difficult to work with.

High

A carbon content of between 0.45 and 0.75 percent yields high-carbon steel. Even more difficult to work with, many of these types of steel require careful preheating or postheating to weld successfully.

Very High

With up to 1.5 percent carbon content, very high-carbon steels are used primarily for heavy-duty springs and metal-cutting tools. Similar to the workability of high-carbon steels, very high-carbon steels require special heat treating in order to weld.

NOTE: Steel with a carbon content below 0.30 percent is called low-alloy steel, *and steel with a carbon content between 1.5 and around 2.0 percent is called* high-alloy steel.

When naming types of steels, standards from the American Iron and Steel Institute (AISI) and the Society of Automotive Engineers (SAE) are used. Table 3.1 shows a portion of the AISI table for the classification of steels.

How to Use Table 3.1
1. The first digit indicates the type of steel (1 for plain carbon).
2. The second digit indicates the alloying elements.
3. The last two digits indicate the average carbon content.

Examples
- AISI/SAE No. 1020: Plain carbon steel, no alloying elements, average 0.20 percent carbon content
- AISI/SAE No. 1518: Plain carbon steel, containing alloying elements (manganese, phosphorus, and sulfur), 0.18 percent carbon content

Of course, mild steel can't do everything. It can be quite heavy and will need some sort of finish to prevent rust from forming on the surface and eventually

10XX	Carbon steel	Non-resulfurized carbon steels, 1.00 percent maximum manganese
11XX	Carbon steel	Resulfurized* carbon steels
12XX	Carbon steel	Rephosphorized* and resulfurized carbon steels
15XX	Carbon steel	Non-resulfurized carbon steels, manganese maximum over 1.00 percent

*Resulfurized and rephosphorized steels contain added sulfur and phosphorus for improved machinability.

TABLE 3.1 AISI Carbon-Steel Designations

eating away the material. Now let's take a look at some common steel alloys that you may come across or be interested in working with for future projects.

Alloys

Although mild steel may be one of the most common types of steel you encounter, other alloys exist around us in daily life. Stainless steel resists corrosion and is used in kitchens for food preparation and many marine applications (AISI 2XX–5XX). Chromoly, also known as *cromo* or *cro-moly*, is a steel alloy containing chromium and molybdenum that has an excellent strength-to-weight ratio, is easily welded, and is stronger than mild steel (AISI 41XX). Chromoly is used frequently for bicycle frames, high-performance automotive roll cages, and other structural tubing.

When steel is combined with other elements, you can make many more steel alloys. Depending on which element or elements are used and how much of each is alloyed, the final physical properties can change drastically. Strength, brittleness, cost, weight, abrasion, elasticity, thermal conductivity, temperature expansion, dimensional stability, toughness, and corrosion resistance are all properties for which there are specific alloys that can be made to fit a particular application. These alloys are also measured by AISI and SAE.

The way in which alloys can be worked or welded also changes with alloy type. Spring steel (AISI 1074), which is used for car springs, antennas, and some rulers, contains 0.74 percent carbon, along with sulfur, manganese, and phosphorus, and these constituents allow the material to return to its original shape if bent. However, when heated and bent, this alloy is very likely to crack or tear, meaning that forging and welding must be done with special heat control and filler material.

Mild-Steel Properties

Strength

Mild steel is very strong when used and welded properly, which is why it is used so frequently today. Like the iron it is made from, it is extremely uniform in makeup, allowing you to engineer with steel and predict how it will perform in demanding applications. This is why a weld, if not performed properly, can cause a carefully engineered structure to fail. For the projects in this book, you'll generally be overbuilding, meaning that while your coffee table is designed to hold some books, a potted plant, and a few cups of coffee, more than likely you could park a small car or stand an elephant on it without it failing. Overbuilding or overengineering your projects gives you as a beginning welder more leeway when practicing welds.

Mild steel has a good, but not great, strength-to-weight ratio. What it lacks with that ratio, however, it makes up by being very easy to work with and affordable. Fancier steel alloys, while sometimes lighter and stronger, usually cost more and involve more difficult welding and forming processes.

Conductivity

Part of the metal–inert gas (MIG) welding process depends on the ability of steel to conduct an electric current. While clean steel accepts and carries a charge very well, any inhibitor such as rust or paint will seriously inhibit that characteristic.

Expansion and Contraction

Like most solids, when steel is heated, it expands, and when it is cooled, it contracts. Many factors determine the extent of expansion and contraction, so you can pretty much bet that after any workpiece is significantly heated and cooled, it's going to bend or warp to some degree. Sometimes this is hardly enough to notice, whereas other times it can throw a whole project out of whack. For example, when the first weld is formed between two pieces of steel, the weld area gets heated very rapidly. While this is happening, the two pieces are still noncontinuous until the weld bridges the gap. Now, when the weld is completed and the weld area cools, it's going to want to contract, but this time as one whole unit. This contraction will always cause some movement to occur over the length of the workpiece.

This effect is more noticeable on thinner materials, especially sheet metal. The heat affects a greater percentage of the material, causing greater warping. In projects later in this book, you'll learn ways to minimize warping and fix it when it occurs.

Corrosion and Rust

As I mentioned earlier, mild steel is susceptible to corrosion. Specifically, when iron and oxygen react in the presence of moisture, rust is formed. This reaction starts on the surface of the material, and because rust is permeable, it will continue to react and eat away at the underlying steel. Over time, this will cause pitting and flaking to occur, eventually leading to serious loss of material. This is different from how copper oxide, that lovely green color on the Statue of Liberty, actually protects the copper below. Rust can form on steel in hours or years depending on the environment.

Rust inhibits the electrical connection required for MIG welding. Before welding a joint, any rust should be removed from the weld area, as well as an area where the grounding clamp can be attached. There are a few easy methods of rust removal that will be covered shortly in this book. If the rust is light surface rust, you may be able to expose fresh steel using only a stiff wire brush or sandpaper. If the material is pitted or irregularly shaped, sandblasting or a wire wheel on an angle grinder may be your best bet. For large and/or pitted areas, chemical rust removers such as phosphoric acid or organic acids do the heavy lifting for you.

When steel rusts, it forms a reddish orange color. Many artists and gardeners choose to use this color as the final finish of a piece of art. If this is your desired effect, you can leave your work outside after welding or speed up the rusting process by lightly spraying the work with saltwater.

Mill Scale

Steel that's been prepared at a mill through a hot-rolling process (more on that later) will come with a thin layer of mill scale on its surface, like that on the left side of the steel in Figure 3.2. This scale is formed when working steel above 2,000°F. Scale poses a couple of problems for the welding and finishing of steel. It blocks the flow of electricity from penetrating into the steel, and rather than forming a solid weld, you'll just be welding to a thin sheet on the surface of the workpiece. Any force to this weld will break the scale right off, causing weld failure. Scale should be removed from all areas to be welded, and any loose and flakey scale should be removed from the whole piece prior to finishing so that it doesn't contaminate your weld. Scale can start to flake off of new steel relatively quickly and, for this reason, can cause problems if finish is applied over it.

Finishing

To prevent rust on a completed steel project, it must be finished. There are many great ways to finish steel, yet another reason it is such a versatile building material. Prior to finishing, however, and as mentioned earlier, any rust, loose debris, and all surface scale should be cleaned off thoroughly. You'll learn more specific finishing techniques in Chapter 12.

Figure 3.2 Mill scale on new steel.

How to Obtain Steel

Clearly, in order to weld, you're going to need some steel. There are two principal ways to get it—buy it or salvage it. Buying steel is great. You can get all kinds of shapes and sizes in unlimited amounts, but at over 40 cents a pound, the cost can add up for a project. In today's world, steel is so common that with a little searching, you can find scrap steel that is cheap or even free. You may be familiar with *found-object welded art*, which is composed entirely of exactly that—found steel. The two main disadvantages to using found or salvaged steel in your projects are that the piece you found and need more of may be unavailable, and usually salvaged steel requires more cleanup and prep before you are ready to weld it. In the remainder of this section, you're going to learn how to contact a steel yard and place an order for new steel and how to safely find salvaged steel such as from a scrap recycling dumpster shown in Figure 3.3.

FIGURE 3.3 Steel-scrap dumpster (don't climb in there!).

Buying Steel

Steel is available from all kinds of hardware and supply stores. The mom-and-pop hardware store nearest you may have short lengths of steel stock, tube, and sheet and most likely will have some steel pipe and fittings for sale. When in a pinch or just browsing for interesting material, such stores can be good places to go. Big-box hardware stores also stock some lengths of steel, usually a slightly larger assortment than small hardware stores but not in full lengths.

The best place to buy steel is from a *steel yard* (also called a *steel supplier*) or a *scrap yard*. A Google search for any of those terms or a look through the Yellow Pages for "steel supply" should return some local results. Also, check the resources at the end of this book to find if any steel suppliers near you have existing relationships with artists. Two of my favorite metal suppliers near Providence, RI, are Mid City Steel and J. Broomfield & Sons Scrap Metal. The men and women at Mid City Steel are always there to help, and they deliver a great product. They seem to understand the needs of artists better than anyone else in the area and typically offer a little more patience and advice. Broomfield has a pretty eclectic collection of salvaged goods, including chain, bumper cars, drum brakes, radiators, and much more.

Steel suppliers generally sell to buyers or construction projects in great quantities and deal with professionals. For artists who deal with a steel supplier, there can be some culture shock. Here are some tips when contacting a steel provider:

- *Respect the provider's time.* Explain yourself during your first phone call. Explain that you are a new metalworker and/or welder and are interested in buying steel. You can ask if the provider has a showroom where you can come browse or pick up materials. Maybe the provider has someone in-house who has experience selling to artists. Do your research before calling by reading this chapter and making a list of materials to purchase. If you still have questions for the provider, explain your project, and the provider probably will be able to offer advice.
- *Not everybody is going to be eager to help.* Many steel suppliers do hundreds of orders a day, and you may get someone on the phone who isn't interested in selling such a small quantity. Don't give up on your first try!
- *Remember that with most materials, you are responsible for buying the whole length.* If you need 2 ft of square tubing, you're just going to annoy a steel provider if you call and ask for that. Square tubing comes in lengths of around 24 ft, so you'd be responsible for purchasing the whole thing. Typically, plate steel can be cut down to order, and the provider may have already cut sections ready to buy.
- *When ordering steel from a steel supplier, you'll have to consider if you want it delivered or if you have the ability to pick it up.* Explain your situation to the

salesperson, and he or she can give you advice. Keep in mind there will be a delivery charge, so if you can wait and put in a big order of your own or join your order with that of with friends, you can save money. Having steel delivered is not like a UPS delivery; you need to be there to meet the delivery vehicle, and usually you must help to unload the material. Don't stand the delivery truck up!

- *If you visit a scrap or steel yard, dress appropriately, just like you would when doing metalwork.* If the steel or scrap yard allows visitors to view the materials or roam around, the supplier should provide you with a hardhat and have you sign a waiver.
- If you start to build a relationship with a steel provider, some homemade cookies or a six-pack will go a long way!

In general, I try to shop locally and avoid ordering steel online or from big-box stores and would encourage you to do the same. Although some of the characters you find in steel and scrap yards can be a little intimidating at first, I've found that many times these people are extremely helpful and are a great resource to have on your side.

Shapes

Steel comes in many shapes and sizes, so when you are shopping for steel, you'll need to know which shapes and dimensions are available. When choosing the proper shape, or *section*, for your project, there are many things to keep in mind. In general, solid sections will be heavier by the foot but are more forgiving during welding and are easier to bend. Hollow sections will have a greater strength-to-weight ratio and more torsional stiffness, but with a thin wall size, they may be tricky to weld and will crimp when bending. Sections of channel steel, angle steel, or I-beam are specifically designed to take loads in certain directions but not all of them. For example, they resist bending and shear forces but don't offer much torsional rigidity. Knowing what dimensions all these sections come in will make designing your project much easier.

Some terms you'll hear when talking about new steel are *sheet, tube, plate, stock, beams, angle, channel, flat, bar, pipe,* and *rounds*. What do they all mean? Take a look at Figure 3.4 to see some common shapes.

Square Stock. Square stock or square bar is a solid square section of steel that is commonly available starting at ¼ in per side and goes up to at least 3 in square. Smaller sections will be easy to bend by hand, and square stock is a great all-purpose fabricating material. Usually this is available at suppliers in 20-ft lengths.

Square Tube. Square tube is available starting at around a ½ in square and goes up to 12 in or more in various increments. Keep in mind that on top of specifying

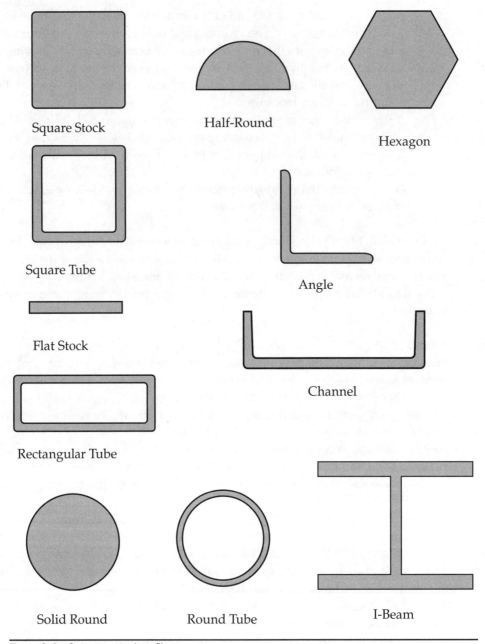

Square Stock

Half-Round

Hexagon

Square Tube

Angle

Flat Stock

Channel

Rectangular Tube

Solid Round

Round Tube

I-Beam

FIGURE 3.4 Common steel profiles.

the dimensions of the square you want, you also must specify what wall thickness you are looking for. The wall thickness is the thickness of the steel that makes up the tube and will be given in gauge or inches. For a gauge chart, see Table 3.3. Square tube can be slightly more difficult to weld than square stock because of the wall thickness, but it has excellent strength-to-weight characteristics, and typically it will be available in 24-ft lengths.

Flat Bar. Flat bar, flat stock, flats, or rectangular bar is a rectangular section of steel that is available in various widths and heights and will come from the steel yard in 20-ft lengths. It is great for bracing or decorative work and is quite strong when force is applied parallel to its long edge.

Rectangular Tube. Rectangular tube, sometimes called *box tube*, is essentially the tube version of flat bar. Just as with square tube, when ordering, you must specify what wall thickness you require. Rectangular tube also has great strength-to-weight characteristics and is used for a wide variety of applications from racecar chassis to structural building components. Usually it comes in 24-ft lengths.

Round Stock. Round stock or rounds are solid round sections that come in 20-ft lengths. They are great for hand-bending decorative work, stakes, and struts.

Round Tube. Round tube—*not* pipe—refers to steel that is measured to its actual outside diameter (OD). It is extremely useful for its strength-to-weight ratio and is available in sizes from $\frac{1}{4}$ in OD to 12 in OD and comes in many different wall thicknesses. Usually it comes in 24-ft lengths.

Steel pipe—yes, steel *pipe*—or black steel pipe is different from round tube by the way it is measured, but as long as you are buying black steel pipe and not iron pipe, plastic pipe, or copper pipe, it can be welded just the same. The way pipe is measured is by *nominal pipe size* (NPS). For pipe less than 14 in in diameter, this NPS number is actually different from the outside diameter. The other difference in measuring is how the wall thickness is designated. Rather than inches, wall thickness is indicated by a *schedule number* (SCH), which refers loosely to the pressure rating of the pipe. The higher the schedule, the thicker the pipe. For this reason, if you order $\frac{1}{2}$-in NPS steel pipe, you're actually going to get something with nearly a $\frac{7}{8}$ in OD with an inside diameter that depends on the specified schedule. Table 3.2 provides some useful NPS sizes from $\frac{3}{8}$ to 4 in.

Pipe measured this way may be used for structural applications or the transport of solids, liquids, and gases and can be made of steel, plastic, cast iron, copper, and other materials. Most of the time when you buy steel NPS pipe, it will come with threaded ends, which will allow you to make removable or temporary connections using fittings and even connect to materials other than steel (that use the NPS

NPS	Outside Diameter (in)	SCH 5 (in)	SCH 10 (in)	SCH 30 (in)	SCH 40 (in)	SCH 80 (in)
3/8	0.675	0.049	0.065	0.073	0.091	0.126
1/2	0.840	0.065	0.083	0.095	0.109	0.147
3/4	1.050	0.065	0.083	0.095	0.113	0.154
1	1.315	0.065	0.109	0.114	0.133	0.179
1¼	1.660	0.065	0.109	0.117	0.140	0.191
1½	1.900	0.065	0.109	0.125	0.145	0.200
2	2.375	0.065	0.109	0.125	0.154	0.218
2½	2.875	0.083	0.120	0.188	0.203	0.276
3	3.500	0.083	0.120	0.188	0.216	0.300
3½	4.000	0.083	0.120	0.188	0.266	0.318
4	4.500	0.083	0.120	0.188	0.237	0.337

TABLE 3.2 NPS Chart

system). When purchasing pipe from a steel service center, you frequently can get it uncoated and with the ends unthreaded, all ready to be painted

Another advantage to using steel pipe is that you can find it at your local plumbing store, hardware store, or big-box shop. At most smaller hardware stores, you can buy pieces of this pipe in very easy-to-manage lengths, such as less than 6 ft, so you don't need to own a pickup truck or roof rack on your car to bring it to your shop. A disadvantage to using black steel pipe is that it has an extra coating that you'll have to remove before you can safely and effectively weld it.

Hexagon Stock. Hexagon stock or hexagon bar is not as readily available as some other types of stock, but many steel and scrap yards do have some in supply. As the name implies, it is a solid hexagonal section that usually comes in 20-ft lengths.

Channel Stock. The most common type of channel stock you'll encounter is C channel, also called *U channel*, for its resemblance to a C or a U depending on which way it's turned. It's a solid section but with a hollow area between the legs. It's very useful for structural applications, and the open channel makes a good area to hide an edge.

Angle Stock. There are two types of angle stock: equal leg, in which both sides of the angle have the same measurement, and unequal leg, in which one side is longer than the other. It comes in many sizes and can be a very strong and lightweight structural component. The open space between the legs also can be

used to hide an exposed edge. It comes in 20-ft lengths but also may be supplied in lengths up to 40 ft.

Half-Round Stock. Half rounds are like a solid round section cut in half. They are used mostly for decoration or can be fit with rollers to make a track. They come in 20-ft lengths.

I-Beams. I-beams, H-beams, or just beams are structural-steel sections resembling an uppercase *I* that have a great load-bearing capacity. The top and bottom of the *I* are called *flanges*, and the piece connecting them is called the *web*. When specifying a section of beam, the dimensions you'll need to know are the beam height (i.e., flange-to-flange distance), flange width, web thickness, flange thickness, and length. These dimensions greatly affect the structural capacity of the beam and require advance engineering to calculate correctly.

Sheet. Sheet steel, or just sheet metal, is steel formed into a sheet whose thickness is under ¼ in. The thickness of sheet steel is called its *gauge*. Gauges correspond inversely to their empirical equivalent and only go as thick as 3 (0.2391 in), roughly ¼ in. Steel thicker than this is called *plate steel*, and the empirical unit is used for its thickness. Thus the next thickest steel plate would be ¼ in thick. Table 3.3 lists decimal equivalents for sheet-steel gauges 30 through 3.

Sheets come as large as 6 by 10 ft, with larger sheets usually available on special request. Commonly, you'll be able to choose from 3 by 5 ft or 4 by 8 ft. You most likely will be responsible for purchasing the whole sheet, but many suppliers will be able to cut it down to a more manageable size if you prefer. Check with your supplier about its policies relating to cutting down sheet and plate.

Gauge	Inches	Gauge	Inches	Gauge	Inches
—	—	11	0.1196	21	0.0329
—	—	12	0.1046	22	0.0299
3	0.2391	13	0.0897	23	0.0269
4	0.2242	14	0.0747	24	0.0239
5	0.2092	15	0.0673	25	0.0209
6	0.1943	16	0.0598	26	0.0179
7	0.1793	17	0.0538	27	0.0164
8	0.1644	18	0.0478	28	0.0149
9	0.1495	19	0.0418	29	0.0135
10	0.1345	20	0.0359	30	0.0120

TABLE 3.3 Sheet Metal Gauge Chart

Sheet metal is also available in a number of variations called *diamond plate*, *expanded sheet*, and *perforated sheet* that can be fun to experiment with.

Plate. Plate steel is steel formed into sheets with thicknesses over ¼ in. Just like sheet steel, plate comes in large sizes, and the weight can really add up. As with sheet, most suppliers will be able to cut plate down to size using either a shear or torch. When I order sheet and plate, I frequently have it cut into a manageable size of 4 ft or less on a side. Plate may be available from ¼ in thick up and in sizes 8 ft wide and up to 20 ft long. If you are just looking for a small piece of plate, you can ask the steel supplier if it has any *randoms* or *drops* in a thickness range that you are looking for. The supplier may have smaller sections of plate already available that will work for you.

Figure 3.5 shows a size and weight chart available from my local steel supplier. Such charts are useful when planning projects because you can see what sizes are commonly available and calculate the total weight of any particular material needed.

Decorative and Ornamental Steel. Decorative and ornamental steel consists of pieces that have been formed by casting or forging to create an interesting detail. Readily available are such pieces as handrails, fence and gate parts, finials, balusters, rosettes, base plates, spheres, hemispheres, and decorative sheet metal. Many of these pieces would be very time-consuming to make and feature metalworking techniques not covered in this book. It is fun to browse one of these decorative metal catalogs to look for inspiration or a small piece that will make a larger project simpler to fabricate. When browsing and ordering decorative metalwork, if you plan to weld the parts, you must make sure that they are steel and not iron or some other material. It won't be required that you purchase any decorative metals for this book, but for your next projects, have a look around and see what inspires you. Some steel suppliers stock types of ornamental steel. If you have a relationship with a steel supplier, ask what kinds of decorative pieces the supplier has. Some online options for purchasing or browsing decorative steel are as follows:

- Decorative Iron, www.decorativeiron.com
- Kings Architectural Metals, www.kingmetals.com

If looking for something very specific, you could contact a local blacksmith and see if he or she can forge a unique piece for you. Or look for a local blacksmithing course to make the piece yourself.

Hot-Rolled versus Cold-Rolled

Another option you'll need to consider is whether you want your steel hot- or cold-rolled. When steel is formed, it is pushed through a series of rollers to "extrude" the

H R PLATES

FLOOR PLATES

U M PLATES

STRINGER CHANNELS

BAR CHANNELS

SHIP & CAR MC CHANNELS

I BEAMS

H R SHEETS

GALVANIZED SHEETS

H R SQUARES

H R ROUNDS

H R STRIP

H R FLATS

ANSI PIPE SCHEDULES

SQUARE-RECTANGLE TUBING WEIGHT PER FOOT

Figure 3.5 Steel section chart.

51

hot metal to its desired size. Hot rolling involves rolling the steel to its final dimensions while it is hot enough to form mill scale (a hard, dark-gray or blue film that forms on the surface of the steel). Cold rolling involves bringing the steel to its final dimensions after allowing it to cool to below scaling temperature. The difference is that hot-rolled steel has less precise tolerances for the finished product than cold-rolled steel and is considerably less expensive. As I mentioned before, another disadvantage to hot-rolled steel is the mill scale, which should be removed before welding or finishing. For the projects in this book, you are going to be using hot-rolled steel, which usually you do not need to specify when ordering.

Finding Steel

As you learned earlier in this book, steel has been a commonly used structural material for many years. Currently, there is a good amount of scrap material generated that can be used for your artistic or sculptural expression. Like they always say, "One person's junk is another person's treasure." Chances are that if you own a home, you've got some scrap metal kicking around in your basement or garage that just needs to be put to a good use. Drive around on a trash or recycling day in most parts of the country and you'll surely see a number of steel scrap items out by the curb. Old bikes, a busted garden cart, car parts, or the sides from a washing machine all may be made out of steel and can be welded. With a little creativity and ingenuity, you can find interesting scrap metal right under your nose.

Scrap yards exist all over the country and usually have material set aside that customers can browse without getting in the way of daily operations. This material may be sold by weight or a fixed price and is usually cheaper than new steel. Another good place to browse are scrap dumpsters at construction or industrial sites. Of course, you must ask the property manager or owner if he or she minds you poking around a bit and *never get inside a scrap metal container*.

The drawback to using found material is that you first have to figure out what it really is made of, what it's covered with (found steel is frequently rusty or painted), and its availability (which may fluctuate). Say that you are looking for another one of those particular Huffy bike frames or a specific folding chair frame . . . well, good luck with that!

Determining If Something Is Steel

When you find something that you suspect you can weld, you first must determine if it is in fact steel. Here are some simple tests you can perform that should give you a pretty good idea what something is made out of.

Visual Test. This initial test is the least accurate, but after you spend some time in the shop and around metals, it will prove to be your best friend. Also, if you are ever poking around at a scrap yard or scrap dumpster in search of steel, it is very useful to be able to "read" materials at a glance. With some practice, you'll soon be able to simply look at or pick up most materials and determine the element of which it is composed.

New steel usually has a dark-gray color and satin sheen. The dark-gray color may be interspersed with areas of blue, gold, and black. If the material in question is rusty, it definitely contains some percentage of iron and probably has been outside for a while. Of course, many secondhand materials you'll find out in the world will have been painted. This makes it more difficult to tell what lies beneath. Look for areas of paint that have chipped or corners that been bent on the material. If you see any rust in these areas, the base material probably contains iron.

If you can't tell completely by looking at it, you could try to pick up the material. After schlepping around pieces of steel in the shop for some time, you'll be able to tell right away when something has the density of steel. Aluminum and titanium are both quite a bit lighter than steel and somewhat more rare.

Magnet Test. Most types of steel are magnetic. You can test to see if the material in question is magnetic by placing a magnet of medium strength on the surface. Only a few materials in our world are magnetic enough that you can feel the attraction without precision tools. These ferromagnetic materials are iron, nickel, cobalt, and gadolinium. If the magnet sticks, the base material could have a high percentage of any of these alloys. Since iron is the most common of these elements, chances are it is an iron or steel alloy.

Spark Test. The next test is a little more advanced. You will need to use a bench grinder to cast a shower of sparks from the material in question (Figure 3.6). You will be learning about the bench grinder in Chapter 6. As the grinding wheel contacts the surface, it breaks off small pieces of the base material with great speed. The friction of this action creates heat, which, in turn, causes the small pieces of base metal to become white hot. The color and spark pattern of these small pieces as they burn and fly away from the grinding wheel tell you a lot about the makeup of the parent material. Figure 3.7 shows the pattern of sparks common to some types of steel.

FIGURE 3.6 Spark test.

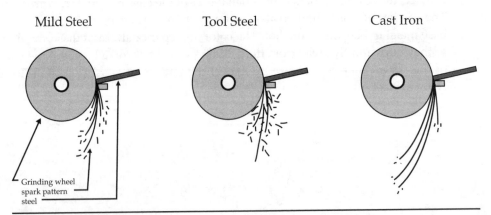

FIGURE 3.7 Spark patterns.

Metalworking Studio

The freedom to create whatever you want whenever you want has its advantages, and setting up your own metal shop can be a rewarding experience. However, to build a functioning metal shop from scratch can cost quite a bit. On top of the thousands of dollars you may spend on tools, you also need to consider electrical work, maintenance, utility costs, and any custom building that needs to be done for safety. As I've mentioned a few times already, I discourage new metalworkers from doing this until they have spent some time creating work in an existing metal shop. Of course, I understand that not everybody has access to a metal shop, so in this chapter I'll review some things to keep in mind when and if you have to set one up. An indoor shop has a clear advantage—all-weather use—but if you're looking to keep things really simple and cheap, a covered outdoor shop is a possibility.

Layout

Safety Concerns

You've already learned many of the safety concerns with metalworking, but how do you apply them to your own metal shop? For starters, a metal shop should not be constructed from flammable materials. If the space uses stick-built construction, care should be taken to "fireproof" the walls and ceilings with fire-resistant boards and panels. Almost never is it acceptable to weld on a wooden floor. Antique wooden floors are even more dangerous if used for industrial purposes at some point—who knows what types of oil and flammable liquids have soaked in. A concrete floor is the only choice for a metalworking studio (besides a dirt floor). When a welding studio is set up properly, a look around the room should reveal nothing that can catch fire with a spark or open flame.

You'll need to check your local building standards to make sure that all electrical work is up to code. Most homes have a 110- to 120-V power supply, but to build a serious metal studio, a 220- to 240-V supply is needed. When dealing with this higher voltage, the stakes are much greater. Always use professionals to deal with wiring, and have all of the work inspected.

There should be plenty of room between tools to allow safe movement and the handling of materials.

Every studio needs some sort of ventilation, even if it is just a few windows or an open garage door. With fans (not blowing toward the weld area, of course), you will be able to ventilate the workspace adequately for most purposes. Better yet, hoods and ventilation systems should be installed, which will help greatly with dust and fumes.

Remember my discussion of gas storage? Gas cylinders always should be secured to a wall, on a trolley, or to the welding machine itself. The best place to store gas cylinders is in a well-ventilated area, typically outside the metal studio but with weather protection. This could mean that you need to build a separate shed for compressed-gas storage. Fuel gases (i.e., acetylene) usually will need to be stored a good distance away from compressed-oxygen tanks as well.

There is a slightly easier way to set up a small home studio—use the great outdoors. If you can construct a secure, *dry*, covered area somewhere outside your home or garage, some of the hazards are reduced. If electrical power is an issue, remember that you can weld, cut, bend, and more with just an oxygen-acetylene (oxy-acetylene) torch. Because the workspace is outside and covered, you can leave the compressed-gas tanks secured to the cart or a wall. This outdoor shop could be on a concrete slab or in the dirt. You will need to consider any other possible flammable items, such as a deck, firewood, or dry grass if welding outside, of course. Also, if you are able to arc weld outside, you must erect welding screens that deflect any breeze away from your welding area. In addition, consider keeping all materials and electrical tools inside a heated or air-conditioned storage area to cut down on the amount of corrosion that can occur.

CAUTION: *Never weld or do hot work directly on concrete. The moisture in the concrete will expand rapidly, causing the concrete to break apart, possibly causing injury.*

Lighting

When you start torch cutting and welding, you'll notice immediately how important lighting is. Anytime you are wearing a shaded filter or welding mask, visibility is reduced. You need to have bright overhead lights directly over your work area, and the addition of a movable work light will help with those hard-to-see areas. If you are welding outside, lighting conditions will vary, but try to take advantage of as much natural light as possible.

Welding Table

A metalworker's welding table can be as simple as a rectangular sheet of steel or as complex as an all-in-one apparatus with built-in clamps and layout guides. The idea behind a welding table is that you can clamp your work to it securely, and because the whole table is clean (unfinished) steel, no matter where you place your negative clamp, your work will be charged. A general rule of thumb for welding tables is that the thicker the steel top, the better the table. A lot of the heat generated by metal–inert gas (MIG) and torch welding will end up being absorbed into the tabletop. This causes the table to warp, and the more it gets heated, the more it will warp. For an inexpensive home shop table, something around $\frac{3}{16}$-in plate will last you quite some time but eventually will show some warpage. A simple heavy-duty welding table is shown in Figure 4.1.

Welding tables can be almost any shape—a circular table for circular projects, a long rectangular table for fences or railings, or a square table for all-around use. Making your own table is a great advanced project that you might want to consider after completing the projects in this book.

Figure 4.1 Example welding table.

Cutting Table

Torch and plasma cutting processes work by heating an area of material and blowing the extra material out of the way with compressed gas. This means that on the backside of your cuts you need to leave room for the material to escape or you'll end up cutting through your tabletop. Cutting tables can simply elevate the work material off the surface of a solid table (but then you have a lot of cleanup to do). Some of them are made of cast iron and have holes for the sparks to escape, and others are made from flat bar welded or positioned together on end to support the material while allowing sparks to escape. Figure 4.2 shows a well-used cutting table.

FIGURE 4.2 Example cutting table.

Cutting/Grinding Area

Angle grinders, chop saws, and bench grinders all create a large amount of dust, sparks, and noise. Many shops will have a separate area for such tools so that the main shop space doesn't get too dirty. A grinding room should have its own worktable where your items can be securely clamped. Having a bench vice in this room comes in very handy.

Steel Storage

Of course, as you start to work on projects, you're going to have a variety of steel lengths, sheet goods, and more odds and ends than you'll know what to do with. A nice metal storage rack will save you a lot of headache in the future. This rack should be secured to the floor or wall of the studio and allow for lengths of your choice to be stored easily. Remember that stock and tube come in lengths over 20 ft. If you don't have space for these, you can set up an area to cut the material down to the correct size when you first receive it.

Horizontal storage racks are great because most of the work you do on lengths of steel is in the horizontal position. Vertical racks take up less floor space but do add the danger of pieces falling a long way and causing injury or damage. The storage rack should be positioned in an area where you can easily transport material to the chop saw or other cutting device. In that way, you'll only have to carry long lengths of material for short distances.

Paint Area

If you're interested in finishing your pieces with a high-quality professional automotive paint job, you'll have to look elsewhere because I'm not going to cover that. There are other books on advanced finishing methods, but for this book, I'm going to keep things pretty simple.

Most kinds of painting require excellent lighting and ventilation and a clean work area. If you want to get the smoothest possible finish, spray painting is your best bet, but you must consider the amount of overspray it produces. Many shops where finishing is a common practice set up a spray booth just for this. For a slightly more handmade finish, you can use latex- or oil-based paints and a brush or roller. For both of these, you need to ventilate your area well to remove any fumes produced. Painting outside is not the best option because debris can get blown onto your new paint job. Direct sun also can cause some strange drying patterns. I'll assume in this book that you have access to an open garage floor or something similar where you can brush or spray paint your projects. Also covered later in this book is wax finishing, which you can do right in your metal shop.

Buying Tools

Many of the tools required for metalwork and the projects in this book are available at just about every hardware store around from the small corner shop to the big-box stores. There are specialty welding supply stores all over this country as well, which you may not be aware of. These stores usually sell welders, hand tools, safety equipment, and the supply gases required for various types of welding. Buying from these stores can save you money because they often will sell consumables in larger quantities than regular hardware stores. I recommend getting consumables such as grinding discs in quantity. In that way, there's always a fresh one around when you need it, and you don't have to make do with a used disk that you really should have thrown away long ago. To find out what welding supply stores there are near you, try a Yellow Pages search for "welding," "steel," "gas," or "hardware." Or search Google for "welding supply" in your area. You also could contact one of the organizations listed in the Resources section at the end of this book to see if they have any tips.

Used tools are fairly common and can be a good investment, but the quality and availability are unpredictable. If you have an existing relationship with someone who is offering a tool and can vouch for its quality, you may be well off. You should be able to see the tool in use before purchasing it. Keep an eye out for any unusual corrosion on the surface and electrical components. There are lots of gems out there, but there are also lots of lemons. Choose wisely!

When buying tools, you need to make sure that you have the power supply to operate them. Many industrial tools require 240 V or even higher, and some use a three-phase power supply.

As far as brands go, there are too many to name, and I can't recommend one over another. I will say that the companies who helped to provide photographs and diagrams in this book are the ones that I've used for years. Miller Welding is the premier name in welding. The company makes almost everything you would need to start welding, and it stands behind its products. Metabo and North Safety also make great products and are always looking to make the best they can. Besides using the products these companies provide, one thing that really stands out is their commitment to the arts. Miller and Metabo understand the connection between industrial arts and industry and have supported the Steel Yard, a 501(3)c nonprofit organization, through donations in the past. A company that shows that kind of support proves to me that it is invested in the future of metalworking.

Cleaning and Maintenance

As with everything, a metalwork shop and the tools within need occasional cleaning and maintenance. When you work in a shared space, a shop supervisor usually handles the maintenance side of things, but cleaning your workspace for

the next person to use is very important. Cleaning up between stages of a project helps you keep track of tools and materials and makes the cleanup and the end of a workday much easier. There are times when I feel "too lazy" to clean up thoroughly, and eventually I end up spending more time looking for the tool I need than actually using it. The area around most of your tools will need more frequent cleaning to get rid of grinding dust, weld spatter, and steel shavings. I generally recommend not putting off cleaning until you *need* to do it; rather, you should make it a part of the process and clean as you go.

If you are responsible for maintaining tools in your own shop, each tool should have a specific set of instruction outlining what maintenance requirements it has. If you can't find this, the information is usually available on the manufacturer's website.

Basic Hand Tools

For the projects in this book, a number of hand tools are needed, some of which are specially designed for metalwork and others of which are more common. To make sure that you have access to all the tools you'll need for the projects in this book, I'm going to review the names and functions of each and provide a few tips.

Clamps

C-clamps, pipe clamps, and bar clamps all have their place in a metal shop. One of the most common clamps you'll encounter is the C-clamp, shown in Figure 5.1. C-clamps come in varying sizes and depths, but two of the biggest advantages of them are the high clamping force and the large throat depth. Their compact size means that it's easy to put one anywhere you need it. For longer clamping, pipe clamps and bar clamps may be preferred.

Vice-Grips

Vice-Grip is a brand name, and there are many other types of grip-style clamps or pliers. The purpose is to hold material securely for grinding, welding, and more. Figure 5.2 shows examples of these types of clamps. If you need to grind pieces of work that are less than 3 in long on a bench grinder, a pair of Vice-Grips to hold your work is a must. Other pairs of Vice-Grips are specially made to hold your weld area together while you create the weld. All in all, this is a very handy tool to have in your shop.

FIGURE 5.1 C-clamps.

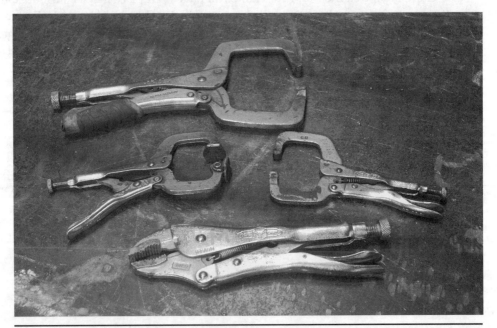

FIGURE 5.2 Example Vice-Grip-style clamps.

Measuring Tape

Well, this one is pretty obvious, but if you're interested in building projects that are at all straight and square, you're going to need a decent tape measure and know how to use it (Figure 5.3). Because I grew up using U.S. standard measurements and most of the steel industry uses them too, make sure that you have a tape measure that uses inches. Some tape measures have a magnetic strip on the end to help hold the tape in place when extended. This isn't necessary but may help.

Wire Cutters

Wire cutters have many uses, but for welding, they come in handy for one thing—cutting the exposed welding wire $\frac{3}{16}$ to $\frac{1}{4}$ in from the tip of the electrode. Having a nice pair of wire cutters that don't bind and cut cleanly every time will save you frustration (Figure 5.4).

Magnetic Angles

Get ready, you're about to have a new best friend. Magnetic angles are made specifically for holding your work together at 90 degrees, 45 degrees, or other angles while you get ready to weld. They come in various sizes and angles and are either electromagnetic or regular, as shown in Figure 5.5. Electromagnetic angles are easier to clean because you can release the metal dust and bits that collect on

FIGURE 5.3 Measuring tape.

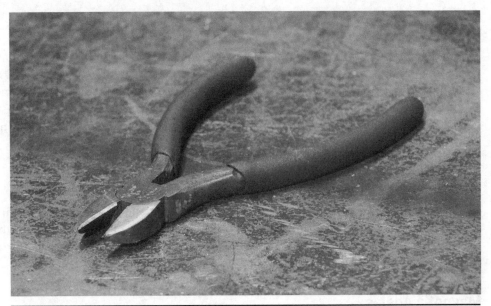

Figure 5.4 Wire cutters.

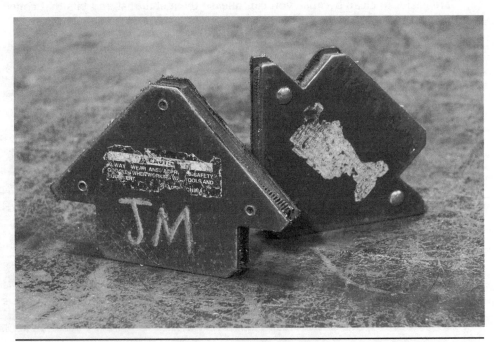

Figure 5.5 Magnetic angles.

them. Keeping these angles clean from debris and weld spatter will help you to make accurate angles for a long time to come. Cleaning these angles with a stiff wire brush will help to remove built-up debris.

Other Layout Tools

Magnetic angles are very handy, but some more traditional layout tools also may be used for increased accuracy. Some of the tools I prefer are a speed square (aluminum or plastic), an adjustable square, a 24-in or larger right angle, and sometimes a level (Figure 5.6).

Slag Hammer

Slag hammers like the ones shown in Figure 5.7, are used to chip off slag that forms over welds or along cuts made with the plasma or oxygen-acetylene torch. A slag hammer has a hardened-steel head that comes to a point on each end that is usually welded to a flexible spring-like handle. On one side, the point is conical, and on the other, the point is a flattened rectangle. Generally, the flat side is used to slide along the surface of the steel, chipping away at the edge, and the conical side can be used to hammer small cut sections out of a recently cut piece of material.

Figure 5.6 Layout tools.

Figure 5.7 Slag hammer.

Files

Metal files are a great quick way to lightly clean off a burr or corner before welding. They aren't very efficient for removing a lot of material (for that I'd recommend using an angle grinder), but they are nice to have around for small jobs. They also leave the finished edge much smoother than a grinding disk, so they can be useful to smooth out corners before finishing. Remember that files cut in only one direction, typically on the push stroke. Different types of files appropriate for metal use are shown in Figure 5.8.

Scribe

A scribe is to metal what a no. 3 lead pencil is to paper—the most accurate and precise way to mark something out. On uncoated steel, the marks can be hard to see sometimes, so a type of stain called *marking blue* can be used, or simply use a Sharpie to make the rough line first and then scribe over that. Scribes are long lasting because the tip is hardened steel. If your scribe ever loses its sharp point, you can grind a new one using the bench grinder. Two handmade scribes are shown in Figure 5.9.

FIGURE 5.8 Files.

FIGURE 5.9 Scribes.

Soapstone

Soapstone is a less precise way of marking steel, but it comes in very handy when welding, torch cutting, and plasma cutting. When you start welding, it will take you some time to get used to the dark environment. By drawing along the intended joint or weld area with soapstone, you can increase contrast of that area from the rest of the material. Soapstone is a naturally occurring type of rock that is resistant to heat, but when heated enough, it will burn away without leaving any impurities in or on the weld. It's also not permanent, so if you make a mark you didn't intend to, just wipe it off. New and used soapstone can be seen in Figure 5.10.

FIGURE 5.10 Soapstone

Grinding and Cutting

Angle Grinder

Grinding is one of the most useful and essential skills for a well-rounded metalworker. With a 4½-in angle grinder, you can clean steel to be welded, chamfer edges, cut through steel sheet and stock, and polish a finished project. And you can do all of this just about anywhere with a standard 120-V outlet. Angle grinders are handheld, so you don't need to schlep your whole project to a special area—you bring the tool to your project. There is still only one tool I have in my garage (a.k.a. "home shop") for metalworking—a grinder. It allows me to cut material down to length with accuracy, prep pieces for welding, and clean up old salvaged steel. All this makes my time in the metal shop even more productive.

The 4½-in angle grinder, shown in Figure 6.1, is named appropriately; it uses a 4½-in disk, available in a variety of compounds, and the 90-degree bend at the head allows you to efficiently apply force against the workpiece. The high-speed grinding or cutting disk (roughly 10,000 rev/min) knocks away little chunks of metal, creating a lot of heat and noise. As these small bits are knocked away, the high heat also causes them to burn, creating sparks. These sparks and small bits of metal are why you always want to keep your skin covered and wear safety glasses and/or a face shield. The loud noise is well above what is comfortable for the human ear, so you need to employ the hearing safety options discussed in Chapter 1. As your high-speed disk is knocking away little bits of steel, the disk itself is being slowly worn down. This creates some fairly nasty dust that accumulates on *everything*, so always wear a dusk mask when using a grinder. Because the discs wear down with use, they are *consumable* items.

Parts

Parts that make up an angle grinder are shown in Figure 6.2. Two parts of the grinder are removable, the handle and the wheel guard. Always use an angle

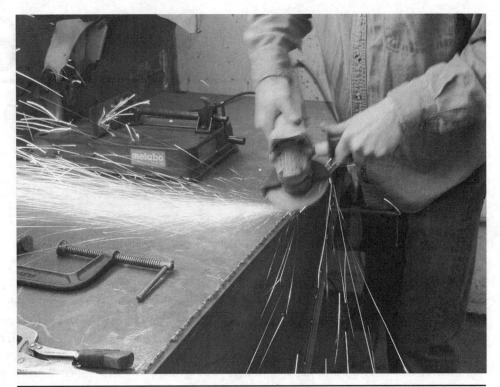

Figure 6.1 Angle grinder with grinding disk in use.

grinder with the handle and guard. The guard will help to direct sparks and debris away from you, making it easier to get in close to the tool and see the work you're doing. The handle gives you a lot more control over the grinder—a very important thing for safe and efficient work. When the grinder is switched on, you'll feel the high torque right away. Especially when using a cutoff disk, this high torque tends to yank the grinder right out of your hands. With the grip provided by the extra handle, you can remain calm and in control. If either of these parts is missing from your grinder, I suggest that you find a replacement part or tool.

The grinding wheel spins in the direction indicated by the arrow on the body of the grinder. This helps you with a few things. It tells you which direction the shower of sparks and metal particles is going to go, tangentially from the edge of the disk, which lets you direct them away from anyone working in your area and away from your clothing. The arrow also indicates which way to tighten or loosen the clamp nut. When you need to remove a grinding wheel, you can turn the clamp nut in the direction of the arrow, and to put a disk back on, you lock the nut in the opposite direction.

Located near the trigger is usually a button of some kind that will lock the grinder in the "on" position. This is useful when grinding away a large surface or

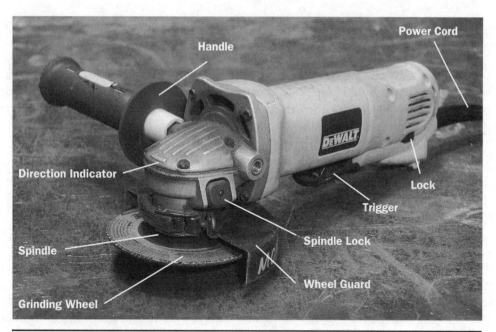

FIGURE 6.2 Angle grinder parts.

a long chamfer. If your grinder ever won't turn off for some mysterious reason, unplug it and make sure that the button didn't get knocked into the locked position by mistake. This kind of thing is uncommon because most buttons are spring-loaded to be off.

Near the spindle is another lock button. This button will lock the spindle in place for easy disk changing. Never use this button to slow down the grinder when powering off because it will wear out the lock quickly. With the lock out of commission, it is quite difficult to change grinding disks.

How to Change a Disk

1. To change a grinding disk, you'll need to have a wrench that matches the clamp nut holding the current disk onto the grinder. This wrench should come with the grinder, but it could be misplaced if you are working in a shared shop. Check with the shop manager to make sure that you have the correct wrench. I prefer to wear gloves during this procedure because I feel more comfortable gripping the narrow wrench and applying force.

2. With the grinder *unplugged* and flipped on its back, use your thumb or index finger to depress the shaft lock button. Ensure that the shaft is locked by trying to turn the disk with your hand or wrench. If the shaft is not locked, gently turn the grinding wheel until the notch in the shaft lines up with the lock button and the button depresses all the way. When locked, the

shaft should only wiggle slightly. Keep the shaft locked during this whole procedure.

3. With the wrench mated to the clamp nut, turn the nut in a counterclockwise direction or as indicated by the arrow on the other side of the grinder. The nut should pop loose fairly easily, but they sometimes get bound up. Double-check the direction you want to turn it if you're having problems, and try again using a little more force.

4. Spin the clamp nut off the rest of the way using your hand. Note that the grinding disk does not have threads but rather rests outside of beveled rings on the flange and the locknut (Figure 6.3). With the clamp nut removed, the disk will come right off. Take care to leave the flange in place on the shaft.

5. Now you can select the disk your work requires and put it on the shaft with the label side facing you.

6. Make sure that the clamp nut is in the proper direction for the type of disk you are using, and turn it finger-tight.

7. Check that the disk is centered on the flange by spinning the shaft. If the disk rotates in an oblong manner, recenter it, and again finger-tighten the clamp nut.

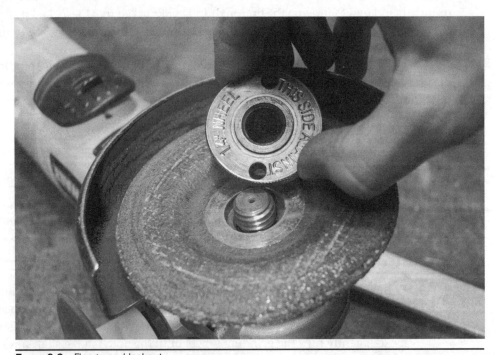

FIGURE 6.3 Flange and locknut.

8. Using the wrench, apply light force to the clamp nut in the direction opposite the arrow. *Note:* Do not overtighten a grinding disk or it will become very difficult to get off.
9. Check to make sure that the clamp nut is oriented the right way by trying to wiggle the disk. If there is any movement (besides from the shaft), make sure that the nut is on properly and that the disk is centered on the shaft.
10. If step 9 checks out, plug in the grinder, and you're ready to go (Figure 6.4)!

Now I'll discuss some types of grinding disks and their intended uses.

Types of Disks

Grinding Disks

Maybe the most common use of an angle grinder is for removing bits of steel by grinding away at the surface. This can be done to expose fresh metal before making a weld, to create a chamfered edge, generally to clean up the steel, or to remove an existing weld or weld spatter. These disks are roughly ¼ in thick and quite strong. They are made up of layers of abrasive material and woven fibers that help to keep the disk together under high revolutions per minute. Grinding disks are made for use on many different materials, so make sure that the ones you are using say that

FIGURE 6.4 A 4½-in grinding disk installed.

they are for use on steel. They also come with a depressed center (type 27) or flat (type 1). Make sure that you buy the ones that work with your grinder.

When selecting a grinding disc for steel, there are some options to consider. These specifics are typically printed on the label side of the disk. They will tell you the size, maximum revolutions per minute, intended material use, and the manufacturer's part number. Every disk should contain a short code that can help you to identify other specifics.

With the disk shown in Figure 6.5, manufactured by Bullard with an A24R code, and using Table 6.1, you can determine that the disk contains aluminum oxide abrasives (first A), is intended for a course to medium grind (24), is in the middle range in terms of grinding disk hardness (R), and is reinforced by one layer of resin-bound fiberglass.

When grinding, make sure to hold the grinder close to your body and to use medium to light force against your work material. The grinder should be held at around a 15- to 30-degree angle with the front edge of the grinding disk making contact with the work surface. Gently, but with even pressure, move the grinder back and forth over the area to be ground. If you notice that the grinder wants to skip around on the surface of the work, increase your pressure. If the motor sounds

Figure 6.5 Bullard grinding disk A24R-BF.

Primary Grain	Grain Size	Bond Hardness	Bond Type	Reinforcement
A = aluminum oxide C = silicon carbide AC = aluminum oxide–silicon carbide combination Z = zirconia–aluminum oxide ZA = zirconia–aluminum oxide–aluminum oxide combination	16 = coarse 24 = medium 30 = fine 36 = very fine <600 = extrafine	M = softest N O P Q R S T = hardest	B = resinoid	The number of fiberglass nets

TABLE 6.1 Abrasive Disk Content Code

like it is bogging down, decrease your pressure. Too much pressure will bog down the electric motor and wear the grinder out prematurely. When the grinding disk is down to about a third of its original diameter, it is time to pop a new one on.

Cutoff Disks

Cutoff discs are abrasive disks that are meant to slice through steel rather than grind away at the surface. When comparing a cutoff disc with a grinding disk, it is easy to see the difference (Figure 6.6)—cutting disks are much thinner. For this reason, they are not intended for perpendicular pressure against the wheel, and using such pressure will cause them to break apart very quickly. These disks cut through steel along a line parallel to the disk. Once a notch is formed by the front of the cutoff disk, the trajectory must be followed to avoid binding between the disk and the material around it. However, this doesn't mean that you can't make angled cuts. As long as you guide the disk through the material in a straight line parallel to the disk, you can make mitered cuts with ease.

The narrow section of a cutoff disk is designed to cut efficiently and quickly. As the edge of the disk cuts through the steel, it only has to remove roughly an $\frac{1}{8}$ in of material from its path (called the *kerf*). It would take a lot longer to cut through material using anything thicker. The small kerf also helps to preserve steel by removing as little as possible. When mounting a cutoff disk, take care to orient the clamp nut the right way (usually the opposite of orientation for a grinding disk; see Figure 6.5).

Cutoff disks are made much like their beefier cousin, the grinding disk. They come with a depressed center (type 27) or flat (type 1) and are made of an abrasive compound bonded to a woven mesh. Use Table 6.1 to figure out the specifics of your cutoff disk. Note that cutoff disks usually are bonded with a harder compound so that they can maintain their strength.

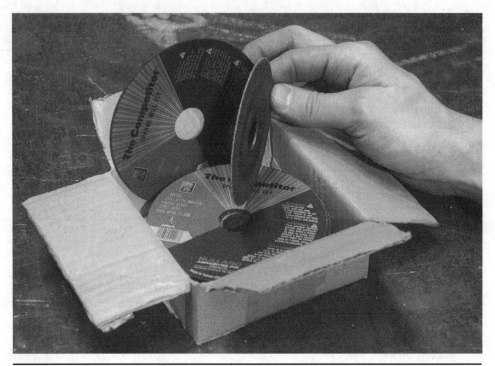

Figure 6.6 Cutoff disk.

When using a cutoff disk, especially when starting out, it is critical that you find a comfortable position before beginning your cut. You should be comfortably standing and stable with the work directly in front of you around stomach height. As the disk works its way through the cut, it will continue to be important that you do not twist or jerk the grinder. Any movement that puts pressure on the top or bottom of the disk will cause it to seize and possibly shatter. This will take some getting used to, but by assuming a solid stance and holding onto the grinder securely, you'll be slicing steel in no time.

The deepest possible cut you'll be able to make in one direction is the distance from the body of the grinder to the end of the cutting disk. This distance also gets smaller the more you use the consumable disk. To increase the effective cutting diameter of a cutoff disk, you can go at the work from both sides, essentially doubling it. When your disk is about two-thirds consumed, it's probably time to put a new one on.

Just as with a grinding disk, medium to light force is all that is required for a good cut. Remember to push the grinder through in a steady straight line to avoid binding. If the grinder motor sounds bogged down, ease back on the pressure. If the disk is just skimming the surface, increase your pressure slightly.

Flap Disks

Flap disks are closely related to grinding disks but with a very different construction (Figure 6.7). In essence, a flap disk is constructed of small flaps of sandpaper bonded together one after the other. As the sandpaper wears down, more fresh paper is exposed below it and will continue to do so until the flap disk is consumed. Flap disks are wonderful for gently removing or smoothing out steel. They also make quick work of any surface coating such as mill scale or paint because they don't dig into the steel like a grinding disk. With some patience, you can bring mild steel to a nearly chrome-like polish using a flap disk.

When choosing flap disks, you'll notice that they have a slightly different rating system than grinding or cutoff disks. They generally tell you what the abrasive type is and the grit of the sandpaper. Most of the time, for steel you'll find zirconia abrasive (labeled with a Z) and a grit of 20 to 120. The higher the grit number, the finer the finish. For other specific flap disks, visit the manufacturer's website to find out intended use.

When using a flap disk, you should hold the grinder much like you would a grinding disk. Using a 10- to 20-degree angle from the work surface and medium to light pressure should yield the best results.

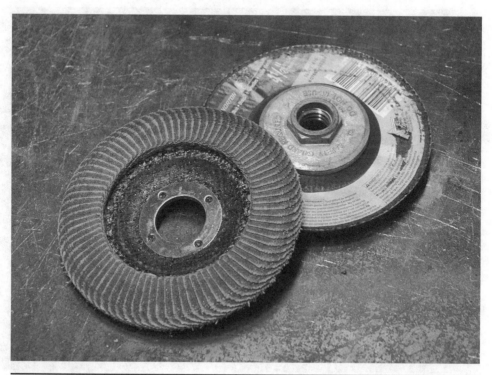

FIGURE 6.7 Flap disk.

Wire Cup and Wheel Brushes

Grinder cup and wheel brushes come in various configurations of steel wire attached to a steel or aluminum hub. They are used primarily for surface cleaning and are great for removing surface rust or paint. The wire cup, shown in Figure 6.8, covers a lot of surface area quickly, and the wire wheel is useful for getting into smaller nooks and crannies.

It should be noted that any loose clothing or jewelry poses an extra risk around wire brushes because they can grab and lock onto loose items with ease. Also, when using a wire cup or wheel, a full-face shield is a must, along with a leather jacket and gloves. Unlike a grinding disk, when pieces of consumed wire fly off a wire brush, they stick like needles.

Using a wire cup is a lot like using a grinding or flap disk. Raise the end of the grinder slightly to give roughly a 10- to 30-degree angle from your work. Work the grinder back and forth over the surface of the work to remove the desired material. A wire wheel is used more like a cutoff disk, where the force should be applied parallel to the wheel.

Most wire cups and wheels do not require a flange or clamp nut on the grinder. They are made with threads that match that of the grinder's spindle. To remove a

FIGURE 6.8 Wire cup.

flange, simply pull it off the spindle. Some grinders have a rubber washer that keeps the cup or wheel in place, so it may take some elbow grease to remove.

Safety for Grinding Consumables
- Visually inspect all disks before use, and throw away cracked or damaged disks.
- Make sure that your grinder speed is below the maximum revolutions per minute printed on the selected disk.
- Always use the correct clamp nuts and mounting flange for the type of disk.
- Listen to the pitch of the grinder's motor. If it starts to sound bogged down, lighten your pressure.
- Use the right disk for the job.

A Place to Grind

Between the metal dust and spent consumables and the shower of sparks, grinding creates quite a mess. Many shops will have a separate area for grinding that has sturdy tables and an air exchange system of some kind. If you're at a shop that doesn't have these, you may want to put down a tarp and grind outside to minimize cleanup. At the end of the day, just roll your tarp up and dump the metal dust in a trashcan.

When setting up to grind, you can clamp your work directly to any sturdy steel table or, ideally, clamp it in a bench vise. The bench vise will allow you to secure your work almost any way you could ever need it and is quick to tighten or loosen.

Angle Grinder Safety

- Grinding makes a mess, so try to do it somewhere where you can clean frequently.
- Make sure that the disk is attached tightly and properly to the grinder before use.
- All guards and handles should be in place.
- All material to be ground should be securely clamped to a solid surface or in a vice.
- Do not start the grinder with the wheel in contact with the material.
- Do not use too much pressure with the grinder. Let the hum of the motor tell you when too much pressure is being applied.
- Mind your spark spray from the wheel of the grinder. If other people are present, erect a screen or control your sparks to go in another direction.
- Do not bring the grinder to a stop by grinding it against the table or your work. Let it slow down on its own.
- Freshly ground work will be hot! Let the work rest for a time before touching it with your bare hands.

Personal Protective Equipment

- Wear safety glasses and/or a full-face shield anytime you're using the grinder.
- Do not wear gloves unless you are using a wire cup or brush with the grinder.
- Always wear long sleeves, but make sure that all clothing, jewelry, and long hair are neatly tucked in.
- Wear hearing projection at all times while grinding.
- Wear a dust mask at all times while grinding.

Practice

Here are some techniques you can practice to apply what you've learned so far in this chapter. Save your pieces once you've completed them because they will come in handy for weld practice later in this book.

Surface Grind

Grinding away at the surface of steel is something you'll be spending a lot of time doing from here on out. The idea is to remove any imperfections or coatings before you get ready to weld. For your practice grind, you're going to clean the four sides of a piece of square tube, remove some undesirable stuff from a piece of sheet metal, and grind out one of your earlier welds.

Practice 1: Surface Preparation, Part 1

1. Find a 12-in length of square tube or solid stock.
2. Clamp it in your bench vise or to a tabletop with a long edge facing up, as shown in Figure 6.9.
3. Plug in your grinder, leaving plenty of spare electrical cord free.
4. Stand with your feet about shoulder width apart a foot or so from your work. As I mentioned earlier, the work should be clamped somewhere around the height of your stomach. Put your dominant hand on the body of the grinder, and grip the handle with your other hand.
5. Practice the motion you'll be making along the surface of the material before switching the grinder on. If you feel comfortable and have full range of motion, go to the next step. If not, adjust your position as required.
6. Switch your grinder on (most grinders have a safety mechanism of some kind), and wait about a second for the motor to reach full speed (you'll know when the pitch of the motor levels out).
7. Once the grinder is at full speed, start to brush the surface of the square stock with the grinding wheel as in Figure 6.10. As soon as contact is made, you'll notice that the grinder tends to pull away from the work, but stay in control of the grinder and you'll have no problem.

FIGURE 6.9 Properly clamped material.

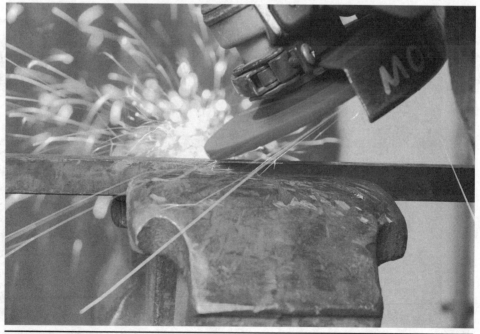

FIGURE 6.10 Making contact with the material.

8. Listen to the sound of the grinder. The motor should be at a steady pitch when you're grinding (the motor will speed up slightly when not in contact with the material). If there is any skipping or clattering across the surface of the work, you may need to increase pressure on the grinding wheel slightly or increase your angle above the work.

9. At this point you should have clean, shiny steel exposed along where you've been grinding. Depending on the surface quality of the steel you started with, it may take longer to get down to this. Keep the grinder moving back and forth slowly along the surface until the whole side is nice and clean like the steel on the left in Figure 6.11.

10. Take note of any spots where the grinder dug into the surface of the steel. As you develop your skills with the angle grinder, you'll be able to keep that from occurring. On the other hand, maybe you want to experiment with the textures you can form on the surface, and with repetition, that small "mistake" could end up looking like fish scales.

11. Repeat this process on at least the other side of the material, and save it for later.

12. When you're finished with the grind, release the trigger and keep hold of the grinder until it comes to a complete stop.

CAUTION: *Never use the shaft lock, your hand, or another object to bring the grinder to a stop. This will decrease the life of the grinder and grinding disk.*

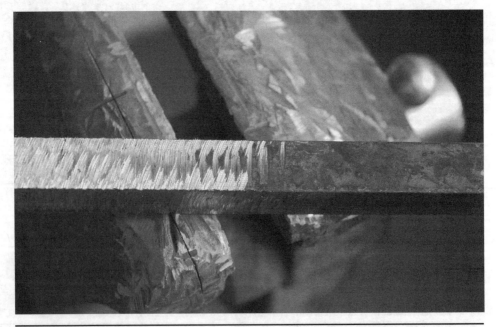

FIGURE 6.11 Cleaned surface.

13. The workpiece is now quite hot, so to remove it from the vice, loosen the clamp and, using a gloved hand or pliers, take the piece and put it somewhere out of the way to cool off.

Practice 2: Surface Preparation, Part 2

1. Locate a small piece of sheet metal, hopefully about 1 ft square, around $\frac{1}{8}$ in thick, and with some dirty stuff on the surface.
2. For sheet metal, you should clamp it directly to the worktable rather than using the vise.
3. Use two clamps to make sure that it doesn't spin when you're grinding, as shown in Figure 6.12.
4. When you find a comfortable position, as in Example 1, fire up the grinder, and let it reach full speed before grinding.
5. When the grinder contacts the surface, you'll feel that the torque tends to yank the grinder around again, but overcome this by pushing back slightly, and you'll be in good shape.
6. Grind away a few square inches of surface junk, or if the steel is fairly clean, just practice grinding away the mill scale. This fresh patch of steel will be perfect for an upcoming weld.
7. Grind away one other spot on the sheet metal where we can attach the welder's negative clamp.
8. When finished, remember to turn the grinder off properly by letting it wind down on its own.
9. Unclamp the sheet metal, and let it cool with the other work.

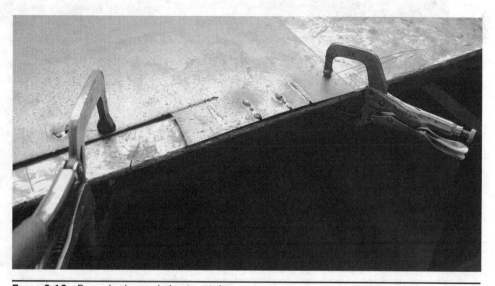

FIGURE 6.12 Properly clamped sheet metal.

Practice 3: Removing a "Blemish" Weld

1. Locate a weld that you or someone else has made on a piece of steel.
2. If the weld is on sheet metal or thin flat stock, clamp it securely to the tabletop. If it's on square or round tube, clamp it in the vice. Make sure that the weld you are going to grind is not obstructed by the clamp or part of the vice.
3. Just as before, find a comfortable position, turn on the grinder, and wait for it to reach full speed.
4. To grind a weld back to flush with the parent material surface, you're going to move along the length of the weld with the front of the grinder wheel contacting the top of the weld bead. Make sure to keep a consistent angle from your work, as shown in Figure 6.13.
5. Move back and forth along the weld from end to end, occasionally taking the grinder away from the work to check your progress. The amount of time required to grind out a weld will depend on the height and width of the weld.
6. Once you get near the bottom of the weld, you can lower the angle of the grinder slightly to help keep the wheel from digging into the parent material.

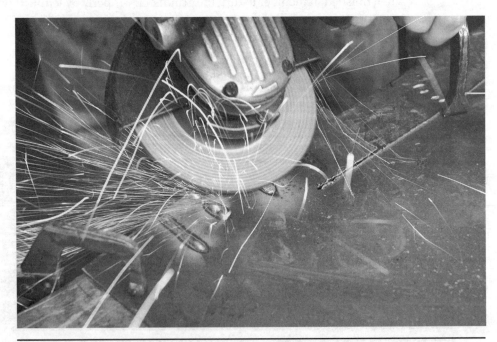

Figure 6.13 Grinding angle.

7. When the weld is almost gone, you'll want to run the grinder perpendicular to the direction you were going a few times to make sure that nothing remains.

8. Be careful not to grind too much material away, but know that if you do, you could always add some more weld to fill it in. Figure 6.14 shows a ground weld.

9. When finished, let the grinder come to a stop, and rest it on the table.

CAUTION: This practice lesson probably will result in the most heat transfer to the work, so be extra careful when moving the piece. Remember to pick it up only using a gloved hand or pliers.

Chamfer

"Knocking off" the corner of a piece of steel is called *chamfering*. A chamfer allows heat from the arc to penetrate more evenly and leaves a place for the extra filler wire to go. It also can be used to clean up a rough edge on a finished project. A chamfer doesn't need to be big, but when chamfering for the highest weld quality, I recommend chamfering at least one-third of the material thickness.

To practice chamfering, you're going to clamp some square stock into the bench vise and chamfer each short edge.

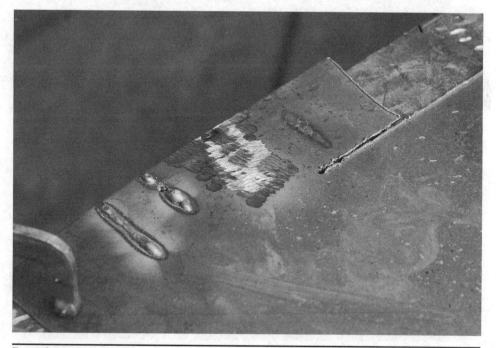

FIGURE 6.14 A weld removed.

Practice 4: Chamfering

1. Find a piece of 12-in-long square stock, and clamp it in your vice vertically.
2. Assume the same position as you did when surface grinding, but roll the grinder 45 degrees to the left or right along the axis of the motor (Figure 6.15). This will give you a 45-degree chamfer along that edge.
3. When you're ready, turn the grinder on, and move it along the side until a uniform chamfer is formed. (Remember the one-third chamfer rule from earlier.)
4. Now you can loosen the base of the bench vise and rotate the piece 90 degrees to have access to the other side. You also could unclamp the work and turn it, taking care not to touch it with your bare skin.
5. Repeat until you have chamfered all four short sides.
6. When finished, shut the grinder off, but leave the square stock in the vice for the next session.

Cutoff

It's time to swap the grinding wheel out for a cutoff disk. (If you've already forgotten how, check back at the beginning of this chapter.) Here we are going to cut some lengths of square stock, sheet, and a section of large tube.

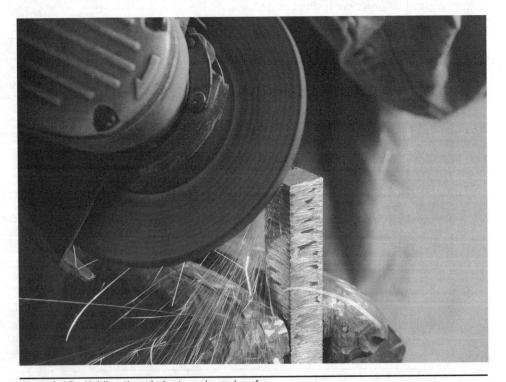

FIGURE 6.15 Holding the grinder to make a chamfer.

Practice 5: Cutting Stock

1. With the square stock clamped in the vice vertically, get in position to cut off the top.
2. Holding the grinder close to your body with your arms kept in close to your side, stand about a foot from the work with the grinder in front of you. In this position, the cutoff disk should be level and almost touching the work you are to cut.
3. If you are comfortable in this position, turn the grinder on and let it get up to speed.
4. Ease the cut disk toward your cut line on the material while keeping the cut disk level.
5. At first contact, keep the grinder steady so that it doesn't jerk away from the material.
6. As the edge of the cut disk works its way through the material, listen to the sound of the motor, and control the speed so as not to bog down the motor.
7. Keep light to medium pressure on the grinder as it continues through, taking extra care not to twist or move the grinder out of the path of the cut. Figure 6.16 shows the cut progress.

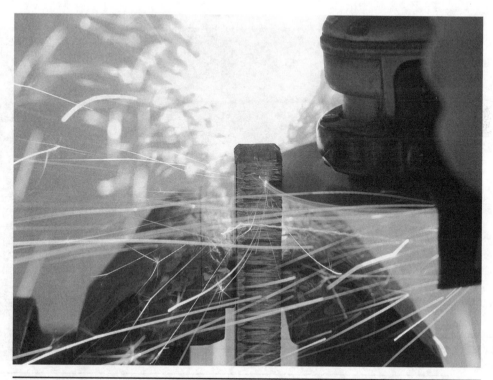

Figure 6.16 Cutting through the material.

8. When the cut is complete, make sure that the hot cutoff length doesn't contact the electrical cord when it falls to the floor.

9. Let the grinder wind down to a stop, and place it on the table.

10. Note that the cut edge has a sharp burr along the back. You'll clean this up with the flap disk in the next section.

CAUTION: Do not use the cut disk as a grinding disk to chamfer the edge because it could break the disk.

Your first cut! For me, cutting with an angle grinder was one of the more intimidating parts of metalwork in the beginning. If you felt at all uneasy during this exercise, try it one or two more times until you feel more confident.

Practice 6: Cutting Sheet

1. Grab a piece of sheet metal, and clamp it to the tabletop with one corner hanging over the edge. Draw a cut line on that corner like that shown in Figure 6.17.

2. Find a position that will let you run the edge of the cutoff grinder along one of the lines to be cut. The grinder disk should be held perpendicular to the

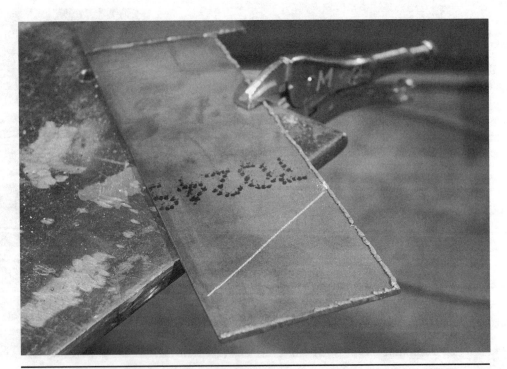

FIGURE 6.17 Clamped sheet with corner marked.

surface of the material, but the grinder can be roughly a 45-degree angle along the cut line.

3. Turn the grinder on, and "trace" along the cut line, making slow, steady passes. With each pass, the trough you are cutting will get deeper and easier to follow. Take care not to go too far over the edge of the other cut line. Progress along your cut line as shown in Figure 6.18.

4. After four or five passes (on ⅛-in sheet, more as it gets thicker), the cut wheel may start to come through the backside of the material. Ease it along the cut line until the first cut is complete.

5. If you need to rotate the work or simply reposition your body to access the next cut line, do it now. If you have to take a hand off the grinder, turn it all the way off first.

6. Follow steps 2 through 4 until the cut corner separates from the sheet metal. Make sure that it doesn't come in contact with the electrical cord from your grinder.

7. Watch out for the sharp edge. To clean it up, chamfer lightly using the grinding disk.

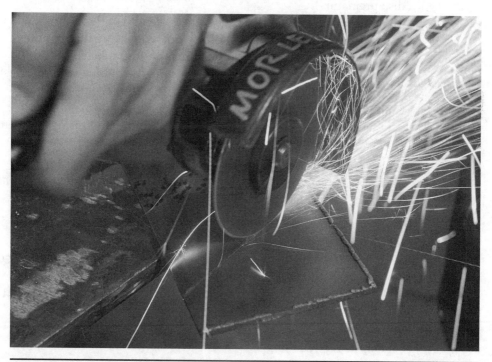

Figure 6.18 Sheet metal cutting.

Practice 7: Multiple Cuts

1. Find a piece of round or square tube whose diameter or width is greater than the depth of the cut disk. Clamp it securely in the bench vise in the vertical orientation.

CAUTION: *If not clamped tightly, round stock or tube has a tendency to spin in the clamp. This can break the cut disk. Take extra care when clamping round material.*

2. Put a mark all the way around the tube using soapstone at a height where you can comfortably make the cut.
3. Start on the side facing you by getting braced and starting the first section of cut.
4. For this, I recommend pushing the grinder straight into the material like you did in your first practice session rather than trying to trace or follow the line in multiple passes. Stop cutting in this direction just before the body of the grinder or the flange makes contact with the material.
5. When the grinding wheel has made it through the tube wall, you'll start to see sparks appear on the inside. Let the grinder go a little deeper to widen the cut, but if you are using a depressed-center disk, do not let the depressed center of the disk make contact with the material. This will wear out the disk prematurely.
6. Move slowly along the line, increasing the length of the cut until you need to reposition either your body or the work. For square tube, you may need to rotate it 90 degrees and slightly more for round tube.
7. When ready, begin another cut along this line, beginning where the last cut left off.
8. Continue this until you've cut all the way through the material.
9. Set the grinder down when it has come to a stop, and make sure that the cutoff work is not making contact with the electrical cord.

NOTE: *Your first cut may not be perfectly flat, but with some more practice, it will get easier. To clean up the edge, you can use the grinding disk to smooth it out.*

Flap-Disk Polishing

Choose your favorite of the pieces you've just cut, and polish the whole thing until it has nearly a chrome finish. Take time to polish the cut edges and corners as well. Note that the flap disk is more forgiving and softer than the grinding disk. At this time, switch out the cutoff disk for a flap disk.

Practice 8: Flap-Disk Polishing

1. Clamp your work securely in the bench vise or to the tabletop.

2. Work the flap disk over the surface, maintaining a roughly 10- to 20-degree angle to the surface of the material until any coating is removed.

3. As rust and mill scale are ground off, the shiny bare steel will show through as in Figure 6.19.

4. Practice rotating the grinder around the work to polish surfaces, edges, and corners while you move your body with it. Take care to control the shower of sparks so that you don't inadvertently shower your clothing or a neighbor.

5. When you need to reposition the work to polish another side, do so.

6. Repeat this until every accessible surface is polished and free of burrs.

Wire-Cup Cleaning

If you have a piece of scrap metal with a surface coating such as paint or rust, try cleaning it with a wire cup. When using a wire cup, you'll want to wear a full-face shield, gloves, and a leather or thick jacket. Remember that most wire cups do not use the flange or clamp nut from your grinder. To put a wire wheel on and take one off, wear a thick leather glove, and spin the cup with the shaft lock depressed, as shown in Figure 6.20. Do not overtighten!

FIGURE **6.19** Clean steel.

Figure 6.20 To tighten or loosen a wire cup or wheel, use this method.

Practice 9: Wire-Cup Cleaning

1. Clamp your work into the bench vise or onto the tabletop. I'm going to clean the surface of some sheet metal, so I'll clamp to the tabletop.
2. With the grinder on and at full speed, work the brush at a 10- to 30-degree angle over the surface of the steel.
3. You may notice that it cleans rust and grime away very quickly but leaves any steel such as weld beads and mill scale intact. (With enough time and pressure, it will start to grind away mill scale.)
4. When finished, take extra care not to let the wire cup snag on anything while the grinder comes to a stop.
5. Now you've got some material ready for welding!

Bench Grinder

A bench grinder is like a bigger, burlier older brother of the angle grinder (Figure 6.21). Rather than use a 4½-in grinding wheel, bench grinders use between 6- and 12-in abrasive wheels. Tools with larger wheels operate at a slower rotational speed than their smaller cousins but usually have a similar rate of speed at the wheel's surface. Bench grinders are meant to be mounted permanently on a wooden or

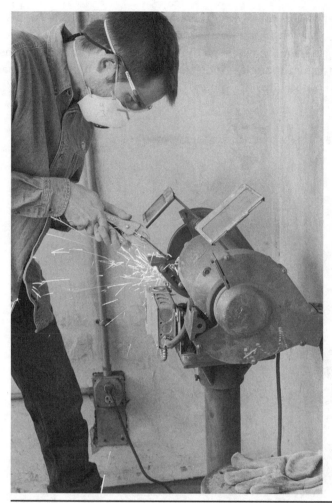

Figure 6.21 Bench grinder in use.

steel workbench or pedestal near stomach height. They should have ample room around them so that longer lengths of steel can be maneuvered with ease. They usually have two sides, one on either side of a big electric motor. The advantage of having two sides is that one can be for rough work and the other for polishing, with no wheel changing necessary. These grinding disks are also consumable, but they last much longer than the smaller angle grinder disks.

Just like the angle grinder, bench grinders also accept other styles of wheels. Wire wheels, cloth wheels for polishing, and other types of grinding wheels all can be interchanged with a bench grinder. This lets the bench grinder perform a wide range of tasks on different types of materials. However, in this book, I'm going to focus on using the bench grinder to grind steel.

Just like its smaller cousin, the bench grinder produces a lot of heat, sparks, and noise. This kind of tool is best located in a separate room. I am not going to cover changing or replacing a grinding wheel on the bench grinder. The instructions are more or less the same as for the angle grinder, and you should check the manual for your specific machine for any tips or pointers.

Parts

Figure 6.22 shows the parts of a bench grinder.

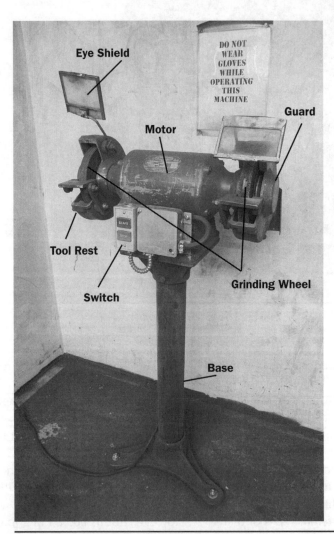

FIGURE 6.22 Parts of a bench grinder.

Safety

- Before using a bench grinder, make sure that the tool rest is positioned $\frac{1}{8}$ in away from the grinding wheel and slightly below the center of the wheel. Make sure that the spark and shatter guards are secure and not in contact with the grinding wheel. Make these adjustments with the machine off and unplugged.
- Do not stand directly in front of the grinding wheel when turning the machine on. Let it come to full speed and run for a minute before using.
- Do not start the grinder with the wheel in contact with the material.
- Do not jam your work into the grinding wheel; rather, let your work contact the wheel slowly and smoothly.
- Always rest your work on the edge of the tool rest nearest the grinding wheel. Failure to do so may cause your workpiece to get jerked out of your hands.
- Gently move your work across the face of the wheel from side to side to prevent ruts from forming in the surface of the grinding wheel.
- As I mentioned earlier, use clamps or Vice-Grips to hold small workpieces. Do not grind anything that can fit between the tool rest and the grinding wheel.
- Freshly ground work will be hot! Let the work rest for a time before touching it with your bare hands.
- When finished, wait by the grinder until it comes to a complete stop. Never use anything to slow the grinder down.

Personal Protective Equipment
- Hearing protection
- Safety glasses and/or face shield
- Long sleeves (not dangling)

CAUTION: *Never wear gloves!*

Practice

Chamfer
The chamfer grind is one of the best uses of a bench grinder. When making multiple short grinds, the bench grinder does not require any reclamping, unlike with an angle grinder. Thus, to chamfer all four sides on the end of a length of square stock, you can complete it in one work cycle. For this same reason, bench grinders are great for chamfering round stock and tubing; just rest the bottom corner of your workpiece on the tool rest, and gently turn your work with the upper corner making contact with the grinding wheel until an even chamfer is formed.

Practice 1: Chamfer

1. Find a short length of flat stock, square tube, or solid stock for this exercise.
2. Double-check the personal and tool-related safety points listed earlier.
3. Turn on the grinder, and let it come up to full speed.
4. Resting your work on the tool rest at a 45-degree angle, gently bring it into contact with the grinding wheel, as shown in Figure 6.23.
5. Move the work back and forth across the grinding wheel gently, maintaining the 45-degree angle.
6. When an even chamfer is achieved on one side, rotate the work 90 degrees to start on the next side.
7. Repeat until all sides are chamfered evenly.
8. When you are happy with the chamfer, set the material down, and turn off the grinder.
9. Remember to wait with the bench grinder until it comes to a complete stop.

NOTE: To chamfer round stock, you can slowly rotate the work while maintaining contact with the grinding wheel to form an even chamfer.

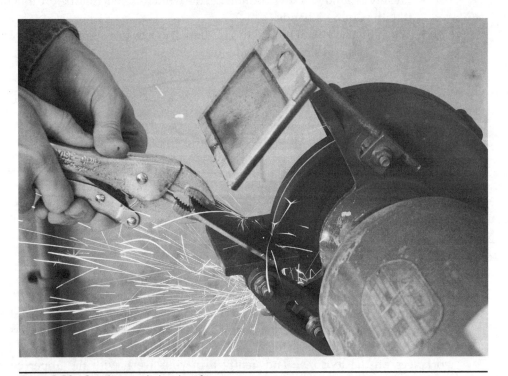

FIGURE 6.23 Starting to grind a chamfer.

Chop Saw

The chop saw is a great tool for making quick, clean, and accurate cuts through many sizes of steel (Figure 6.24). Much like the angle grinder, it uses a consumable cut disk made of an abrasive material and woven layers for strength. You'll learn how to use a chop saw and some of its advantages and drawbacks in this section.

The chop saw is used only for one thing—cutting. Sometimes chop saws are called *miter saws*, but that term usually refers to the woodworking version of a chop saw. Unlike the angle grinder, when making a cut with a chop saw, no guesswork is required to make a straight or mitered cut. Your work is securely clamped to the tool bed, and the cutoff disk moves only along one axis. The chop saw doesn't allow for different types of wheels to be attached to it. It should be used only with a cutoff disk that is rated properly both for speed and the material in use. Chop saws typically come with 6- to 14-in blades, and the larger the blade size, the greater the material capacity.

With the material clamped to the tool, one clear advantage over the angle grinder is the ability to make accurate cuts easily. Another advantage is that

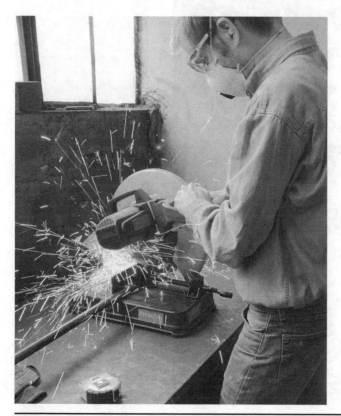

FIGURE 6.24 Chop saw in use.

depending on the wheel size and clamp depth of your chop saw, you will be able to put multiple items in the saw at one time. This comes in extremely handy when your work starts to increase in scale and you have many individual pieces that go into a project. Most chop saws also have adjustable clamps so that you can make mitered cuts quickly and easily. The larger wheel means that you have a much greater possible depth of cut; a 14-in shop saw will have nearly a 6-in cut depth compared with the 1½-in depth on an angle grinder.

Just like angle grinders and bench grinders, chop saws create a lot of noise, debris, and sparks, so they usually will be located in a separate room from the welders and cold-working tools.

Chop saws are usually set up on a metal tabletop where both ends of the work can be supported. The distance to the right and left of the chop saw will dictate how long you can cut material. Be sure to support long lengths of steel using an adjustable work rest such as that shown in Figure 6.25.

FIGURE 6.25 Supporting long work.

Chop saws have adjustable fence positions so that the cutting disk can be used efficiently on many materials. The cutting disk should make contact with the material at roughly the middle of the disk for the best cut possible. If needed, adjust the fence position for the material you plan to cut using the included wrench or an adjustable wrench.

Short material may not be able to be cut using a chop saw. If the end of your material does not go past the middle of the clamp head, it will not be clamped properly. For short material, you will need to use a cutoff disk on an angle grinder.

Note the direction of clamping force on a chop saw. It can only be applied from the clamp head through the material against the fence. The chop saw will allow you to clamp multiple items, but they always must be clamped with this force in mind. In Practice 4 later you'll see the correct way to clamp multiple pieces.

Parts

Figure 6.26 shows the parts of a chop saw.

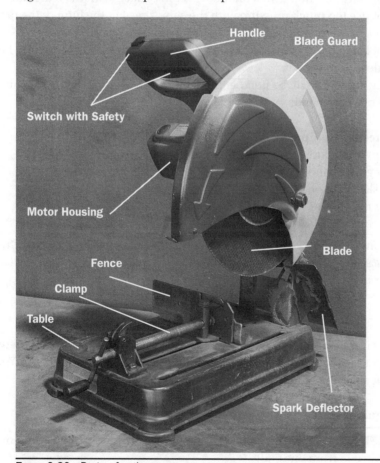

Figure 6.26 Parts of a chop saw.

Types of Disks

As I mentioned earlier, chop saws should be used only with the approved sized cutoff disks. These disks come in various compounds for use with different materials. Just as with angle grinder wheels, you can learn what each disk is for by reading its code. Refer to Table 6.1 to find out what material the disk is for and what type of abrasive compound it uses. To change a disk, make sure that the tool is unplugged, and refer to the manual that came with the tool.

Safety

- Keep both hands on top of the handle of the chop saw.
- Make sure that the clamp is fastened securely and at the proper angle.
- Make sure that the disk is tightly and properly attached to the chop saw before use and free of damage.
- The material to be cut should be clamped securely to the chop saw.
- Do not start the chop saw with the wheel in contact with the material.
- Do not use too much pressure with the chop saw. Let the hum of the motor tell you when too much pressure is being applied.
- Do not bring the chop saw to a stop by grinding it against your work. Let it slow down on its own.
- Freshly cut work will be hot! Let the work rest for a time before touching it with your bare hands.

Personal Protective Equipment
- Hearing protection
- Safety glasses and/or face shield
- Long sleeves (not dangling)
- *Do not wear gloves.*

CAUTION: *If the workpiece becomes loose during a cut, the saw may throw the material, and this most likely will cause the disk to shatter, potentially causing injury. Always clamp your work properly!*

Practice

The chop saw is an easy tool to master, once you know how to clamp a variety of materials into the tool and get the feel for how much pressure is needed. You'll clamp and cut a variety of materials here to gain experience.

Practice 1: Square Stock at 90 Degrees

1. Locate a length of ½- to 1-in square stock, and with soapstone, put a mark roughly 6 in from one end.

2. Lay the material across the table of the chop saw with the mark roughly aligned below the cut disk, as shown in Figure 6.27.

3. If your chop saw is equipped with a quick release on the clamp, undo it now, and slide the clamp close to the material. If your saw doesn't have a quick-release clamp, begin turning the clamp so that it almost holds the material against the fence.

4. At this point your material should be free to slide back and forth, but with some friction between the fence and the clamp. Bring the cut wheel down (with power off), and slide the workpiece so that your cut mark is directly below the disk. For more precise cuts, you need to consider which side of the cut mark to aim for to accommodate the blade kerf, which can be $\frac{1}{8}$ to $\frac{3}{16}$ in wide (see Figure 6.28).

5. While gently holding the cut disk again the mark, tighten the clamp all the way, and then give it one more extrasnug twist. Now when you move the cut disk up and back down to the mark, it should still be right where you want it. If it is not exactly in the right spot, loosen the clamp slightly and adjust.

6. With one hand, grab the end of the material to the left of the saw and wiggle it up and down. If your work is clamped properly, the whole saw should

Figure 6.27 Lining up the cut mark.

FIGURE 6.28 Chop-saw kerf.

 move with your workpiece, and the workpiece should not come out of the clamp. If it does, tighten the clamp more.

7. With your workpiece clamped securely and in the right spot for your cut, you are ready to turn the saw on. With both hands on the handle of the chop saw, switch the saw on (if there is a safety mechanism, release it).

8. Let the saw get up to full speed, and when the hum levels out, gently bring it down to the material.

9. As sparks fly, use gentle but steady pressure to keep the saw moving through the material, taking care not to overload the motor. If your speed is too fast, the motor will sound bogged down, and the blade could stop. If your speed is too slow, the material will start to heat up and melt rather than be chipped away by the abrasive disk.

10. Continue with this pressure until all the way through the material, and then let the saw dip slightly past the table height.

11. Release the trigger, and let the saw come to a complete stop before removing your work.

12. Chop saws generate quite a bit of heat, so your work will be hot to the touch a couple of inches from your cut area. The 6-in piece probably will be heated all the way through, so leave it where it is.

13. Note that on one or both cut sides there is a sharp burr. Remove this either with a hand file, an angle grinder, or a bench grinder.

Practice 2: Round Tube at 30 Degrees

For this cut, you first need to adjust the fence and possibly the clamp head. You need to be extra sure to clamp round stock securely in the chop saw to keep it from spinning in the clamp. Locate a piece of 1½- to 3-in round tube for this cut. Make a mark around 3 in from the end.

If your chop saw requires tools to adjust the fence, get them now. Some chop saws have the tools built into the hardware or include a tool rest on the base for easy access. Loosen the fence by undoing one or two bolts depending on your saw.

1. At this point, the fence should move fairly freely. You should see marks on the base of the saw that indicate the angle of the cut. Thirty and 45 degrees can be seen on my saw in Figure 6.29.
2. Line up your fence with the 30-degree mark, and tighten it back up lightly.
3. Place your material on the bed along the clamp, and check to make sure that the wheel contacts it near the center, as you saw in the preceding practice. If it does not, either move the fence back and forth, if possible, or rotate the fence to the other 30-degree mark and recheck the position. Now tighten the fence adjustment nut all the way.
4. Tighten the clamp loosely so that you can slide the material back and forth between the fence and the clamp.

FIGURE 6.29 Miter measurement marks.

5. Lower the disk near the material, and line up your cut mark, keeping in mind the kerf of the cut disk.

6. Tighten the clamp all the way, and make sure that the material isn't going to slip by grabbing the left side of the length and trying to move and twist it. It should move with the chop saw as one.

7. With both hands on the handle and the cut disk off the surface of the steel, turn the saw on. Let it come up to full speed.

8. Gently lower the saw to the surface to begin the cut.

9. The first section of this cut will take a bit of time because there is quite a bit of material to cut through. As the disk moves further into the material, the cut will get easier, and you'll be able to increase the speed of the cut somewhat while keeping the same pressure. When near the bottom, the cut speed will slow again. Figure 6.30 shows the difference in material through a section of tubing.

10. Keep your pressure even by listening to the hum of the motor until the cut is complete.

11. Let the cut disk drop down below the material slightly before bringing it up and switching the machine off.

12. Let the saw come to a stop before undoing the clamp.

13. Keep in mind all the heated areas before touching your work.

14. At this point you can put the material away for later use or grind off the burr as you did in the preceding practice session.

Practice 3: Flat Bar
When cutting something that isn't symmetrical, such as flat stock or rectangular tubing, you need to consider the direction in which to clamp it. This becomes more important as the short dimension gets thinner because it is possible for it to slip under the clamp or fence. Figure 6.31 shows flat stock that might slip under the clamp midcut. You want to clamp flat stock in the chop saw vertically so that there is no risk of it slipping under the clamp and to best take advantage of the clamping

FIGURE 6.30 Cross section of tube cutting.

Figure 6.31 Improperly clamped work.

force. It is easier to control your speed and pressure when cutting through thinner material as well. When cutting through the wide dimension of a rectangle, there is a greater risk that the lower speed will create excess heat and that the cut won't be able to be completed.

1. Lay the material vertically across the table on the saw, and adjust the clamp so that the material doesn't fall over but is able to slide back and forth.
2. Line up your mark with the blade of the saw, taking the kerf into consideration, and tighten the clamp all the way. Double-check the tightness by lifting up on the material to the left of the saw. Again, it should not come loose during this step.
3. With both hands on the handle, start the saw, and let it reach full speed before cutting.
4. Start the cut gently, and continue to ease the saw through the material.
5. Even pressure and speed will give you a clean cut without too much heat or excessive wear.
6. When finished, allow the saw to come to a stop before removing your work.
7. Don't forget that it's going to be hot!
8. Remove the burrs using one of the methods I mentioned in the preceding practice session.

Practice 4: Multiple Items

As I mentioned earlier, one of the great features of a chop saw is its ability to cut multiple items at once. To do this, the items must be clamped in a particular way, and round material must never be clamped more than one at a time in a chop saw. Square, flat, and rectangular pieces are best for cutting in multiple quantities.

The clamping force is created between the fence and the adjustable clamp. When material is clamped, the fence and clamp will move out of parallel to some degree, and this must be considered before clamping multiple items. Figure 6.32 shows multiple items clamped incorrectly and the clamping surfaces coming out of parallel.

For your practice session, locate two or more pieces of flat stock that are the same dimension and follow these instructions:

1. Lay all of your pieces across the table, and clamp them into the saw at the proper cut position, as shown in Figure 6.33.
2. With both hands on the handle, start the saw, and let it reach full speed before cutting.
3. Start the cut gently, and continue to ease the saw through the material.
4. This material is thicker than your other cuts, so be careful not to use too much pressure. Even pressure and speed will give you a clean cut without too much heat or excessive wear.

Figure 6.32 Incorrect clamping.

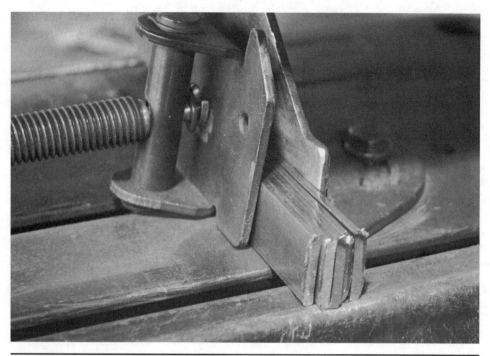

FIGURE 6.33 Multiple items clamped correctly.

5. When finished, allow the saw to come to a stop before removing your work.
6. When handling your work, remember that it will be very hot.
7. Remove the burrs using one of the methods I mentioned in an earlier practice session.

Practice 5: Angle Stock

When clamping angle stock in a chop saw, do so with the point of the angle pointing upward. The legs should be diagonal to the clamp and table so that they don't slide under the clamp or fence. Angle pieces should not be clamped more than one per cut.

1. Lay the material across the table on the saw with your mark near the disk.
2. Adjust the clamp so that you can slide the material back and forth.
3. Line up your mark with the blade of the saw, and tighten the clamp all the way. Double-check the tightness by lifting up on the material to the left of the saw.
4. With both hands on the handle, start the saw, and let it reach full speed before cutting.
5. Start the cut gently, and continue to ease the saw through the material.

6. As the cut disk first enters the material, it will have more material to cut through than after it passes through the corner. Keep even pressure as it moves through this.
7. When finished, allow the saw to come to a stop before removing your work.
8. Don't forget that your workpiece is going to be hot!
9. Remove the burrs using one of the methods I mentioned in an earlier practice session.

NOTE: *Taking care to use the proper pressure will give you the cleanest cuts while minimizing wear to the chop saw and consumables. Once your cut disk gets worn down, you will notice significantly less cutting power. Replace the disk often.*

Drill Press

A drill press is a motorized drill attached to a stable worktable that allows you to carefully control the depth, speed, and angle of a round hole. This is a fairly common tool around all sorts of shops whether they are focused on wood or metal, and the machines are generally interchangeable. With a handheld drill, even the most experienced metalworker will have trouble making holes through steel that are uniform in depth and perfectly straight. The drill press allows you to dial in the exact angle you need and to repeat it easily (Figure 7.1).

There are many reasons why you might need to drill a round hole into a piece of steel. Maybe you need to bolt something together, allow another piece of round material to fit through something, create a hole for a plug weld, or give the hot gas you create during welding a way to escape. You could theoretically do all of those things using a handheld drill, but that would put you in direct control of the drill angle, speed, pressure, and stop control. When using a drill press, you are able to set the drill angle, drill depth, speed, and exact location so that while the drill is running, you only need to focus on using the correct pressure. This will give you a cleaner, more accurate hole and extend the life of your drill bits and allow for better repetitive drilling.

The biggest drawback a drill press has over a handheld drill is its size. You must be able to put your work on the drill press table, whereas with a handheld drill you can drill anywhere. However, with good project planning, you won't have to worry about this drawback.

Drill presses can be either a workbench model or a floor-mounted model. Whichever type you have, make sure that the base is securely clamped down. When drilling long stock, the extra weight may cause an unsecured press to tip over.

Drill-press tables do not usually have a built-in clamp. However, your work always must be securely clamped to the drill table. For this you can use either regular deep-throat C-clamps or Vice-Grips or a tabletop adjustable vice. A separate

FIGURE 7.1 Floor-mounted drill press in use.

adjustable-height support placed on one or both sides of the drill-press table may help to support the ends of long work.

Parts

Figure 7.2 shows the parts of a drill press.

Accessories

Center Punch

A center punch is a hardened piece of steel ground to a point. When the punch is hammered into mild steel, it will create a divot. This divot keeps the tip of the drill bit in place when starting a new hole so that accurate holes can be made.

NOTE: *When using a center punch, make sure to hammer on a solid surface and one that absorbs sound, such as wood. If you hammer a center punch into steel that's on a metal table, the sound will reverberate and be very loud.*

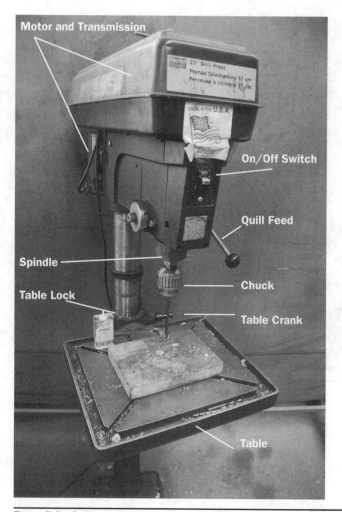

FIGURE 7.2 Drill-press parts.

Deburring Tool

A deburring tool allows you to remove the burr from the inside edge of a drilled hole. It will also work on edges cut with a chop saw or angle grinder. Run the sharp edge of the tool along the burred edge using moderate pressure.

Adjustable Vice

This clamp will allow you to easily position your work securely and off the surface of the table (Figure 7.3). Nobody likes it when their table is full of drill holes, so always keep your work off the surface when drilling all the way through. The vice also should be securely clamped to the tabletop. This will allow you to slide your

Figure 7.3 Adjustable vice and clamp.

work through the vice without any complicated readjusting so that you can easily repeat drilling holes.

Automatic Center Finder

This tool helps you to locate the chuck directly over the point where you want to drill in your material. One side is secured in the chuck, whereas the other side rests in the center punch mark on your material. By lowering the quill arbor gently, you can bring these two pieces into alignment and clamp your work securely.

Drill Bits

There are a couple of types of drill bits that are used frequently with steel. Twist bits are the most common, and if you have a drill-bit magazine already, chances are that you've got some appropriate twist bits. Because of the friction created with drilling steel, drill bits will build up heat. The various materials and coatings offered on drill bits help to resist this heat. With the bits mentioned in this book, cutting oil always should be used to preserve the life of the drill bit.

Twist Bits

Twist bits are multiuse bits, meaning that they can be used for wood, plastics, masonry, and various types of metal. They are shaped like a screw with cutting edges along both sides and come to a point at the tip. They can be made of many types of steel alloys and are coated in different finishes. For drilling steel, you'll need to use a drill bit that is harder than your work material. A bit made of high-carbon steel, high-speed steel, or tungsten carbide is preferable. A proper coating such as titanium nitride can help to extend the life of your bit. A nice feature of twist bits is that they can be sharpened and used for quite some time (Figure 7.4).

Holes drilled through steel that is over $\frac{1}{4}$ in thick should be made by stepping up the drill-bit size gradually. Use $\frac{1}{4}$-in steps to achieve the desired hole size. For example, if you want a $\frac{5}{8}$-in hole, start with a $\frac{1}{4}$-in bit, follow that up with a $\frac{1}{2}$-in bit, then finish it off using a $\frac{5}{8}$-in bit.

Center Drill Bits

Center drill bits are made for harder materials such as steel and help the bit to find and stay on center. The smaller tip helps to start an accurate hole, and as it drills a *pilot* hole, the outer diameter begins to cut too.

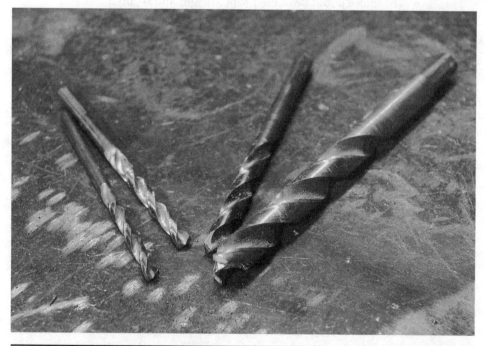

FIGURE 7.4 Twist bits in various sizes.

Unibit

A unibit is a type of drill bit that is used on thin sheet metal to quickly make a hole without the need to start the hole with a pilot bit. The stepped design allows the user to continuously make the hole larger until the desired size it achieved.

Speeds

As a general rule, the harder the material, the slower the drill speed. This is done to reduce the heat created from friction as much as possible. However, there are other factors that influence proper drill speed, such as hole size and hardness of the drill bit. Most drill presses should have included somewhere on them a chart for determining proper drill speed. Always refer to this chart, and set your drill speed before turning the machine on. For a general guide, refer to Table 7.1.

Safety

- Make sure that the bit is securely fastened in the chuck before use. Give each hole on the chuck a turn with the key to make sure.
- Remove the chuck key from the chuck before turning the drill on.
- Spin the chuck with your hand to ensure that the bit is in straight and not bent.
- Bits should be sharp and not bent or broken.
- The table should be at the proper height and secured.
- All material to be drilled should be securely clamped to the table or in a vice.
- Long material should be clamped such that it will make contact with the column, not the operator, if it slips.
- The table should be free of other objects that could get caught.
- If using a depth stop, set this before turning the machine on.
- Do not start the drill press with the bit in contact with the material.
- Do not put too much pressure on the drill bit by overloading the quill feed.
- Never side load a drill bit.
- Always let the drill press come to a stop on its own.

Hole size	⅛ in	¼ in	⁵⁄₁₆ in	⅜ in	⁷⁄₁₆ in	½ in
Speed (revolutions per minute)	800–3,000	400–1,500	300–1,200	200–1,000	200–900	200–700

TABLE 7.1 Speed Recommendation for Drilling in Mild Steel

Personal Protective Equipment
- Always wear safety glasses and/or a face shield.
- Any jewelry, long hair, or loose clothing must be rolled up securely.
- Hearing protection is recommended.

CAUTION: Never *wear gloves while operating a drill press!*

Drilling Practice

To practice drilling using the information just presented, gather some short sections of round and square stock or tube.

Practice 1: ½-in Hole Through Flat Stock

To drill a ½-in hole, you'll need to use a pilot bit to make the process easier and cause less wear on the bits. If your bits are on the dull side, you may need to use an extra pilot bit in the process. I'd start with a ⅛-in bit and then move to a ¼- or ⅜-in bit and end with a ½-in bit. If you are using sharp bits, you can start with a ¼-in bit and go directly to the ½-in bit.

1. Using the center punch, punch a divot into the surface of your flat stock where you want to drill a hole.
2. Set a scrap of wood on the table of the drill press with your work on top.
3. Set the press to the proper speed for a ¼-in hole. Refer to the tool manual or speak with the shop supervisor to determine the correct speed for your specific machine. Take note of the speed for a ½-in hole as well.
4. Slide your ¼-in bit into the jaws of the chuck, and using the chuck key, bring the jaws together.
5. Clamp the bit into the chuck, and turn the chuck with a chuck key or your hand.
6. If the bit is straight, tighten the chuck fully using the remaining two chuck-key holes. If the bit is crooked, loosen the chuck, and adjust the bit until it is straight. If the bit is bent, remove and dispose of it.
7. So that you don't have to adjust the table height between using the ¼- and ½-in bits, you will use the longer of the two to set the height. If the ½-in bit is longer, hold it next to the chuck approximately where it would be when clamped properly. Loosen the table clamp, and bring the table up so that the tip of the drill bit is about 1 in away from the top of your workpiece.
8. Using the quill feed, lower the bit so that it is just above the surface of your workpiece, and slide your workpiece so that the divot is directly below the tip of the drill.

9. Release the quill feed, and securely clamp your workpiece and the wood beneath it.

10. Check for alignment one more time. If the piece has shifted, realign beginning with step 7. If the drill bit still lines up with the divot, continue on.

11. To set your depth stop, you will need to check with your specific tool manual or shop supervisor because many different types are common. You will want to set the depth so that the entire tip of the bit passes through the end of the material but not through the scrap wood.

12. Apply a small pool of cutting oil to the center-punch mark.

13. With one hand on the quill-feed handle, turn the drill press on, and with the other hand, let the drill come up to full speed.

14. Gently lower the bit to the surface of the workpiece, and increase pressure until flakes of steel start to appear. If you use the proper speed and a sharp bit, you shouldn't need to use much pressure. If the bit is dull and the speed is set too high or too low, more pressure will be needed, which can result in a broken bit.

15. Light to moderate pressure should be used, and the drill motor never should sound bogged down or come to a stop.

16. Note the small pieces of steel that are removed from the material. They should have a silvery finish. If the flakes start to look brown or blue, this indicates that there is too much heat being created. If heat builds up, remove the drill bit from the material for a minute to let it cool off. Apply a little more oil, and try cutting again using slightly less pressure. Make sure that your bit is sharp and of the proper hardness for the steel you want to drill. If you hear a high-pitched squeal, the bit is probably dull and needs to be sharpened.

17. Continue through the material with gentle pressure as long as you see silvery steel flakes or a spiral appear.

18. Once the depth stop is engaged, you will not be able to move the quill feed anymore.

19. When you've reached the end, move the quill up and down one last time to free any burrs on the backside of the hole and return the quill to rest.

20. Power down the drill press, and let it come to a stop.

21. Do not move your work! You still need to finish the hole, and if it moves, you will need to readjust everything.

22. With the chuck key, remove the ¼-in bit and open the jaws so that they will accept the ½-in bit.

23. Insert the new bit into the chuck, and tighten it.

24. Check to make sure that the bit is straight, and if so, tighten it using both other chuck-key holes.

25. Set the drill speed to the proper ½-in-bit speed.

26. This bit should still be aligned with the hole in your material and be about 1 in from the surface. Double-check this, and if anything has moved, reclamp your work or adjust the table height.
27. Apply more cutting oil around the last hole.
28. You have to disable the depth stop now because it won't do you any good with a longer bit. Rather than reset it, you'll use another more basic technique: When wood chips appear on the surface of the material, you've made it through!
29. Turn the drill press on again, and let it come up to full speed.
30. Ease the bit onto the surface of the material, and it should start cutting right away.
31. Using gentle pressure, ease the bit through the material, watching the metal chips along the way. If heat builds up, let the work cool, add more oil, and repeat drilling with slightly less pressure.
32. When wood chips start to appear on top of the workpiece (being pulled up by the drill bit), back the bit out of the hole, and check to make sure that you've made it all the way through. If there is still a burr at the bottom, ease the bit back in, and move it up and down past the backside a few times.
33. Shut the drill off, and let it come to a stop on its own before undoing any clamps or the bit.
34. Remember, the work may be hot, so use caution when unclamping your work. Dump any metal shavings into a trashcan, and wipe off the excess cutting oil.
35. You also can use the deburring tool to smooth out the corner of the hole on either side.
36. Return bits to their proper storage area, and clean up around the drill press.

Practice 2: ⅛-in Hole Through ½-in Square Stock

1. Refer to the machine manual or shop supervisor to set the drill speed for your ⅛-in hole.
2. Use the center punch to mark a spot for the ⅛-in hole.
3. Put the adjustable vice on the table, and clamp your work in it with your mark over an area that will let the bit pass through.
4. Mount the ⅛-in drill bit using the steps in Practice 1 to make sure that it is centered.
5. Set the depth so that the bit will pass through the material but not come in contact with any part of the adjustable vice.
6. With the bit at its highest resting point, adjust the table so that you have roughly an inch between the bit and the highest point on the vice. If the vice were to bump the bit, even with the drill off, it could break the bit.
7. Move the divot to under the drill bit, and line it up by lowering the bit with the quill feed.

8. Clamp any secure part of the vice to the table.

9. Confirm that nothing has moved in the clamping process.

10. Apply oil to the divot.

11. With one hand on the quill feed, turn on the drill and let it come up to full speed.

12. Ease the bit down to the surface of the workpiece, and increase pressure until you start to see it cut.

13. Continue to use light pressure to ease the drill bit through the work. Keep an eye on the metal flakes to make sure that you're not building up too much heat.

14. You should feel the bit pass through the backside of the metal because there is nothing there to resist the pressure. Ease up slightly when you are close to the end.

15. Pass the bit through the hole once or twice, stopping at the depth stop.

16. Raise the bit all the way up, and turn off the drill press.

17. When the bit has stopped, you can remove your work from the clamp.

18. Undo the chuck, and return the drill bit to its holder.

19. Clean any metal filings from the table.

Practice 3: ¼-in Hole Through 1-in Round Tube

1. Refer to the machine manual or shop supervisor to set the drill speed for your ¼-in hole.

2. Use the center punch to mark a spot for the ¼-in hole.

3. Put the adjustable vice on the table, and clamp your workpiece in it with your mark over an area that will let the bit pass through, similar to Figure 7.5.

4. Mount the ¼-in drill bit using the steps in Practice 1 to make sure that it is centered.

5. Set the depth so that the bit will pass through the material but not come in contact with any part of the adjustable vice.

6. With the bit at its highest resting point, adjust the table so that you have roughly an inch between the bit and the highest point on the vice. If the vice were to bump the bit, even with the drill off, it could break the bit.

7. Move the divot to under the drill bit, and line it up by lowering the bit with the quill feed.

8. Clamp any secure part of the vice to the table.

9. Confirm that nothing has moved in the clamping process.

10. Apply oil to the divot.

11. With one hand on the quill feed, turn on the drill and let it come up to full speed.

12. Ease the bit down to the surface of the workpiece, and increase pressure until you start to see it cut.

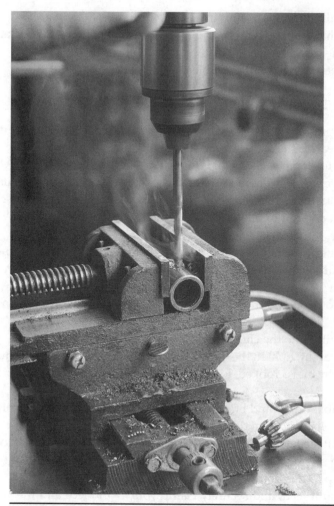

FIGURE 7.5 Adjustable vice with tube.

13. Continue to use light pressure to ease the drill bit through the work. It won't take long to cut through one wall of your tube. Keep an eye on the metal flakes to make sure that you're not building up too much heat.

14. You should feel the bit pass through the backside of the metal shortly, and you can continue to ease it down to the next surface.

15. Increase pressure until the bit starts to cut here as well. You may not be able to see any metal flakes, so you'll need to go by feel to attain the correct pressure.

16. Again, the bit should pass through the wall pretty quickly.

17. When you feel the bit complete the hole, pass it through the hole once or twice, stopping at the depth stop.

18. Raise the bit all the way up, and turn off the drill press.
19. When the bit has stopped, you can remove your workpiece from the clamp.
20. Undo the chuck, and return the drill bit to its holder.
21. Clean any metal filings from the table.

Practice 4: ⅜-in Hole Through Sheet Metal

1. Set the drill press to the proper speed for a ⅜-in hole. Refer to the tool manual or speak to the shop supervisor about your specific machine.
2. The safe way to clamp sheet metal is to the table with a piece of scrap wood below it, as you did in Practice 1. For this exercise, you're going to use a unibit to gradually increase the hole up to ⅜ in. Make sure that your scrap wood is thick enough to allow the bit through without coming in contact with the table.
3. Using the center punch, punch a divot into the surface of your sheet metal where you want to drill the hole. You won't need to use much force to make a good mark.
4. Set the scrap of wood on the table of the drill press with the sheet metal on top.
5. Clamp the unibit into the chuck, and turn the chuck with your hand.
6. If the bit is straight, tighten the chuck fully using the remaining two chuck-key holes. If the bit is crooked, loosen the chuck and adjust the bit until it is straight.
7. Loosen the table clamp and bring the table up so that the tip of the drill bit is about an inch away from the top of your workpiece.
8. Using the quill feed, lower the bit so that with your workpiece just off to the side, the ⅜-in stepped area on the bit will fully pierce the sheet metal. Set the depth stop to this point.
9. Release the quill feed, and securely clamp your workpiece and the wood below. Use a block of wood to prevent damage to the sheet metal.

Caution: If sheet metal catches on the drill bit and spins, it can cause serious injury!

10. Check for alignment one more time. If the workpiece has shifted, realign it beginning with step 7. If the drill bit still lines up with the divot, continue on.
11. Apply a small pool of cutting oil to the center-punch mark.
12. With one hand on the quill-feed handle, turn the drill press on with the other and let it come up to full speed.
13. Gently lower the bit to the surface of the workpiece, and increase pressure until flakes of steel start to appear. Light to moderate pressure should be plenty.

14. Shortly the stepped bit should penetrate the surface and start to cut through. Continue through the material with gentle pressure.
15. Once the depth stop is engaged, you should be at the ⅜-in mark of the unibit.
16. Return the bit to its highest position, and turn the drill off.
17. When the drill comes to a stop, unclamp your work and deburr the hole.

Roll Bending

Rollers, also called *slip rollers*, are tools that use adjustable hardened-steel rollers to make an even cylindrical bend in sheet, plate, tube, or solid stock. Rollers can be either manual or electric powered and come in a variety of widths so as to be able to roll Richard Serra–sized work all the way down to compact jewelry work. Rollers consist of one or two drive rollers that force the material through an adjustable gap in a trailing roller to give it its bend, as seen in Figure 8.1. The closer the adjustable roller is to the guide rollers, the tighter is the bend. Thicker-walled tubing may be able to be rolled on a regular slip roller, but thinner-walled tubing usually will be crushed without the extra side support provided by a specialty tubing roller. Another type of small roller is called a *ring roller*. The ring roller is much like a tubing roller, but it has flat rollers. Ring rollers have a very limited capacity and are used mostly for scrollwork.

Slip rollers used for sheet and solid stock will be wider than tubing rollers and have long, smooth rollers. These slip rollers have two feed rollers in the front with an adjustable gap to accommodate a wide range of materials. Just behind the feed rollers is another adjustable guide roller that when brought up will decrease the diameter of the bend and when brought down will lessen the bending force. On one side of the rollers there usually will be a series of grooves meant to allow for the rolling of round and square stock and wire. I am going to focus on this type of roller in this book because I believe it is the most versatile. Rolling sheet metal opens up many design opportunities, and because you can use a sheet metal roller to roll solid stock, there's a lot you can do.

In a mechanical slip roller, a hand crank is turned to feed material through the feed rollers, and when the material comes in contact with the third roller (slip or guide roller), it slides over it, creating a bend between the pinch point in the feed rollers and the tangent on the guide roller. After one pass like this, the material is reversed to help form a uniform, symmetrical bend.

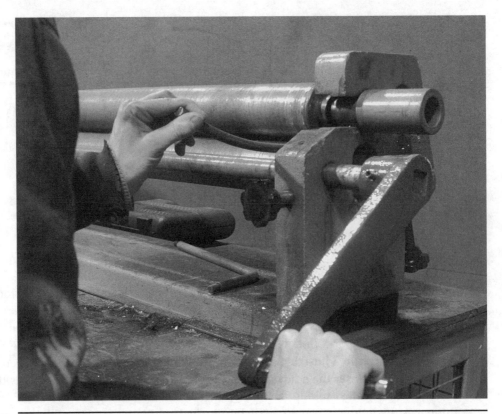

FIGURE 8.1 Slip roller in use.

More affordable rollers will be hand operated, which somewhat limits the rolling capacity. For your purposes, a hand-operated roller is ideal (and you get a great workout!). Electric rollers have more safety concerns, and for beginners, a manual feed is the way to go. Check your roller manual to see what the maximum capacity of your tool. Never exceed this rating because you could easily damage the rollers or supports.

NOTE: Never run round or textured steel through the flat rollers of a slip roller.

Given steel's excellent workability, you don't need to worry about affecting its strength while rolling. If you rolled a length of material back and forth, alternating the direction of the bend each time, eventually you would cause significant damage to the structure (think of bending solid wire many times with your hand). For normal use, though, the steel structure is not weakened, and the new shape actually may increase the potential strength of the material. When rolling a relatively tight bend, multiple passes should be made to ease the steel into the curve. This technique

will prolong the life of the roller and make the rolling process much easier for the operator.

Parts

Figure 8.2 shows the parts of a slip roller.

Operation

1. Adjust the feed rollers so that the workpiece fits between them snuggly. Keep the feed rollers parallel.

NOTE: *Only roll material that is flat and smooth. Grind off any burrs or slag with an angle grinder, and never roll anything with protruding surface welds.*

2. With the workpiece extending through the feed rollers, adjust the guide roller so that it will contact the workpiece but not block it from rolling through. Keep the guide roller parallel to the feed rollers.

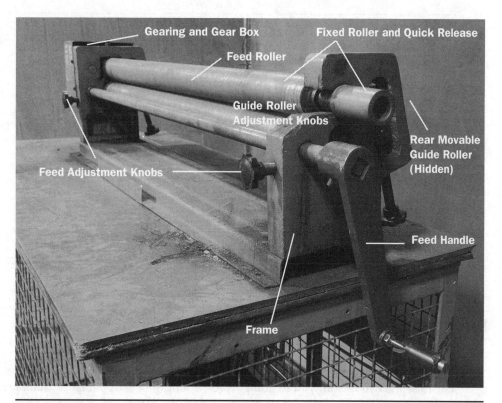

FIGURE 8.2 Parts of a slip roller.

3. Start feeding the material through the rollers by turning the hand crank. If the material slips, either increase the feed pressure or lower the guide roller.

4. Always keep your hand that is supporting the work at least a foot away from the feed rollers.

5. Start with the material perpendicular from the beginning and keep it so the whole way through. This will ensure that you have a symmetrical bend. If you desire a spiral or cone, you can feed your material through at an angle.

6. The first pass will put a gentle curve in the work that helps you to feed the steel through for the subsequent passes.

7. For the next pass, increase pressure from the guide roller by bringing it up. Don't start out with too much pressure on this pass because it's much harder to undo a roll than it is to make one.

8. Continue increasing pressure on the guide roller until the desired curve is achieved.

9. If you are rolling multiple shapes that are meant to be the same radius, run all of them through on each pass before making any adjustment to the roller.

10. If needed, undo the quick release to pull your work out along the length of the top roller rather than bend it over the roller.

NOTE: When rolling multiple pieces, always put them through in the same location on the roller. This will ensure that they all come out with the same radius. Mark the location on the roller with soapstone.

Safety

- Be mindful of where you put your hands and fingers.
- Your support hand always should be at least a foot away from the feed rollers.
- Roll one piece at a time.
- Watch out for loose flakes of mill scale when rolling.
- Use a partner for large pieces.

Personal Protective Equipment

- Wear safety glasses or a full-face shield.
- Gloves are not recommended.
- Do not wear loose clothing.

Rolling Practice

Practice 1: Rolling Flat Stock into a Circle

For this practice lesson, you're going to roll a length of 1-in flat stock that should yield a 4-in-diameter cylinder. To figure out the length of stock needed, it's basic

math: $4 \times \pi = 12.5$, so the length of flat stock you need is 12.5 in. Make sure that your roller has a minimum roller diameter smaller than 4 in, and if not, increase the length of your material. Make sure that the surface and edges of your material are clean and smooth.

1. Hold the material in between the feed rollers, and adjust the movable roller so that the piece fits snug. Ensure that the two rollers are parallel by sliding your workpiece through at multiple points or with a gauge if your roller includes one.
2. With the workpiece held between the rollers, adjust the guide roller so that it just comes into contact with the leading edge of your material but not so much that the material won't be able to slide past.
3. With your material perpendicular to the feed rollers, roll it through one time. This passage should offer little resistance but will result in a slightly curved piece of metal such as that seen in Figure 8.3.
4. Bring the guide roller up slightly using a few turns of the adjustment knobs. Turn each knob the same number of times.
5. Pass your material through another time, and note the amount of bend.
6. Adjust the guide roller again appropriately, and try another pass. Your workpiece should look similar to the one in Figure 8.4.

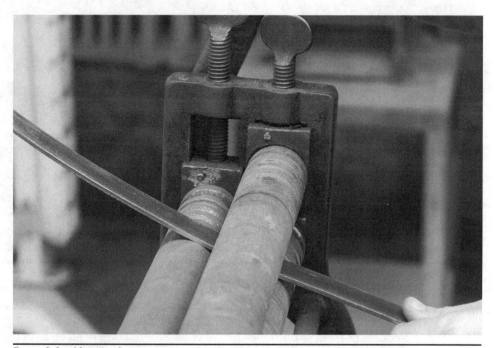

FIGURE 8.3 After the first pass.

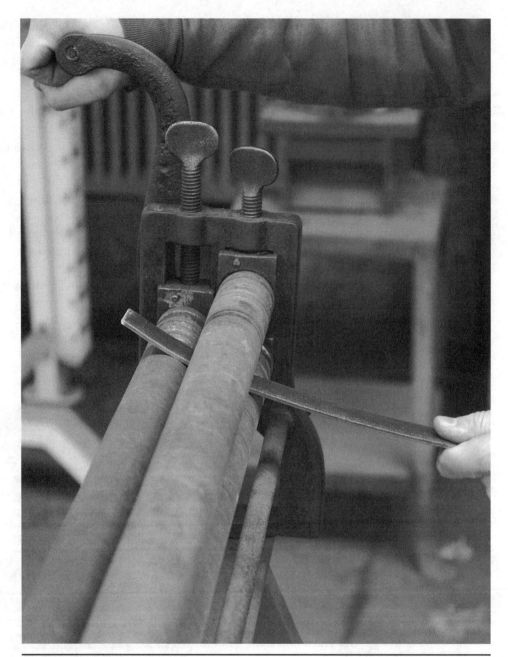

FIGURE 8.4 After the second pass.

7. Adjust the guide roller one more time for another pass.
8. Repeat this process until the ends of your material nearly meet, as in Figure 8.5. It took five passes for me to complete this on my roller.

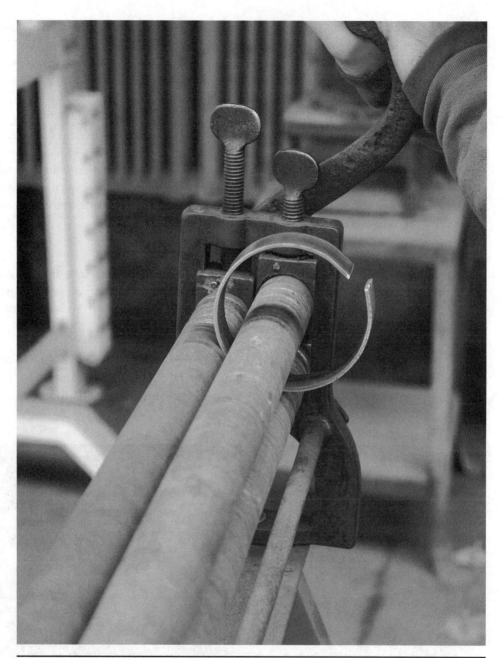

FIGURE 8.5 Completed roll.

9. If you have a quick-release type of roller, undo it and slide your hoop off. If
 there is no quick release, just flex the steel and slide it over the fixed roller.

10. Inspect your cylinder. If rolled properly, the ends should line up very close
 together, and the radius should be very symmetrical. If the edges don't line

up, this means that the work was not fed through perpendicular to the rollers or the rollers weren't completely parallel. A well-aligned roll will look like the one in Figure 8.6. Just apply a little pressure, and it will close right up, ready to weld.

11. Save this workpiece, and you'll weld it together in Chapter 19.

NOTE: *Depending on the bend radius, there may be a noticeable flat section of metal at the start and end of the rolled piece equal to the distance between the feed rollers and the point of contact with the guide roller. Usually it's not much, but if you want to remove it, just start with material that is slightly longer than you need, and cut off the flat section with an angle grinder. Or, before you roll your work, form both ends over another curved surface with a wooden hammer to start the curve.*

Practice 2: Rolling a Hoop from Round Stock
For this exercise, you need to use the wire grooves on the rollers. If your roller does not have wire grooves, I suggest that you skip this practice. Start off with a length of ⅜-in round stock that is 37¾ in long (to make a 12-in hoop) with a ⅛-in miter on each end.

1. Align your length of round stock with the smallest wire groove into which that it can fit without getting hung up on the edges. Some rollers have wire grooves at ½, ⅜, and ¼ in. If your roller has three, try the middle one.

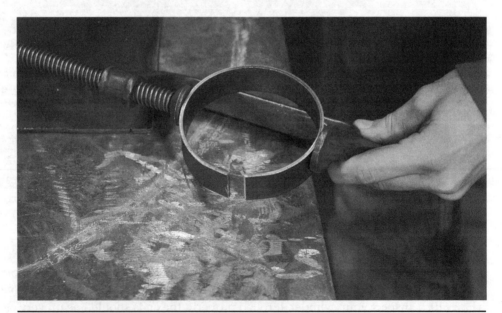

FIGURE **8.6** Edge alignment.

2. Adjust the feed roller to add the correct amount of pressure so that the workpiece doesn't slide out freely.

3. Step back or off to the side to optically align the adjustable feed roller so that it is parallel with the fixed roller.

4. Adjust the guide roller so that the material makes enough contacts to achieve a slight bend on the first pass but not so much that the workpiece gets stuck when you start to crank the handle, just as in Practice 1.

5. Now you're ready for the first pass. Start feeding the material through the roller so that a slight bend is made. Be sure to support the stock so that the bend continues straight up and doesn't twist off to one side. If you start to develop a twist, it will take quite a bit of labor to straighten it back out. Figure 8.7 shows the first pass of my workpiece.

6. After the first pass, adjust the guide roller to make a tighter radius.

7. Feed the stock through so that the curve is vertically aligned again, and keep it that way through the whole rolling process. If it starts to twist, just twist the feed side to keep it straight.

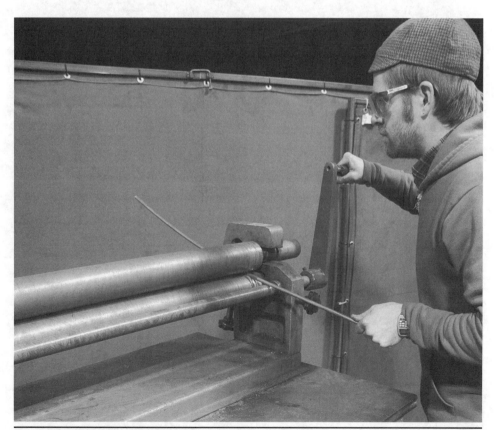

Figure 8.7 First pass with ⅜-in stock.

8. Repeat steps 6 and 7, making small adjustments to the guide roller until the hoop is nearly closed like the one shown in Figure 8.8.
9. If you can bend the hoop to pull it over the top roller, do so, or undo the quick release and slide it off.
10. The ends should be close enough together that you can easily connect them with your own force, as shown in Figure 8.9.
11. Save this piece to practice welding later in this book.

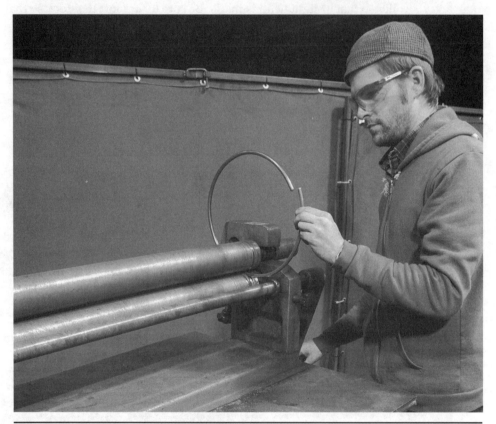

FIGURE 8.8 Almost closed hoop.

FIGURE 8.9 Finished hoop.

Oxygen-Acetylene Torch

The oxygen-acetylene (oxy-acetylene) torch is arguably one of the most versatile metalworking tools in existence. With no other tool can you weld, cut, bend, and more—all without electricity. As you learned earlier in this book, oxy-acetylene welding and electrical welding were developed around the same time during the 1800s. The speed and focused heat of electrical welding made it more useful in industry, and not many more advancements were made to oxy-acetylene welding after World War I. However, oxy-acetylene torch work never died out. For one thing, the setup was still the most efficient way to cut through steel, something that wouldn't be achieved with electrical power until the middle of the twentieth century. Using the same welding setup, one can weld a variety of metals, such as different steel alloys, brass, bronze, aluminum, and more, by changing the filler material. Also, anywhere welding was needed where there wasn't access to electricity (rural areas), the oxy-acetylene torch was the only way to go.

One reason I am starting out with the oxy-acetylene torch is that it gives you a chance to watch how steel responds to heat at a slower speed than with electrical welding. With metal–inert gas (MIG) welding, milliseconds after the trigger is pulled the steel has already become a liquid, and the welding process has begun. You would need super-high-speed cameras to see this process in detail. When using the oxy-acetylene torch to weld or cut steel, you first need to bring an area of steel up to its melting temperature. This alone takes from 10 to 30 seconds, and during that time, you are able to watch the steel gradually change from a dull gray to a molten yellow-white pool. Only when you see the pool of molten steel is your material ready to be welded or cut. Figure 9.1 shows a cut underway.

Today, the main reason to use a torch setup is its versatility and cost. If you wanted to outfit a shop to weld, cut, and heat different metals, you'd be looking at spending tens of thousands of dollars. For less than $300 (plus gases), you can buy a torch kit that will do all that. Maybe it's the Luddite in me, but I think that there

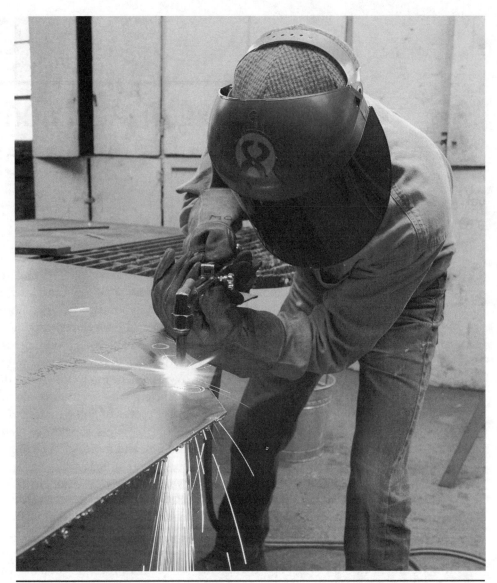

Figure 9.1 Oxy-acetylene cutting in process.

is something rewarding about slowing down and enjoying the process that reduces welding to an easy-to-understand process. Also, I really like fire.

Whether you are cutting, welding, or heating steel to bend, the basic principles behind the oxy-acetylene torch are the same. Pressurized gas is let out of each gas cylinder and into a pressure regulator. These regulators not only restrict the flow of gas to a controllable rate known as *pound-force per square inch* (lbf/in^2) but also tell you the pressure of the gas in each cylinder.

When you open the regulators, gas will start to flow through the hoses until it reaches another restriction. The hoses should be connected to the torch head with all valves closed to prevent a gas leak. If when you open the regulator you hear a constant hiss, close the valve and check all knobs on the torch and for leaks along the hose.

For each application of your torch, you will adjust the regulators to a different pressure. Recommended pressure settings will be given in the practice sessions of this chapter. When this pressure reaches the torch head, you must allow it to enter the torch and continue through the tip. There you have another adjustment. Each of the knobs on the torch controls the flow of oxygen or acetylene to the tip of the torch. If you were to burn acetylene alone, it would burn at around 4,000°F and create a lot of soot, and as you learned earlier, oxygen is not flammable by itself. It's the mixing of these two gases that creates a flame that is over 6,000°F hot, more than hot enough to melt steel.

Before you are ready to weld, cut, or heat steel, you must carefully calibrate the hose pressure and each of the control knobs on the torch to the proper setting for your torch tip and material. This takes some practice, especially when you are wearing insulated gloves, so be patient. The pressure at the regulator is really not how much gas pressure you want at the tip of the torch but rather slightly more than that so that you are never "starved" for gas at the end of the torch. If you were to let the full amount of gas escape from the torch tip, the pressure most likely would extinguish the flame. (This is not the case for torch cutting, when you actually do want the full blast of oxygen to blow the molten steel out of the way.)

By replacing the torch head and tips, you can drastically change the function of the oxy-acetylene setup. For welding, the torch head has an oxygen mixing valve, an acetylene mixing valve, and a single hole at the end of the welding tip where the flame is formed. For the rosebud, again you have these two mixing valves, but now you have a series of small holes at the end of a much larger tip. For cutting, you still have the same two mixing knobs at the base of the torch, but now you also have an oxygen blast knob and blast trigger along with a series of holes at the end of the tip. In the middle of this series of holes is the oxygen blast hole that allows the full flow of oxygen when the trigger is depressed.

Up next is a review of all these parts, and you'll learn more about the specifics of how each functions, as well as the proper settings and accessories for each.

Parts and Accessories

Torch and Tank Setup

Figure 9.2 shows the torch and tank setup.

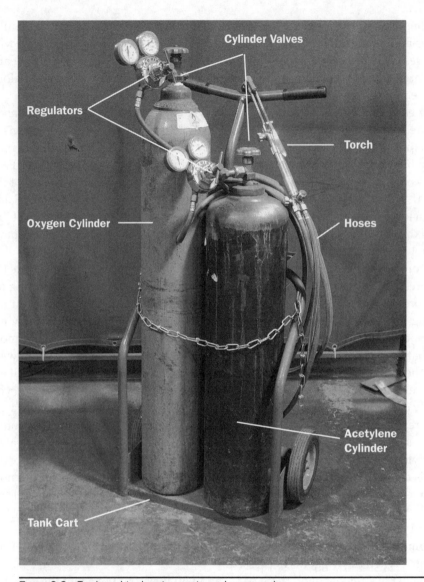

FIGURE **9.2** Torch and tank setup parts and accessories.

Parts Detail

Figure 9.3 shows the parts in detail.

Torch Detail

Figure 9.4 shows the details of the torch head.

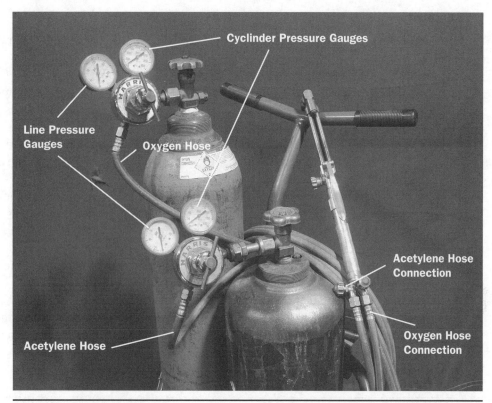

FIGURE 9.3 Parts detail.

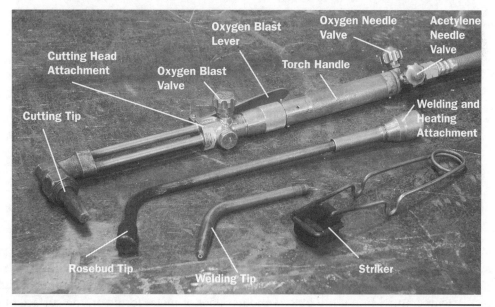

FIGURE 9.4 Torch-head details.

Safety

- Tighten all brass fittings just to slightly oversnug using the apparatus wrench.
- Never use acetylene gas at over 15 lb/in^2.
- Always inspect your equipment before use. Discard damaged equipment and hoses.
- Only use a sparker to light the torch.
- Before opening a gas valve, make sure that the regulator is closed by turning the valve counterclockwise until it turns freely. Both the working gauge and the cylinder gauge should read zero.
- Make sure to use the proper regulator for the gas cylinder (acetylene should be red past 15 lb/in^2).
- Stand to the side of the regulator when opening gas cylinders.
- Open the gas valves slowly.
- Never use the torch around flammable materials such as oil or gasoline.
- Don't use either gas to clean off tools or clothing.
- Always keep your torch pointed away from your body and others.
- Consider the area just below your workpiece because sparks will fall there when you are torch cutting. Do not leave hoses or flammable objects in this area.
- Put up a welding screen if you are working in a shared shop.

CAUTION: Never light a torch with a cigarette lighter or gas lighter. The heat from the torch flame can cause the lighter to explode. Always use a sparker.

Personal Protective Equipment

- Always wear properly shaded safety goggles or a face shield (shade no. 4).
- Insulated welding gloves should be worn at all times.
- Wear heavy nonflammable (leather) boots.
- Wear heavy, uncuffed pants.
- Wear long sleeves.
- Synthetic materials should never be worn.
- If desired, wear a leather apron to protect your clothing.

Torch Cutting

Oxy-acetylene cutting uses a flame of over 6,000°F to heat up an area of steel and then, with a high-pressure continuous flow of oxygen, blast the molten pool through the steel (Figure 9.5). During this process, the oxygen plays a triple role. First, it mixes with the acetylene flame, which then burns at a much higher temperature. In not too long, a molten pool of metal forms on the surface of the

FIGURE 9.5 Torch with cutting head.

steel where the flame has been in contact. When the blast trigger is depressed, a stream of oxygen flows from the center hole on the cutting tip. This stream not only physically forces the molten steel through the material but also creates an oxygen-rich environment that oxidizes the surrounding steel. This steel oxide melts at a lower temperature, so even material that wasn't in direct contact with the flame now can melt rapidly and be blown away by the oxygen blast. This is a cycle that continues as long as a small "pool" of molten steel is kept just ahead of the torch. For this reason, a travel rate, in inches per minute, should be followed when cutting through materials of varying thicknesses.

NOTE: *It's the oxidation of steel that allows the oxy-acetylene torch to cut through steel. For this reason, you can't cut nonferrous metals such as aluminum, stainless steel, or bronze with an oxy-acetylene torch.*

Oxy-acetylene cutting is probably one of the most popular uses for the setup today. In construction, demolition, and even computer-controlled fabrication, cutting torches of various sizes are used quite frequently. Tips are available for the cutting attachment from 000 to 6,000 being the smallest. With these tips, you can safely cut steel from $1/8$ in thick all the way up to 4 in with the same torch head! Table 9.1 presents a cutting reference that provides tips and the recommended pressures. A good rule of thumb is to use a gas ratio of roughly 5:1, oxygen to acetylene.

Operation

Now I'm going to walk you through proper torch setup, flame lighting, cutting, and shutdown procedures. These steps should be followed every time you prepare

Metal Thickness (in)	Tip Size	Oxygen Pressure (lb/in²)	Acetylene Pressure (lb/in²)	Inches per Minute/ Speed	Kerf (in)
1/8	000	20–25	3–5	20–30	0.04
1/4	00	20–25	3–5	20–28	0.05
3/8	0	25–30	3–5	18–26	0.06
1/2	0	30–35	3–5	16–22	0.06
3/4	1	30–35	3–5	15–20	0.07
1	2	35–40	3–6	13–18	0.09
2	3	40–45	4–8	10–12	0.11

Note: Each manufacturer will have different recommended tip size and pressure, so consult your user's manual.

TABLE 9.1 Example Torch Cutting Settings Table

to make a cut. I recommend reading this section in its entirety before trying to follow along with it or the practice sessions.

Setting Up Your Work Area and Gas Cylinders

1. Make sure that your workspace is clean of any flammable materials and that you are wearing all required personal protective equipment (see the preceding list).
2. Parts to be cut should be on your cutting table and free of coatings or contaminants. Use a heavy piece of steel or a clamp to secure your workpiece if it does not sit stably (Figure 9.6).
3. Inspect the tanks and gas lines for damage and possible leaks.
4. Make sure that the oxygen and acetylene needle valves on the torch handle are closed, the regulator turns counterclockwise freely, and both gas cylinders are fully closed.
5. If the cutting attachment is not already secured to the torch handle, attach it now securely.
6. Select the proper tip using Table 9.1, and secure it to the end of the cutting attachment using the brass nut.
7. With your torch set up properly and all valves closed, you want to find your working position before you go ahead and introduce gas.
 a. Position your torch tip perpendicular to the work material with your body braced against part of the table. Make sure that your feet and hoses aren't directly under the work material.
 b. If you are right-handed, hold the torch in your right hand, and use your left hand to brace the torch just in front of the oxygen burst handle. Bracing the torch with one hand will help you to keep it steady during the cut. Figure 9.7 presents an example.

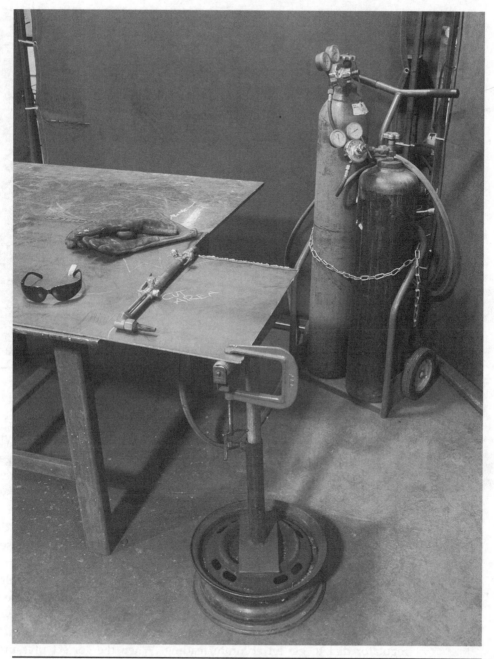

FIGURE 9.6 Work in place and cutting area prepared.

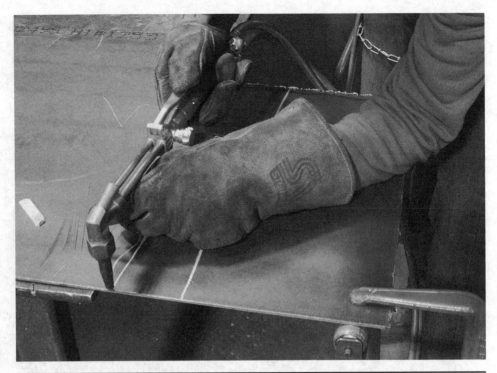

FIGURE 9.7 My braced working position.

 c. Practice moving the torch along the full range of motion required for your cut, or plan on repositioning yourself to make a longer cut. When you find a comfortable position, you can move on to introducing gas.

 8. Slowly open the oxygen cylinder valve two to three full turns. If you hear a leak, close it and check your equipment. Do not open the valve all the way because it could become jammed open.

 9. Check the cylinder pressure gauge on the regulator. It should have a reading between 0 and as much as 3,000 lb/in^2, as in Figure 9.8. It is okay to use an oxygen tank until it runs out of gas.

 10. Before you introduce oxygen into the hose by turning the regulator clockwise, open the needle valve on the torch slightly, and then ease the regulator valve open. Use the operator's manual to determine what pressure setting is correct for your material. You may need to tap on the regulator dial to get an accurate reading. When the correct pressure is reached, close the needle valve on the torch.

 11. You are now ready to open the acetylene cylinder. Turn the handle (or use the apparatus wrench shown in Figure 9.9) very slowly and only a half to one full turn to open the tank. If you are using an apparatus wrench, leave it on the tank for easy shutoff.

FIGURE 9.8 Oxygen cylinder reading.

FIGURE 9.9 Acetylene cylinder with apparatus wrench.

12. Check the tank pressure gauge. It should have a reading between 0 and 250 lb/in² (Figure 9.10). If your acetylene reading is 50 lb/in² or less, replace the tank with a new one or inform your shop supervisor.

13. Just as with oxygen, before you adjust the acetylene regulator to introduce gas into the hose, you need to slightly open the needle valve on the torch. Introduce acetylene by turning the valve slowly clockwise. Use the operator's manual to determine the correct pressure setting for your material. You may need to tap on the regulator dial to get an accurate reading. When the correct pressure is reached, close the needle valve on the torch.

Caution: *Never adjust the acetylene gas to over 15 lb/in².*

Caution: *Acetylene gas is scented like rotten eggs. If you ever smell this when working with a torch, shut the tank off immediately, and check your tools or contact a shop supervisor.*

Figure 9.10 Acetylene pressure reading.

Lighting and Mixing the Flame

Now you have your gases set properly at the tanks and pressure leading all the way to the torch handle through the hose. The next steps illustrate how to light the flame.

1. To light the flame, you need to start with the flammable gas acetylene. Gently open the acetylene needle valve about one-eighth turn or until you hear a very quiet hiss of gas escaping. If the gas ever sounds like a roar, close the valve and try again. Too much acetylene gas when lighting could cause burns on your lighting hand.
2. Point your torch tip away from you but perpendicular to your line of sight. Make sure that it's not directed toward any other materials, and hold the handle perpendicular to the ground.
3. With a small stream of acetylene coming out of the tip of the torch, use a gloved hand and a striker to create sparks at the tip. You may need to squeeze the sparker a few times to get the hang of it.
4. The flame should ignite with a quiet poof and not a loud whoosh. If you get a whoosh, you probably started off with too much acetylene.

NOTE: *The black soot that is created from the acetylene flame is normal and will go away once you add oxygen.*

5. Now you want to adjust the needle valve and watch the flame at the tip of the torch.
6. Add more gas by turning the valve counterclockwise until the flame reaches the torch manufacturer's recommendation. For most torches, this will be just before the base of the flame separates from the tip or when you hear a rustling sound from the flame.
7. Sometimes you'll add too much acetylene, and the flame will be blown out. If this happens, close the needle valve all the way, and start over from step 1.
8. With the acetylene flame adjusted properly, now you want to introduce oxygen. Gently turn the oxygen needle valve counterclockwise until you start to see the flame turning blue. If you open the oxygen too much at first, it could blow the flame out. If this occurs, shut off both the oxygen and acetylene needle valves, and start over at step 1. When oxygen is first introduced, the flame should start to have distinct sections like those illustrated in Figure 9.11.
9. With some oxygen introduced to the acetylene flame, it will start to appear blue. Continue to add oxygen until you can see three distinct flame areas— one longer transparent flame, roughly a foot long; a smaller, brighter blue cone that extends inside the transparent flame; and a small series of cones

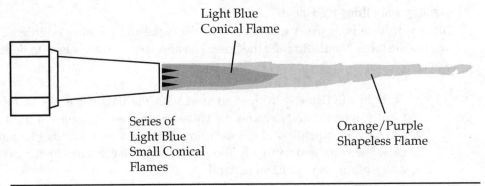

Light Blue
Conical Flame

Series of
Light Blue
Small Conical
Flames

Orange/Purple
Shapeless Flame

FIGURE 9.11 Parts of a torch flame.

around the tip. You want to mix a *neutral* flame for the best results when cutting. (Double-check the manufacturer's recommended setup.)

a. When you can clearly see the longer, less-defined flame and the inner cone, you have a *carburizing* flame, which contains too much acetylene and not enough oxygen. This will result in the transfer of carbon to the steel.

b. As soon as oxygen is increased and the inner cone recedes inside the smaller set of cones at the tip, the flame is *neutral*.

c. If too much oxygen is added, the result is an *oxidizing* flame that can result in the formation of undesirable oxides (Figure 9.12).

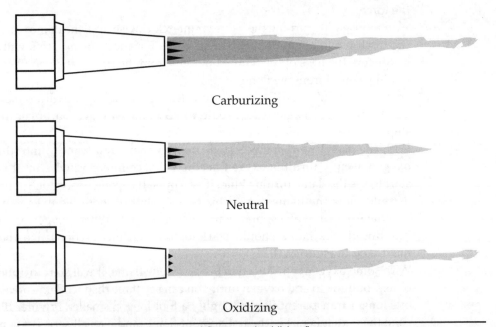

Carburizing

Neutral

Oxidizing

FIGURE 9.12 Carburizing flame, neutral flame, and oxidizing flame.

10. The last adjustment you need to make is to open the oxygen-blast needle valve. Open this valve about two full turns counterclockwise to allow the full flow of oxygen when the lever is pressed. No oxygen will flow until the blast lever is pressed.

11. Once the blast valve is open and a neutral flame is achieved, you should check to see if the flame changes when the oxygen blast is introduced by pressing the handle on the torch. Be sure to push the handle all the way, and the flame should make a loud hissing sound.

12. When the handle is pressed, look at the small cones near the tip of the flame. If part of the middle flame appears around them, increase the oxygen slightly until it goes away.

13. Now you are ready to cut!

Making a Cut

1. Return to the position you practiced in earlier, making sure to keep the hoses out of the way of the flame and where sparks will fall.

2. Move the end of the cutting tip to where you want to start the cut, and hold it ⅛ to ³⁄₁₆ in away from the surface. You can start a cut anywhere on the surface of steel, but starting at an edge is easiest for beginners. Figure 9.13 shows me starting a cut on the edge.

3. Note the flames that redirect around the cutting tip. These spread out a few inches away from the torch, so keep your hands and arms away from this area.

4. You should be able to hold the tip steadily in the same location while the workpiece heats up. If you have trouble doing this, try repositioning your body to find a more secure brace. Moving the torch around too much during this phase will greatly increase the amount of time needed to bring the steel up to temperature.

5. Watch the surface of the steel just below the small series of cones. This will change from a dull gray to a dark red to orange and finally to yellow. When the surface color reaches yellow, some very small pools of molten steel will appear just below each cone. When the steel has reached this point, it is ready to cut.

 a. If the oxygen-blast handle is pushed before the steel has reached a melting temperature, nothing will happen. The oxygen burst will just blow the heat around the surface of the steel, and it will never come up to temperature.

 b. When the first sign of a molten pool is seen on the surface, this is the ideal time to start the cut. This helps to eliminate excess heat buildup around the cut area.

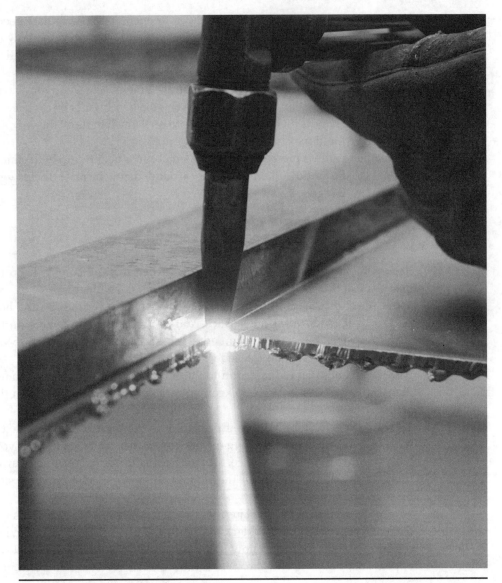

Figure 9.13 Starting at the edge.

 c. If more heat is applied than necessary, the material may start to melt and drip down, even without the addition of oxygen, creating a not so attractive cut.

6. At the first sign of these pools, push the trigger all the way in. It's all or nothing with the oxygen burst. Anything less than the full flow will cause the blast to make an improper cut.

7. When the cut begins, a shower of sparks will appear below the material, as in Figure 9.14 (aren't you glad your feet aren't under there now?).

8. To continue a successful cut, you must keep the trigger pressed all the way, maintain a steady distance from the surface, and travel at the recommended speed (refer to Table 9.1 for suggested travel speeds). As long as you do these three things, you will have a nice clean cut. Of course, this is a lot to

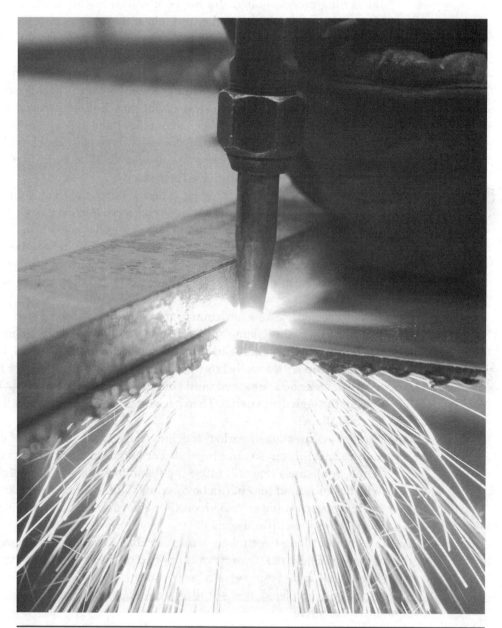

Figure 9.14 Cut underway.

keep in mind for your first few cuts, so listed below are some common problems that newcomers face and how to solve them.

a. *Traveling too fast and/or jerky movement.* A steady speed at the recommended rate is critical for a clean and successful cut. Moving too fast or making jerky movements will break the cycle that keeps the cutting process going, and the pool will be lost. If this happens, release the oxygen-blast handle, and reheat the last area that was cut until a pool forms, and then restart the cut. Consider bracing yourself more securely.

b. *Touching the surface of the material.* When the torch tip makes contact with the surface of the steel, a *backfire* usually occurs. A backfire may blow the flame out and will cause a loud pop. If this happens, close the needle valves on the torch, and relight the torch starting at "Lighting and Mixing the Flame" above. If there was a backfire but the torch didn't go out, you can continue your cut. Make sure that you are braced sufficiently to keep the torch steady.

c. *Drifting away from the surface of the material.* When the torch tip rises more than ¼ in away from the surface of the steel, the flame has a hard time keeping the steel hot enough to keep the cycle going. If the pool is lost in this way, release the oxygen-blast handle and reheat the last area that was cut until a pool forms, and then restart the cut. Make sure that you can clearly see the distance between the torch tip and the steel.

d. *Moving too slowly.* Some newcomers are a little timid when it comes to controlling a 6,000°F flame and end up moving very slowly. Chances are that you may continue to cut even when moving too slowly, but you'll end up with a really large kerf and a deformed workpiece. Try slowly increasing your speed until you reach the limit of how fast you can cut through the material. Then back off that slightly, and you'll be in good shape!

e. *Backfire.* As mentioned earlier, touching the surface of the steel can cause a backfire, but so can a bit of slag or hot metal if it interrupts the flame. Sometimes this will cause the flame to automatically relight, which is okay, and the cut can be continued. If the torch has repeated backfires, you should close both needle valves and have a professional inspect the torch tip and seals.

9. As you continue along the cut line, remember that when you are finished, the cut piece will fall to the floor if not supported by the cutting table. If you want to let it fall, keep your feet and hoses clear.

10. When the cut is completed, release the oxygen-burst trigger and prepare to shut down the torch.

Shutting Down a Torch

After a cut is completed, you need to learn the correct procedure for turning off the torch and shutting down the gases. If you are shutting the torch off while you reposition your work but are not leaving the torch area, you can leave the gases set to the proper pressure. If you plan to leave the work area, even if you will come back to the torch later, shut the gases down properly to avoid accidents.

1. With the oxygen trigger released, the first thing you should do when turning off the torch is to close the oxygen needle valve by turning it clockwise. Be careful not to overtighten the brass knob.
2. At this point, the acetylene flame will still be burning, so the next step is to quickly but gently close the acetylene needle valve.
3. Close the oxygen-blast needle valve last.
4. Now no more gas should be escaping from the torch, and the torch handle is shut down properly but ready to use again shortly.

NOTE: *Opinions differ on whether oxygen or acetylene should be turned off first. Personally, I think it's best to let the lack of fuel pressure extinguish the flame with no chance of it blowing back into an open fuel line. Turning off the fuel gas first will result in a loud pop as the flame is extinguished, which I think should be avoided.*

Shutting Down the Gases

With the flame extinguished and no gases escaping from the torch handle, now you can shut down the gas tanks and bleed the lines. For this, you start with the fuel gas to decrease the chance of a leak. Always be sure to follow these instructions so as to leave the tool in working order for the next person and avoid a buildup of acetylene gas that could cause an explosion.

1. Close the valve on the acetylene gas cylinder all the way. Be careful not to overtighten it.
2. Open the acetylene needle valve on the torch handle, and watch both pressure gauges on the regulator return to zero.
3. Close the acetylene needle valve on the torch handle.
4. Close the acetylene regulator by turning it counterclockwise until it moves freely.
5. Close the valve on the oxygen cylinder.
6. Open the oxygen needle valve on the torch handle and watch both pressure gauges on the regulator return to zero.
7. Close the oxygen needle valve.
8. Close the oxygen regulator by turning it counterclockwise until it moves freely.

9. Close the oxygen-blast knob on the torch, and double-check that all knobs and regulators are closed.
10. Gently coil the hoses around the cart handle or hose rest, and rest the torch handle in the tray.

Cutting Practice

Practice 1: Cutting Sheet Metal

To practice, you'll cut out some pieces from a 10-gauge sheet. Place the sheet on your cutting table or with the end to be cut hanging fully off your normal work area if no cutting table is available. Set your gas pressure and torch tip for cutting 10-gauge steel.

1. First, mark your cut line on the surface of the steel using soapstone. Try cutting out 6-in squares that you can use later for welding practice.
2. Find a position that is comfortable, and practice moving along the cut line.
3. When ready, light the torch and mix your flame.
4. When you achieve a neutral flame, get in position with the tip of your torch $\frac{1}{8}$ in off the material and directly above the edge.
5. Do not use the blast trigger yet, but wait and look for the molten pools to form.
6. When the steel below the torch looks glossy, pull the blast trigger all the way.
7. Continue to hold the trigger as you move along the cut line at a comfortable rate. You'll know that you're going too fast if the cutting process stops or sparks shoot up and now down through the material. Too slow and you'll have excess slag on the bottom.
8. Complete the cut, and shut down the torch.
9. After the cuts are complete, the material may be held together by some slag on the underside, as in Figure 9.15. If the cuts were successful, you can give each piece a solid tap to break it free or twist it off along the cut line.

NOTE: *Practice makes perfect, so repeat this process as many times as you like, cutting different shapes and directions and heavier-gauge steel.*

Practice 2: Cutting Thick Stock

Grab a piece of ¾-in solid round stock for the next practice cut. Set your pressure and cutting tip accordingly.

1. Support your stock so that an inch or so hangs off the end of your table. Put a mark where you intend to make the cut at about an inch.

FIGURE 9.15 Nonseparated material.

2. Find a good position to make the cut where you can clearly see that the torch flame will heat your stock.

3. Light and adjust your flame properly, and bring the torch to about $\frac{1}{8}$ in from the leading edge of your cut, as in Figure 9.16. Gently angle the torch toward your material to reduce heating time.

4. It will take quite a bit longer to bring the surface up to temperature with this material, so be patient. Holding the torch steady and angled toward the surface will help to speed things up.

5. When a pool is formed (it should be easier to see on stock like this than on sheet metal), turn the torch perpendicular to the ground, keeping the flame and cones in contact with the pool, and fully depress the blast trigger.

6. The cut should begin immediately, so keep the torch steady and move along the surface of the stock. As you go, maintain the $\frac{1}{8}$-in distance from the surface even though it is curved.

7. Continue until the cut is complete, and be sure that the falling piece of steel doesn't touch your clothing or the gas hoses.

8. Turn off the torch when the cut is complete.

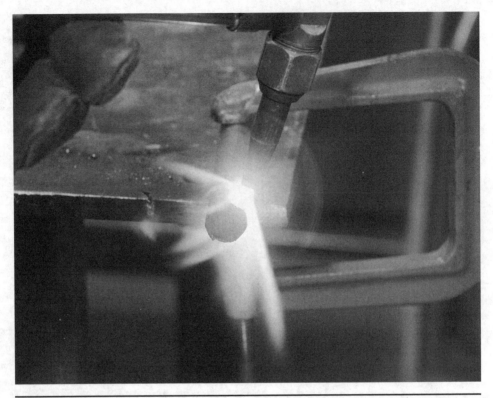

FIGURE 9.16 Angled tip for round stock.

Torch Welding

Oxy-acetylene torch welding uses the mixture of oxygen gas and acetylene gas to make a superheated flame that burns at around 6,000°F, much like the flame we mixed for torch cutting. The process uses a torch handle that differs from the cutting attachment in two main ways: (1) there is no trigger to introduce an oxygen blast, and (2) the end of the tip has only one exit hole. Without the need for an oxygen blast, we use a much different ratio when adjusting gas pressures at the regulators.

A number of different-sized tips are available, and you determine the one to use based on the thickness of the steel to be welded. Table 9.2 shows the tip sizes recommended for metal thicknesses from $\frac{1}{64}$ to $\frac{1}{4}$ in. Two leading brands of torch handles and parts are Victor and Harris. They use different numbering techniques for their tips, so in the second column of the table you can see both side by side. Also in this table you'll notice the pressure recommendations for the corresponding material. The golden ratio here is more like 1:1, with a slightly lower acetylene pressure for thicker materials. Again, since you're not using a burst of oxygen, you

Metal Thickness (in)	Tip Size, Harris/Victor	Oxygen Pressure (lb/in²)	Acetylene Pressure (lb/in²)
<$\frac{1}{64}$	000/0	3–5	3–5
$\frac{1}{32}$	00/1	3–5	3–5
$\frac{3}{64}$	0/2	3–5	3–5
$\frac{1}{16}$	1/3	3–5	3–5
$\frac{3}{32}$	2/4	4–7	3–5
$\frac{1}{8}$	3/5	5–10	3–6
$\frac{3}{16}$	4/6	6–12	4–7
$\frac{1}{4}$	5/7	7–14	5–8

TABLE 9.2 An Example Torch Welding Tip Chart

do not need very high pressure for the oxygen. Refer to your torch manual for specific settings and instructions on how to change torch tips.

Filler

Filler is an essential part of most welding operations, and torch welding is no different. To fill in your weld areas, use filler rods that are fed by hand. The rods come in a variety of diameters commonly between $\frac{1}{16}$ and $\frac{1}{8}$ in. They should be copper-coated to prevent oxidation and may be around 36 in long. When I torch weld, I typically cut these rods in half to make them more usable, but you will generate a few extra inches of wasted rod this way.

When selecting a filler rod, it should not be thicker than the base material to be welded. For most of the material in this book, $\frac{1}{16}$- to $\frac{3}{32}$-in rod will work great. When purchasing torch welding rods, you also can use most tungsten–inert gas (TIG) welding rods for mild steel.

NOTE: *You actually can torch weld without using filler rods. To do so, you need to "weave" the molten pools of steel together between the two base materials. It's a little tricky but a fun trick to practice.*

Flux

Another anomaly: Flux isn't actually required for torch welding when you use a well-balanced neutral flame. With too much or too little oxygen, though, the weld can suffer. I typically use a brush-on all-purpose flux such as Stay-Clean Paste Flux just to play it safe. Brush this flux in between the two pieces to be welded to promote a clean weld pool and filler flow.

Operation

The procedure for setting up a torch for welding is much like it is for cutting, with key differences in recommended gas pressures and needle-valve adjustment.

Setting Up Your Work Area and Gas Cylinders

1. Make sure that your workspace is clean of any flammable materials and that you are wearing all the required personal protective equipment (see earlier list).
2. Parts to be welded should be on your cutting or welding table and free of coatings or contaminants. Use clamps or magnets to hold your pieces together securely and in the proper orientation, as shown in Figure 9.17.
3. Inspect the tanks and gas lines for damage and possible leaks.
4. Make sure that the oxygen and acetylene needle valves on the torch handle are closed, the regulator turns counterclockwise freely, and both gas cylinders are fully closed.
5. If the welding attachment is not already on the torch handle, attach it now securely.
6. Select the proper tip using Table 9.2, and secure it to the end of the welding attachment using the brass nut.
7. With your torch set up properly and all valves closed, you want to find your working position before you go ahead and introduce the gas. Because torch welding takes significantly longer than MIG welding, some welders prefer to sit while working. If you are right-handed, hold the torch in your

FIGURE 9-17 Work in position for welding.

right hand, and use your left hand to hold the filler rod. Brace your right hand or elbow against the table so that you can hold the tip steadily near your weld area, as shown in Figure 9.18.

8. Slowly open the oxygen cylinder valve two to three full turns. If you hear a leak, close the valve and check your equipment. Do not open the valve all the way because it could become jammed.

9. Check the cylinder pressure gauge on the regulator. It should have a reading between 0 and as much as 3,000 lb/in². It's okay to use an oxygen tank until it runs out of gas.

10. Before you introduce oxygen into the hose by turning the regulator clockwise, open the needle valve on the torch slightly, and then ease the regulator valve open. Use the operator's manual to determine the correct

Figure 9.18 My braced working position.

pressure setting for your material. You may need to tap on the regulator dial to get an accurate reading. When the correct pressure is reached, close the needle valve on the torch.

11. You are now ready to open the acetylene cylinder. Turn the handle (or use the apparatus wrench) very slowly and only one-half to one full turn to open the tank. If you use an apparatus wrench, leave it on the tank for easy shutoff.

NOTE: *Open the fuel gas last to lessen the risk of explosion or fire.*

12. Check the tank pressure gauge. It should have a reading between 0 and 250 lb/in^2. If your acetylene reading is 50 lb/in^2 or less, replace the tank with a new one, or inform your shop supervisor.

13. Just as with oxygen, before you adjust the acetylene regulator to introduce gas into the hose, you need to slightly open the needle valve on the torch. Introduce acetylene by turning the valve slowly clockwise. Use the operator's manual to determine the correct pressure setting for your material. You may need to tap on the regulator dial to get an accurate reading. When the correct pressure is reached, close the needle valve on the torch.

Lighting and Mixing the Flame

Now you have your gases set properly at the tanks and pressure leading all the way to the torch handle through the hose. Before lighting the flame, make sure that your filler rods are within reach. The next steps show how to light the flame.

1. To light the flame, you need to start with the flammable gas, acetylene. Gently open the acetylene needle valve about one-eighth turn or until you hear a very quiet hiss of gas escaping. If the gas ever sounds like a roar, close the valve and try again. Too much acetylene gas when lighting could result in burns on your lighting hand.

2. Point the torch tip away from you but perpendicular to your line of sight. Make sure that it's not directed toward any other materials, and hold the handle perpendicular to the ground.

3. With a small stream of acetylene coming out of the tip of the torch, use a gloved hand and a striker to create sparks at the tip. You may need to squeeze the sparker a few times to get the hang of it.

4. The flame should ignite with a quiet poof and not a loud whoosh. If you get a whoosh, you probably started off with too much acetylene.

NOTE: *The black soot that is created from the acetylene flame is normal and will go away once you add oxygen.*

5. Now you must adjust the needle valve and watch the flame at the tip of the torch.

6. Add more gas by turning the valve counterclockwise until the flame reaches the torch manufacturer's recommendation. For most torches, this will be just before the base of the flame becomes separated from the tip or when you hear a rustling sound from the flame. Figure 9.19 shows what this should look like.

7. Sometimes you'll add too much acetylene, and the flame will be blown out. If this happens, close the needle valve all the way, and start over from step 1.

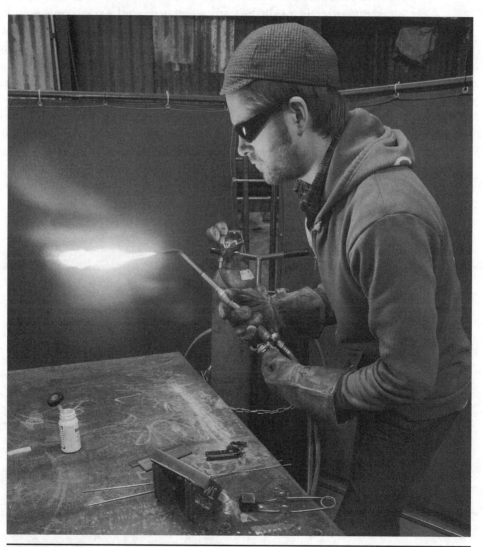

FIGURE 9.19 Holding the torch with an acetylene flame.

8. With the acetylene flame adjusted properly, now you want to introduce the oxygen. Gently turn the oxygen needle valve counterclockwise until you start to see the flame turning blue. The flame will appear similar to the cutting flame but without the series of small cones; rather, there will be one small cone in the middle of the welding tip. If you open the oxygen too much at first, it could blow the flame out. If this occurs, shut off both the oxygen and acetylene needle valves, and start over at step 1.

9. With some oxygen introduced to the acetylene flame, it will now appear blue. Continue to add oxygen until you can see three distinct flame areas—one longer transparent flame, roughly a foot long; a smaller, brighter blue cone that extends inside the transparent area; and a small cone around the tip. You want to mix a *neutral* flame (see below) for the best results when welding. (Double-check the manufacturer's recommended setup.) Figure 9.20 shows carburizing, neutral, and oxidizing flames for a welding tip.

 a. When you can clearly see the longer, less defined flame and the inner cone, you have a *carburizing* flame, which contains too much acetylene and not enough oxygen. This will result in the transfer of carbon to the steel.

 b. As soon as the oxygen is increased and the middle cone recedes inside the smallest cone at the tip, the flame is *neutral*.

 c. If too much oxygen is added, the result is an *oxidizing* flame, which can result in the formation of undesirable oxides.

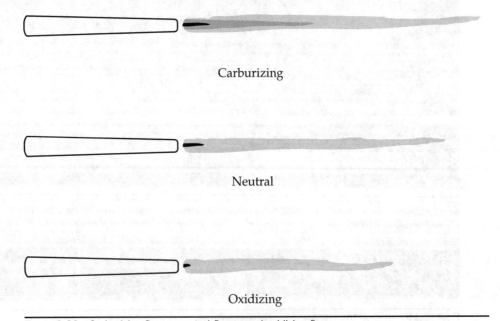

Carburizing

Neutral

Oxidizing

FIGURE 9.20 Carburizing flame, neutral flame, and oxidizing flame.

10. With a proper flame mixed, you are now ready to efficiently heat your material and create a weld!

Making a Weld

1. Return to the position you practiced earlier, making sure to keep the hoses out of the way of the flame and hot material.
2. Move the welding flame to where you want to weld, about ¼ to ⅜ in away from the surface, as shown in Figure 9.21.
3. You should be able to hold the tip steadily in the same location while making a gentle circular motion as the work area heats up. If you have trouble doing this, try repositioning your body to find a more secure brace. Moving the torch around too much during this phase will greatly increase the amount of time needed to bring the steel up to temperature.
4. The steel will change from dull gray to a dark red to orange and finally to yellow. When the surface reaches yellow, there should soon appear a small shiny pool of molten steel. Keep circling the torch around this pool, and get ready to add filler.
5. To create the weld, move the torch in a small circular motion to mix the molten steel and/or add the filler rod slowly. When the filler rod is brought

FIGURE 9.21 Starting to weld.

in front of the flame, it should melt quickly and be added to the weld pool. For your first torch welds, plenty of extra "swirling" will be needed to join the material.

6. To continue a successful weld, you must maintain a small molten pool on each surface. If you move too fast, the steel will not be hot enough to melt fully, and if you move too slowly, the steel will melt and drip away, leaving you with significantly less material.

7. As you continue along the weld seam, remember that the area around the weld will be very hot to the touch some distance away from the torch.

8. When the weld is complete, pull the torch away from the weld area, and rest the filler rod on the table. Prepare to close the needle valves to extinguish the flame. Your welded piece should look something like the one in Figure 9.22.

Shutting Down the Torch

The steps for shutting down the torch when welding are nearly identical to those when you use the torch for cutting. If you are shutting the torch off while you reposition your work but are not leaving the work area, you can leave the gases set to the proper pressure. If you plan to leave the work area, even if you plan to come back to the torch later, shut the gases down properly to avoid accidents.

FIGURE 9.22 Torch-welded steel.

1. The first thing you should do when turning off the torch is to close the oxygen needle valve by turning it clockwise. Be careful not to overtighten the brass knob.
2. At this point, the acetylene flame will still be burning, so the next step is to quickly but gently close the acetylene needle valve.
3. Now no more gas should be escaping from the torch, and the torch handle is shut down properly but ready to use again shortly.

Shutting Down the Gases

With the flame extinguished and no gases escaping from the torch handle, you can now shut down the gas tanks and bleed the lines. For this, you start with the fuel gas to decrease the chance of a leak. Always be sure to follow these instructions so as to leave the tool in working order for the next person and avoid a buildup of acetylene gas that could cause an explosion.

1. Close the valve on the acetylene gas cylinder all the way. Be careful not to overtighten it.
2. Open the acetylene needle valve on the torch handle, and watch as both pressure gauges on the regulator return to zero.
3. Close the acetylene needle valve on the torch handle.
4. Close the acetylene regulator by turning it counterclockwise until it moves freely.
5. Close the valve on the oxygen cylinder.
6. Open the oxygen needle valve on the torch handle, and watch as both pressure gauges on the regulator return to zero.
7. Close the oxygen needle valve.
8. Close the oxygen regulator by turning it counterclockwise until it moves freely.
9. Gently coil the hoses around the cart handle or hose rest, and rest the torch handle in the tray.

Welding Practice

To practice welding, set up some of the sheet metal squares you cut out in the earlier torch-cutting session. Clean off any slag built up along the seam using a slag hammer. Use layout magnets if needed to hold the pieces together. Practice making welds along the seams using the correct torch pressure and tip size.

1. Find a well-braced position, and practice moving the torch tip along the weld seam.
2. Light the torch and adjust the gas to achieve a neutral flame.
3. Bring the flame into the corner created by your two pieces of sheet metal, and start moving it slowly back and forth over the corner, about ¼ in in total width.

4. When a molten pool forms, dip the filler rod with your other hand about $\frac{1}{16}$ in away from the surface but between the pool and the flame. Within a second or two, the filler rod should start to melt and combine with the molten base material.

5. Continue your way down the weld seam, repeating this technique.

Torch Bending

The last attachment for the oxygen acetylene torch I will cover is a heating tip called a *rosebud*. It's named after the rosebud-shaped flame it puts out, and it is used for rapidly heating large areas of steel. The rosebud tip attaches to the torch handle just like a welding tip, but the head is much larger, as can be seen in Figure 9.23. With the increased head comes a need for much more fuel and higher heat output. In this book, you'll use the rosebud to heat and bend steel, but it also can be used to heat up large areas for finishing techniques.

NOTE: *Some rosebud tips require more acetylene gas than small-volume hobbyist tanks can produce. If you're limited by the size of your acetylene tank, keep in mind that you can use the cutting tip as a small version of the rosebud if you don't use the blast trigger.*

When heating steel to bend, you don't want to bring the surface up to its melting temperature. Rather, you want to heat the material all the way through as much as

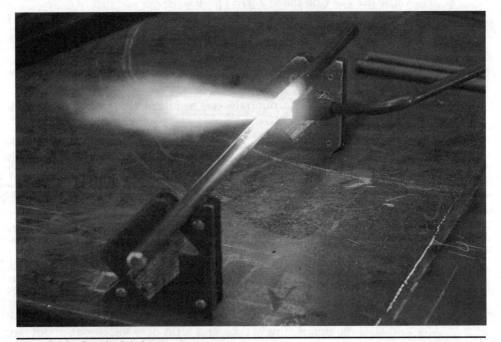

FIGURE 9.23 Rosebud tip in use.

possible. In this way, when you begin to bend, the steel bends evenly and consistently. The size of the rosebud tip helps to distribute that heat evenly with its large area. It is possible to burn the surface using a rosebud tip if you keep it in one place too long on the surface.

For most rosebud tips, a pressure of 10 lb/in^2 of both oxygen and acetylene is recommended. Refer to the manual that came with your torch for the exact setting.

Your working position for the rosebud is not as critical as it is for cutting or welding. The rosebud still can heat efficiently within about an inch of the surface, which makes it more forgiving. Since the goal is to heat up an area, any movement away from the marked area just means that the heat will extend a little farther away.

After heating and bending, it's a good idea to remove the mill scale that flakes off the surface of your steel (Figure 9.24). This will give the steel a more attractive finish and keep the debris from getting in your eyes.

Heating up steel to bend it is a great way to be able to bend thicker stock by hand. Keep in mind that multiple bends in the same location will drastically weaken the steel structure, so try to keep your bends to one heat, one bend.

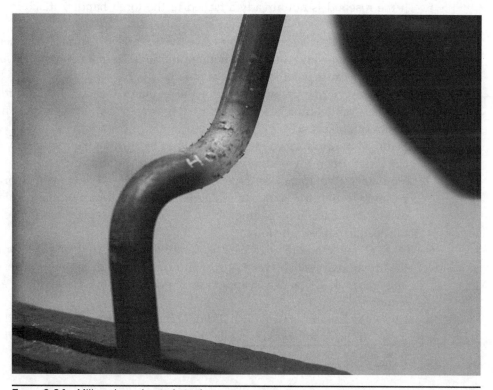

Figure 9.24 Mill scale on heated steel.

TIP: The rosebud tip creates a much louder flame, and the pops that may occur are much louder than those heard during cutting or welding. For this reason, it's a good idea to wear hearing protection when starting off with the rosebud.

Operation

The procedure for setting up a rosebud torch tip is similar to that for setting up a welding tip. A lot of it may sound like repetition, but there are a few differences to keep in mind.

Setting Up the Work Area and Gas Cylinders

1. Make sure that your workspace is clean of any flammable materials and that you are wearing all the required personal protective equipment (see earlier list).
2. Parts to be bent should be clamped securely in a vice or supported on your worktable close to where the bending will take place.
3. Inspect the tanks and gas lines for damage and possible leaks.
4. Make sure that the oxygen and acetylene needle valves on the torch handle are closed, the regulator turns counterclockwise freely, and both gas cylinders are fully closed.
5. If the rosebud is not already attached to the torch handle, attach it now securely.
6. Slowly open the oxygen cylinder valve two to three full turns. If you hear a leak, close the valve and check your equipment. Do not open the valve all the way because it could become jammed.
7. Check the cylinder pressure gauge on the regulator. It should have a reading between 0 and as much as 3,000 lb/in^2. It is okay to use an oxygen tank until it runs out of gas.
8. Before you introduce oxygen into the hose by turning the regulator valve clockwise, open the needle valve on the torch slightly, and then ease the regulator valve open. Use the operator's manual to determine the correct pressure setting for your material. You may need to tap on the regulator dial to get an accurate reading. When the correct pressure is reached, close the needle valve on the torch.
9. You are now ready to open the acetylene cylinder. Turn the handle (or use the apparatus wrench) very slowly and only one-half to one full turn to open the tank. If you use an apparatus wrench, leave it on the tank for easy shutoff.
10. Check the tank pressure gauge. It should have a reading between 0 and 250 lb/in^2. If the acetylene reading is 50 lb/in^2 or less, replace the tank with a new one or inform your shop supervisor.

11. Just as with the oxygen, before you adjust the acetylene regulator to introduce gas into the hose, you need to slightly open the needle valve on the torch. Introduce acetylene by turning the valve slowly clockwise. Use the operator's manual to determine the correct pressure setting for your material. You may need to tap on the regulator dial to get an accurate reading. When the correct pressure is reached, close the needle valve on the torch.

Lighting and Mixing the Flame

To light the flame, you need to start with the flammable gas, acetylene. Gently open the acetylene needle valve about one-eighth turn or until you hear a very quiet hiss of gas escaping. If the gas ever sounds like a roar, close the valve and try again. Too much acetylene gas during lighting could result in burns on your lighting hand.

1. Point the rosebud tip away from you, and squeeze the striker to create sparks at the tip. The flame should ignite with a whoosh.
2. Open the acetylene needle valve nearly all the way. The flame will be loud!
3. Turn the oxygen needle valve counterclockwise until you see the flame begin to turn blue.
4. Continue to add oxygen until you can see three distinct flame areas—one longer transparent flame, roughly a foot long; a medium-sized, brighter blue cone that extends inside the transparent flame; and a small series of cones around the tip. You want to mix a *neutral* flame for the best results when heating, just as you did with the cutting and welding tips. (Double-check the manufacturer's recommended setup.)
5. With a proper flame mixed, you are ready to efficiently heat your material.

Heating

1. Move the rosebud tip to where you want to heat, and keep the tip about ¼ to 1 in away from the surface, making a gentle circular motion. For solid stock or tube, move up and down along the length of the material you want to heat slowly. I find that the rosebud works best when heating 8 in or less of material. For anything larger, a forge is the way to go.
2. Move the flame around the material, including the back if you are heating material over ¼ in thick.
3. Gradually, you will see the material go from gray, to red, to orange, and then to yellow. If you heat it too long, it may turn white and start burning.
4. When the material is yellow, it is ready to bend.
5. Quickly shut off the oxygen and then the fuel gas, and rest the torch on the table.
6. Grab your work wearing insulated gloves, and perform the bend.

CAUTION: Your workpiece will be heated up a good distance away from the working area (up to 10 in or so). Use extreme caution when handling recently heated material.

7. When your bend is complete, wire brush the mill scale off, and leave the workpiece on the floor out of reach of the hoses or your shoes.

Shutting Down the Torch and Gases
For instructions on shutting off your torch and gases, refer to the earlier welding section.

Bending Practice
For practice, you are going to bend a length of ½-in round stock in a vice. For comparison, I will also bend it using no heat so that you can see the advantage offered by the rosebud.

1. Start with a 20-in-long section of ½-in round stock.
2. Clamp it vertically in the vice (or, if necessary, horizontally over a sturdy worktable).
3. Make a mark where you want the bend to happen. Put this mark above the jaws of the vice because they will act as a heat sink and absorb some of the heat. Figure 9.25 shows the clamped work with the bend area marked.
4. Light and adjust your torch following the earlier instructions.
5. Bring the torch close to the surface of the material, and move it up and down over the marked area. Rotate the torch slightly around the material so as to be sure to heat it up all the way through.
6. When the material is a solid orange or yellow, shut off the torch quickly and prepare to bend.
7. If you have over 10 in left above the bend area, you may use your glove to make the bend, and if not, use a piece of hollow pipe that fits over the stock. Figure 9.26 shows me easily bending stock using gloves.
8. Bend the material perpendicular to the jaws of the vice until you achieve the desired angle. If necessary, gently nudge it back slightly to fine-tune the bend.
9. Place the workpiece under your work area, and shut down the torch and gases properly.
10. Figure 9.27 shows the hot bend you just made next to a cold-bent corner where I used a long length of pipe to bend the material by hand. Notice the greater diameter of the cold-bent corner.

FIGURE 9.25 Workpiece clamped and marked with soapstone.

FIGURE 9.26 Bend in progress.

FIGURE 9.27 Hot- and cold-bent corners.

Plasma Cutter

Plasma cutting is a process that uses high heat created by an electric arc (plasma) and an air blast to cut through metal, leaving a very clean and easy-to-finish cut (Figure 10.1). As the electric arc travels through air, plasma is created, giving the tool its name. Where the oxygen-acetylene (oxy-acetylene) torch cutting method in Chapter 9 oxidized the material in order to cut it, the plasma cutter's electric arc lets you cut many types of conductive metal, even nonferrous ones. Another key difference between the plasma cutter and the oxy-acetylene torch is that for most metals, compressed air can be used as the cutting force rather than compressed specialty gases. This means that you can set up a plasma cutter to run off an air compressor, a common tool in shops.

Plasma cutting does not require any preheating like oxy-acetylene cutting. Just like electric welding, the electric arc is capable of melting steel within milliseconds of when the trigger is pulled. This makes plasma cutting ideal for cutting thin materials such as sheet metal, in which excess heat causes warping. The heat-affected zone from plasma cutting is very small. Take a look at the left corner of the workpiece in Figure 10.2. The darker color that extends from the edge about $\frac{1}{32}$ in is the heat-affected zone. In the same figure, the right side was cut using a torch, and the heat-affected zone extends $\frac{1}{4}$ in or more into the material.

Completing the cutting process is the air blast. Pressurized air travels from the air compressor into the body of the plasma cutter, where the pressure is controlled by a built-in regulator. When you pull the trigger of the plasma gun (or torch), an electric arc is created between the work material and the plasma gun tip, and at the same time, the blast of air forces the plasma through the work material. As long as the tip is close enough to the work and the trigger is pulled, the cutting process will continue.

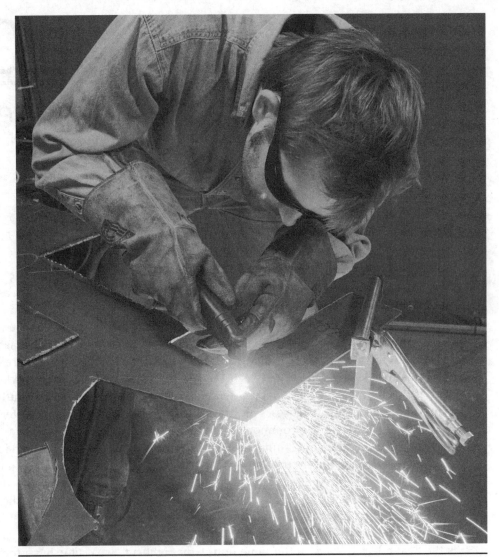

FIGURE 10.1 Plasma cutting in progress.

NOTE: When you pull the trigger on the gun at a distance where the electric arc is not completed, you still should see a plasma flame exit the tip of the torch. This is so because many plasma cutters are equipped with a high-frequency start that initiates the plasma flame within the gun. This is designed to help start the cutting process and illuminate the work area. If your machine does not show a plasma flame when you pull the trigger, it may be of the contact-start variety. Refer to the owner's manual for more information.

There are a few downsides to owning a plasma cutter over an oxy-acetylene torch if you must decide which one to purchase. One of the downsides is the

FIGURE 10.2 Heat-affected zones, plasma left and oxy-acetylene right.

capacity to cut thicker materials. Whereas an oxy-acetylene torch can cut up to 6-in solid steel, most hobbyist or light industrial plasma cutters are not rated for over ½-in material. However, in my own work, I rarely need to cut plate that is over ¼ in thick, so a plasma cutter works fine. Another downside is cost. A light plasma cutter will run you over $800 new (plus the cost of a compressor), whereas a robust torch setup can be had for less than $600. Finally, the plasma cutter does only one thing—cut. In Chapter 9 you learned about the wide range of tasks a basic oxy-acetylene torch can accomplish. The two tools complement each other quite well, though, if you can afford both.

NOTE: *Plasma cutters need a supply of dry air. Your air compressor should be outfitted with at least one air dryer that you check and empty regularly.*

Parts

Plasma Cutter

Figure 10.3 shows the parts of a plasma cutter.

Plasma Torch

Figure 10.4 shows the parts of a plasma torch.

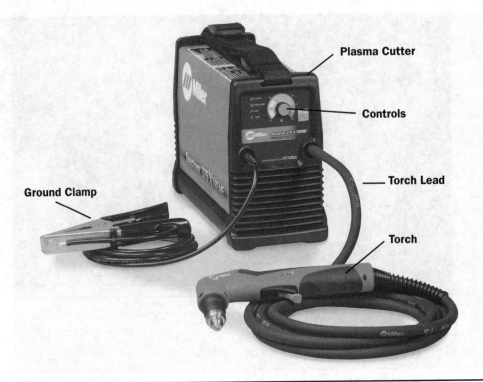

Figure 10.3 Plasma cutter. (*Photo courtesy of Miller Electric Mfg. Co.*)

Accessories

A few accessories can make your cuts more accurate and come standard with some plasma cutters. I am not going to review how to use these accessories, so if you have them, be sure to read the owner's manual that came with them. These accessories include the following.

Drag Tip

This tip must be paired with an extended electrode and allows the user to drag the tip of the plasma cutting torch along the surface of the material to be cut. The drag tip helps you to keep the proper standoff distance to make a precise cut. I prefer not to use this type of tip because it blocks my visibility around the cut line. A drag tip is shown in Figure 10.4.

Roller Guide

Roller guides have wheels that attach near the end of the torch gun, helping to maintain proper standoff and making it easy to travel in a straight line. Roller guides provide better visibility than a drag tip. A roller guide from Miller is shown in Figure 10.5.

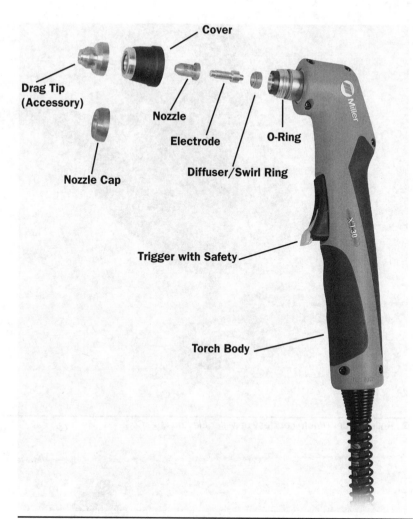

Cover

Drag Tip (Accessory)

Nozzle

Electrode

O-Ring

Diffuser/Swirl Ring

Nozzle Cap

Trigger with Safety

Torch Body

FIGURE **10.4** Plasma torch detail. (*Photo courtesy of Miller Electric Mfg. Co.*)

Circle-Cutting Guide

The circle-cutting guide is similar to the roller guide (it may share some parts) and features an adjustable arm that turns the plasma cutting torch into a compass. This is very useful when a near-perfect circle is desired, but it isn't needed for the projects in this book. Figure 10.6 shows a circle-cutting attachment from Miller.

Safety

- This device produces *extreme* heat of over 10,000°F. Do not handle recently cut material without gloves, and keep all skin covered at all times.
- This device produces ultraviolet (UV) light. Always wear goggles or a face mask of the proper shade (nos. 4 to 9).

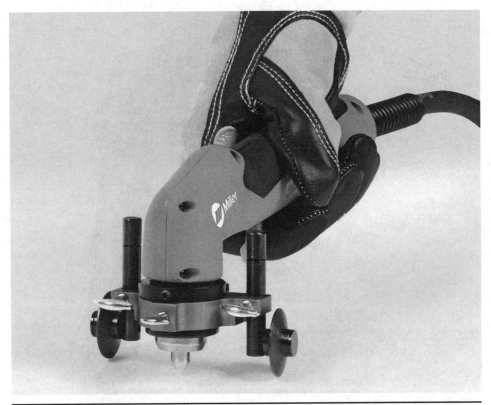

FIGURE 10.5 Roller guide. (*Photo courtesy of Miller Electric Mfg. Co.*)

FIGURE 10.6 Circle-cutting guide. (*Photo courtesy of Miller Electric Mfg. Co.*)

- Plasma cutting produces a shower of sparks below (and sometimes above) the work material. Keep the floor below your cutting table free of flammable material.
- Plasma cutters require electricity between 110 and 660 V. Always use caution when plugging in and unplugging a plasma cutter. Never cut in wet conditions or near standing water.
- Always inspect the equipment before use, including the lead, electrical cord, and air hose. Replace damaged equipment if needed.
- Do not let recently cut material fall onto the gun lead because it will cause damage.
- Usually the end of the air hose that connects to the air compressor will allow air to escape freely when unplugged. Use caution when unplugging this end by turning your head away from the hose and firmly holding the hose end.

Personal Protective Equipment
- Always wear shaded safety glasses, goggles, or a facemask (shade nos. 4 to 9).
- When cutting for extended periods, wear an N95 or N99 dust mask.
- Wear insulated welding gloves at all times.
- Wear heavy, nonflammable boots, uncuffed pants, and long sleeves.
- Wear clothing made of natural fibers (cotton or wool) or leather, never synthetics.
- A welding cap, bandana, or nonsynthetic hat will keep stray sparks from getting in your hair.
- Surround your work area with welding screens to minimize spark travel.

CAUTION: *Plasma cutters are equipped with a safety mechanism for good reason: With a high-frequency start unit, the plasma flame at the end of the torch is very hot and dangerous. Never pull the trigger with the torch aimed at body parts or clothing.*

Operation

Amperage

Most plasma cutters require a constant amount of air pressure, which leaves the amperage as the one adjustment to make before you start cutting. The amperage required for a clean cut has a lot to do with the travel rate of the user, so, in theory, you could cut 22-gauge sheet metal and ¼-in plate all with the plasma cutter set to its lower amperage. However, you'd be traveling really slow through the ¼-in plate, and by turning up the amperage, you can travel faster. The only way to know how to set your amperage is to make a few test cuts and inspect them. You'll make

test cuts later in this chapter, but in general, a lower amperage setting will allow you to cut slower (good for thin sheet metal) and a higher amperage setting creates a lot more heat (good for thicker steel).

Travel Rate

Figure 10.7 shows how cut speed relates to material thickness. To read the chart, find your material thickness on the bottom, move up until it intersects the mild-steel line, and on the left side at that intersection is the ideal cut rate given in inches per minute. Steadiness is an important factor in creating a clean cut. As you make a few cuts later in this chapter, you'll see how every bit of user input shows in the profile of the cut material.

Angle of Torch

A plasma cutting torch can be held and used at any angle, but for a straight cut, it should be held perpendicular to the surface. You do not need to angle the torch at the beginning of a cut or during the length of the cut, but at the end of the material if you slightly angle the torch toward the edge, you will help to completely cut through the material.

For making an angled cut, simply hold the torch at the desired angle. For example, to cut a chamfer, hold the torch at 45 degrees to the corner, and move the plasma flame along the top $\frac{1}{8}$ in of your material to remove the corner. You can even vary the angle of your cut on the fly to make organic shapes and more.

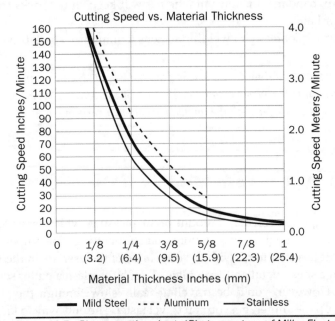

FIGURE 10.7 Plasma cutting chart. (*Photo courtesy of Miller Electric Mfg. Co.*)

Standoff

The height from the plasma tip to the workpiece is known as *standoff*. This distance should be kept at $\frac{1}{16}$ to $\frac{1}{8}$ in at all times. If the nozzle touches the material, it will prematurely wear the tip out. Finding a steady position for your body during the length of the cut is critical.

Preparing to Cut

Work Area

1. Make sure that your workspace is clean of any flammable materials and that you are wearing all the required personal protective equipment (see earlier list).
2. If possible, use a perforated table designed for torch or plasma cutting. If no table is available, make sure that your cut line overhangs your worktable and is supported.
3. Parts to be cut should be on your cutting table and free of coatings or contaminants.

Compressed Air Check that your air compressor is on and is supplying the recommended pressure for your unit.

Body Position The best position for plasma cutting will be a position similar to the one you used for oxy-acetylene cutting. You should be braced against your table or work with your face near enough to the cut area to have good visibility. Make sure that your legs and boots are not directly below the path of the cut where sparks will fall.

Plasma Cutter

1. Inspect your electrode, nozzle, and nozzle cap. Replace any worn parts before continuing. Figure 10.8 shows what a worn nozzle and electrode look like. The nozzle and electrode on the upper left should be replaced.
2. Turn the plasma cutter on.
3. Check that the air pressure is consistent by releasing the trigger safety and pulling the trigger. Be sure to aim the gun away from your work, body, clothing, and other tools. If necessary, adjust the pressure at either the compressor or using the regulator on your machine or both.
4. Place the ground clamp as near as possible to your cut area.
5. If you already know what amperage to use, go ahead and set it now. If not, take the following steps to find out.

FIGURE 10.8 New and worn nozzle and electrodes.

Finding the Correct Amperage for Plasma Cutting For this, you're going to use a piece of 10-gauge mild steel.

1. Follow the preceding steps to prepare your machine and work area.
2. Turn the amperage of your welder all the way up, and make a perpendicular cut through the material at roughly the proper cut speed for your machine. Using Figure 10.7, my cut speed would be about 140 in/min, or a little over 2 in/s (your machine may be different depending on the output amperage).
3. When your cut is complete, inspect the side of the cut and bottom of the material, but watch out, it's going to be hot, so be sure to wear gloves.
4. Look for a clean, straight cut edge with very little slag on the backside, like the lower cut in Figure 10.9. For thicker material, a subtle J shape in the side of your cut should appear that points in the direction opposite that of your travel.
5. The second indicator of proper travel speed is slag. Figure 10.10 shows a medium to high amount of slag buildup on the back of a plasma cut. If too much slag forms, either increase your travel speed or turn up the amperage to find a comfortable setting.

Figure 10.9 Edge of a cut.

Figure 10.10 Slag.

Making a Cut

Before proceeding, double-check that the grounding clamp is placed near the cut area, the machine on and set to the right amperage, and the regulator on the machine is set to the right pressure as laid out in the preceding instructions.

1. Find your preferred position, and hold the plasma torch near the starting corner of your cut, as shown in Figure 10.11.

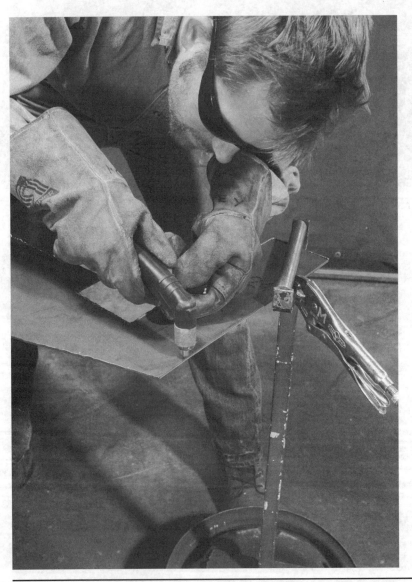

FIGURE 10.11 Starting a cut.

2. Make sure that your standoff is about $\frac{1}{16}$ to $\frac{1}{8}$ in before you pull the trigger. When ready, release the safety mechanism on the trigger, and pull and hold the trigger.
3. Move steadily along the cut line at the proper speed while maintaining good standoff.
4. As you near the very last $\frac{1}{8}$ in of your cut (the edge of the material), gently rotate the torch tip toward the end at about 10 degrees. That will help to undercut the last bit of material, making a complete cut.
5. Watch out for the falling material as the cut is completed.
6. Release the trigger, and rest the plasma torch on the table or back on the machine.

NOTE: *The blast of air that continues after the trigger is released is normal. It helps to cool the tip and will turn off within 30 seconds. During this cooling cycle, the plasma cutting can be resumed if needed.*

TIP: *If at any time along the cut sparks are directed up from the material rather than through it, this means that the plasma cut did not go all the way through. If this happens, you can immediately go back over the area or return to it after the cut is complete.*

Shutting Down the Plasma Cutter

After all your cuts are made, you will need to prepare the plasma cutter for its next use.

1. Gently coil the gun lead and grounding wire around the machine.
2. Turn the machine off. Most machines will go through a quick cooling cycle at this point.
3. Turn off the air compressor and/or disconnect the hose.

Practice

Following the steps in the preceding section will prepare you for making a straight cut. Two other useful tricks covered here in the practice area are plunge cutting and using a straight guide.

Practice 1: Plunge or Pierce Cutting

To create a hole in steel or start a cut line that's not on an edge, you need to know how to plunge cut.

1. Follow the preceding instructions to set up your cut area and plasma cutter.
2. When you are ready to cut, hold the torch at 45 degrees from the surface at the proper standoff, as shown in Figure 10.12.

Figure 10.12 Preparing for a plunge cut.

Caution: Do not angle the torch toward yourself or anyone else for a plunge cut because the first second or two of this cut produces a shower of sparks above the material and in the direction of the angled torch.

3. Release the safety, and pull the trigger when you are ready.
4. Sparks should be created above the material, and once the sparks go below, you can angle the torch back to perpendicular.
5. If you just want to make a small hole, now you may release the trigger. However, from this point on, you also may move in any direction on the surface of the steel.
6. Figure 10.13 shows some facial features for a small jellyfish I made using plunge cuts.
7. When you are finished, shut down the torch using the method described earlier.

Practice 2: Cutting a Really Straight Line

No fancy guides are needed to cut an extremely straight line using a plasma cutter, just a spare piece of straight steel and some clamps. For this practice, choose a length of steel against which you can rest the nozzle or nozzle cap of your torch, as in Figure 10.14. This is your guide. This piece needs to be thicker than ¼ in but not

FIGURE 10.13 Plasma-cut jellyfish face.

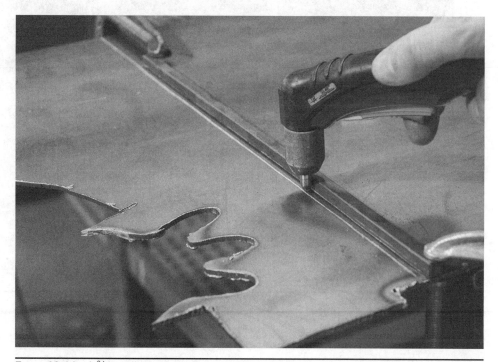

FIGURE 10.14 A ⅜-in solid-stock guide.

more than about an inch (enough to maintain proper standoff but not interfere with the cup).

1. Draw a straight line across the sheet metal using your guide.
2. Position the guide at a distance from your line equal to half the width of your nozzle cap or nozzle so that the center of the nozzle is directly on top of the cut line.
3. Clamp your guide to the workpiece in a way that does not interfere with the path of the plasma gun. You also can hold the guide stationary with magnets, but it could shift on you unexpectedly during the cut.
4. Cut your material, resting the plasma gun gently on your guide as you move along the cut line. Too much pressure on the guide and you'll have a hard time keeping steady.
5. Figure 10.15 shows my progress along the cut line.
6. Make sure to give your cutoff work a place to fall so that it doesn't land on your toes or the plasma lead.
7. Shut down the plasma cutter, and store any hot material safely.

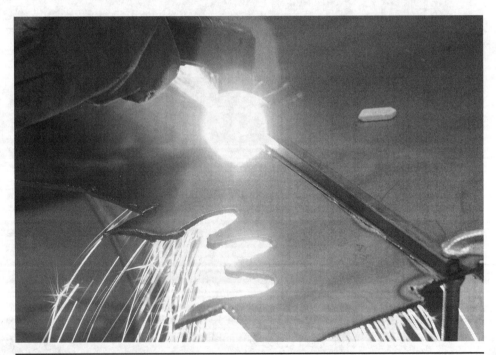

FIGURE 10.15 Moving along the guide.

Metal–Inert Gas (MIG) Welder

N ow onto the bread and butter of this book. My guess is that 99 percent of readers will skip ahead directly to this chapter to start making welds. That's fine, but I think the information leading up to this chapter is pivotal in understanding what it takes to form a sound weld. Most important, though, getting a project to the point where it's ready to weld takes quite a bit of preparation. From cutting material down, cleaning the surface, and chamfering corners, as you learned earlier in the book, there are quite a few tools you need to be comfortable with. As you'll see in the projects in Part 2 of this book, welding makes up a small percentage of the work performed to complete a welding project. With that said, let's get welding!

Parts

Figure 11.1 shows the parts of a MIG welder.

Power Source and Transformer

Inside a MIG welder is a transformer that converts household or shop electrical alternating-current (ac) voltage into direct current (dc) and bumps the amperage way up. The electric arc that jumps between the workpiece and the positive electrode is hot enough to melt steel in milliseconds.

CAUTION: Be careful of any electrical connections while the welder is turned on.

On/Off Switch

A switch on the front of the MIG welder will start the electrical transformer and ready the machine for welding. Usually there is a short cycle after the machine is switched on or off, and it is ready to be used.

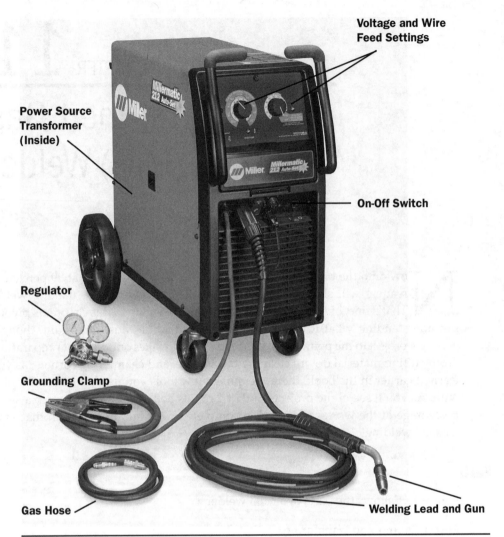

Voltage and Wire Feed Settings

Power Source Transformer (Inside)

On-Off Switch

Regulator

Grounding Clamp

Gas Hose

Welding Lead and Gun

FIGURE 11.1 MIG welder. (*Photo courtesy of Miller Electric Mfg. Co.*)

Voltage and Wire-Feed Settings

Two knobs on the front of the MIG welder allow for control of welding voltage (heat) and wire-feed speed. You will need to adjust these two controls to match the thickness of the steel you want to weld. You can find suggested settings for these on the weld chart that accompanies your machine.

Negative, or Grounding, Clamp

Connected to the negative terminal of the transformer is a thick-gauge wire with a steel clamp attached to the end. This clamp is responsible for negatively charging

your work when you are welding so that a complete circuit if formed. Remember, to complete the circuit, the clamp does not need to be clamped directly to your work but can be clamped to a conductive work surface nearby. If the clamp is attached to an area of steel with paint or corrosion, the electric charge will be greatly inhibited, resulting in a poor weld.

Welding Lead and Gun

Exiting through the front of the MIG welder is the welding lead, which runs into the MIG gun. Inside this lead is a coiled sleeve through which the positively charged filler material runs, a tube carrying shielding gas, and wiring for the trigger. The welding lead is very fragile and should be kept coiled gently when not in use and never allowed to kink. When working, do not let pieces of steel or tools fall onto the welding lead because they could cause damage.

Shielding Gas and Regulator

The tank of shielding gas should be securely attached to the body of the welder and be fitted with a pressure regulator. Just as with oxygen and acetylene tanks, the regulator controls the high-pressure gas from the tank and lets you work with a consistent supply.

Weld Chart

Some MIG welders have a weld chart located on the front of the welder that gives suggested settings for different material thicknesses and setups. If there is no weld chart on the front, check the side panel or the manual that accompanied the machine.

MIG Gun

Figure 11.2 shows the parts of a MIG gun.

Gun

The gun is connected to the MIG welder by the welding lead and consists of a number of parts you'll learn about shortly. Once the adjustments are made on the body of the MIG welder, the only control you have over the machine is using the on/off trigger located on the gun.

Trigger

The trigger is usually located near where the gun and welding lead meet. Since your hand is on the trigger at all times while welding, it is kept a distance away from the end of the gun, where heat builds up. Your trigger should be a simple on/off switch, and most don't have any sort of safety mechanism. With the welder off, pulling the trigger does nothing. With the welder on, pulling the trigger tells the computer

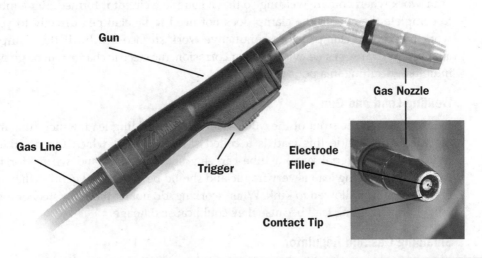

FIGURE 11.2 Typical MIG gun. (*Photo courtesy of Miller Electric Mfg. Co.*)

inside the welder to do three things: start the flow of gas, push welding wire through the lead, and begin to run an electric current through the welding lead and negative clamp. However, remember that for a circuit to be completed, the welding wire must be close to the negatively charged workpiece or table. Thus, if you pull the trigger with the tip away from the work area, you can clearly hear gas escaping through the gun and should start to see welding wire pass out of the gun tip.

Gas Nozzle

The copper-colored shield at the end of the gun is the gas nozzle. Its purpose is to direct the flow of shielding gas toward the weld area. The reason gas nozzles are copper and not, say, steel is so that weld spatter doesn't stick permanently to them. A little weld spatter will stick to the tip, so as you weld, you'll have to occasionally clean the tip to keep the flow of gas free. Gas nozzles should last quite a long time if kept clean.

Gas Diffuser

The gas diffuser helps the shielding gas flow evenly out of the gas nozzle and to the weld area. With the gas nozzle in place, you won't be able to see the diffuser, and it threads directly into the gun handle. It is replaceable, but under normal operating conditions, it is not a consumable item.

Contact Tip

The contact tip is more or less hidden inside of the gas nozzle, connected to the end of the gas diffuser. It is a consumable item that directs the filler material to the weld

area. If you weld with the contact tip too close to the weld area, the tip will start to deform and restrict filler movement. The diameter of the small hole inside the contact tip must match the diameter of the weld wire.

Electrode/Filler

A small piece of wire, just a fraction of an inch in diameter, may be visible extending out of the gas nozzle. This is the filler, and when charged, it also becomes the electrode. The length of filler wire extending beyond the contact tip is called *stick-out*, and for MIG welding with solid wire, it usually should be around ¼ to ⅜ in. Common sizes for solid wire are 0.024, 0.030, and 0.035 in. For all-purpose welding, 0.030-in wire is a great choice because it can weld sheet metal as thin as 22 gauge and also complete nearly ½-in structural welds. No, we're not welding with copper wire—that copper color is just a coating that protects the steel filler wire from corroding and rusting together.

Gas Line

An invisible part of the welding lead and gun, the gas line runs inside the MIG welder and connects through the rear to the gas regulator.

Inside a MIG Welder

Figure 11.3 shows the inside of a MIG welder.

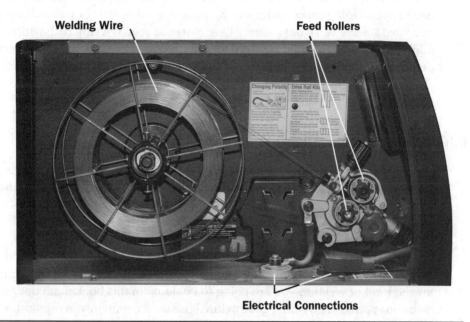

FIGURE 11.3 View of the inside of a MIG welder body. (*Photo courtesy of Miller Electric Mfg. Co.*)

Spool of Welding Wire

Most welders will have a door that swings open on the side for access to the spool of welding wire and the feed rollers.

Feed Rollers

The feed-roller mechanism found inside the welder pulls wire from the spool and pushes it along the housing inside the gun lead. These rollers are adjustable depending on the size of weld wire in use. Refer to your MIG welder's manual for more information on adjusting these rollers.

Electrical Connections

You'll notice a few large-gauge wires and terminal ends inside the welder. More than likely the ends of these wires will be covered to reduce the chance of accidently touching the terminals. The positive wire should be fastened to the feed rollers to give the filler wire its charge.

So how do all these parts work together? When the MIG welder is on and you pull the trigger, three things happen simultaneously: the positive electrode and negative clamp become charged, the feed rollers push welding wire through the lead and out through the contact tip, and shielding gas starts to flow from the tank through the lead and out the gas nozzle. The parts at the end of the gun are copper for a few reasons. MIG welding creates some spatter, and these copper parts keep the molten steel from sticking permanently. If you have a length of weld wire in front of you, you may be wondering why it is also copper-colored and not steel (we're not welding copper after all). Because steel rusts rather quickly, if a spool of uncoated steel wire sat out for very long, it would soon develop rust, which would inhibit the flow of electricity and could keep the wire from unwinding. This copper deoxidizing coating keeps it from rusting and also aids in the transfer of electricity. The coating burns up immediately because copper melts at a lower temperature than steel.

MIG Welder Consumables

When you start setting up your welder, there are two consumable items you need to choose well before you get in the shop and weld: the shielding gas and the filler wire.

Shielding Gas

Shielding gas for MIG welders is most commonly a carbon dioxide (CO_2) and argon (Ar) mix. Gases are available in varying percentages from welding suppliers, and for the level of welding you are going to be doing in this book, I am not going to focus on specifics. A welding gas mixture I use most commonly in my studio is a 25 percent argon–75 percent CO_2 mixture. This mixture is affordable, helps to stabilize

the welding arc, and aids penetration. For a more stable arc with deeper penetration, 100 percent argon could be used, but it is significantly more expensive. Gas flow is set by the regulator attached at the tank, but notice that the units on welding regulators are not in pounds per square foot but rather in cubic feet per hour (ft^3/h or cfh). The rate chosen is dictated by the size of the opening on your gas nozzle. Check your manual or weld chart for specific figures, but a good place to start is in the 25 to 30 ft^3/h range. Too little gas and impurities may find their way into your weld area, but too much gas can cause turbulence, which also allows impurities into the weld.

Filler Wire and Contact Tip

You learned earlier that solid welding wire is available in different diameters from 0.023 to 0.035 in. Table 11.1 shows that to achieve a structural weld, thicker-gauge wire may be required. For sculptural purposes, 0.030-in wire can make great welds up to ½ in (possibly using two or three passes along the same seam) with the right settings and a good chamfer/bevel.

The contact tip, as you learned earlier, must match the diameter of wire used so that it accurately feeds the wire to the weld area. A contact tip that is too small won't let the wire through, and one that is too large will wear out prematurely as the wire arcs with the inside of the tip.

Another option for welding wire is either solid wire or flux-cored wire. Flux-core wire will allow you to weld without a separate shielding gas and works well outside. It also is required for some structural applications.

Material Thickness	Wire Thickness		
	0.023 in	0.030 in	0.035 in
24 gauge	X		
22 gauge	X	X	
20 gauge	X	X	
18 gauge	X	X	X
16 gauge		X	X
14 gauge		X	X
⅛ in		X	X
³⁄₁₆ in			X
¼ in			X
⁵⁄₁₆ in			X
⅜ in			X
½ in			X

TABLE 11.1 Single-Pass Wire Thickness Recommendations

MIG Welder Adjustments

Once you have the correct gas and wire setup, there are two adjustments that must be made on the MIG machine. These adjustments are made to match the material you are welding and control the amount of heat and filler material added to the weld.

Wire Speed/Feed

One of the controls on the front of your welder is used to adjust the rate at which filler wire is fed through the gun. This control will be labeled either "Wire Speed" or "Wire Feed" or have an icon that looks like a straight length of wire between two circles. Generally, the thicker the material, the more filler you need to use. I mentioned earlier that spatter can be a problem with MIG welding. This is frequently a result of using too high of a rate of filler material in relationship to the weld voltage. Figure 11.4 gives you an idea of the different wire speeds and the wire thickness/material thickness that corresponds with each.

Voltage

The other knob on the front of your MIG welder controls the output voltage. Different welder brands have their own ways of labeling the range of voltage, but the knobs perform the same task. Even though the labeling may change, you can still see that there are a number of voltage steps from high to low. Lower voltage gives you less heat and weld penetration, whereas higher voltage has much more heat, higher penetration, and is used for thicker materials. Refer to Figure 11.4 to see how voltage corresponds with material thickness.

How to Use Figure 11.4

Reading the figure from left to right, you start with the "What Material Are You Welding?" column broken up into a few rows: "Steel," "Stainless Steel," and "Aluminum." For our purposes, you can stick with the first "Steel" row from now on. Moving right, you see a column for "Suggested Wire Types" with rows for "Solid" and "Flux Core." Since you're using solid wire, you can move to the right to "Suggested Shielding Gases and Flow." The gases listed here are a 75 percent argon mix, 100 percent CO_2, and a row for flux-core wire. Move to the right from the gas you are using—in my case, it's 75 percent argon. The next column, "Wire Sizes," is broken up into rows for 0.023-, 0.030-, and 0.035-in wire. Move to the right from 0.030-in solid wire, and you have a number of columns in this row with pairs of numbers such as 6/70 and 4/50. These pairings correspond to a voltage and wire-feed setting that you will make on the front of the machine. As long as your welding material, wire type and size, and gas do not change, you can always go back to this row to find your suggested weld settings. The last column of importance is the material thickness, and it shows a number of profiles that mirror the thickness

FIGURE 11.4 Miller 212 weld chart. (*Photo courtesy of Miller Electric Mfg. Co.*)

of material to weld. For example, if you are planning on welding 14-gauge material, move to the right to the 14-gauge column, and read down at the intersection of the selected 0.030-in row. The magic numbers here are 4/50. On a Miller welder, the numeric voltage range is from 15 or so, and the wire feed is from 0 to 100. It is physically impossible to set the welder to a voltage of 50 and a wire speed of 4, so you know that the numbers must correspond in order of voltage first and wire speed second. Turning to the front of the machine, you can dial these settings in with the machine on or off.

NOTE: *Make sure to click the voltage dial in fully to avoid shorts in the circuitry.*

The weld chart is an extremely useful tool for new welders to dial in proper settings. Once the machine is set up properly, everything else falls to the person making the welds to keep a steady distance from the weld area, move at the right speed, and stop and start the welding process at the right time using the gun trigger.

You Are in Control

Up to this point, you've looked exclusively at how MIG welding equipment and its settings affect your welds. You've learned how the *welder* creates a weld, but how do *you* do it? If you assume that the welder is set properly, then what control over the situation do you have? As it turns out, a lot! The distance from the electrode to the base metal, the speed at which you move, the angle of the gun, the pattern of motion (or weave), and the steadiness of your hand all greatly affect weld quality. Even with the best equipment and perfect settings, in the hands of an inexperienced welder, a poor weld can still be created.

Thankfully, the following rules will help you to create consistent and strong welds. Remember that you must follow all these rules to start and maintain a quality weld. If you break any one of them during your weld, the results will be apparent.

Distance from Weld Area (Stick-Out)

You've already learned the term *stick-out*, so it shouldn't come as a complete surprise that you need to consider how far your electrode is from the weld area and at what distance you hold the gun from your material. Different weld applications require the weld gun to be held at various distances from the surface, but for the purposes of this book, you can assume that a stick-out of $1/4$ to $3/8$ in is ideal. You may notice that when you are welding at a lower voltage, your distance from the weld area has less room for error. Also, depending on the type of weld you're making, say a tee joint or an inside-corner weld, it may be more difficult to keep the gas nozzle at the proper distance. For your first few weld beads, I suggest that you start with butt joints or lap welds on a flat surface.

As you weld, if your distance grows too far from the weld area, you'll start to notice the weld arc sputter and pop, making it extremely difficult to see and creating a very poor weld. As soon as you hear the weld arc pop, move the gun closer to the weld area, and you should be able to continue the weld. One of the biggest challenges for new welders is remembering to keep the gun in close.

TIP: When starting out on some practice welds, keep your gun nearly stationary, and focus exclusively on the distance between the MIG gun and the weld area. Move slowly across the material surface while maintaining the proper distance.

Of course, just as the gun can be too far from the weld area, it also can be too close. When you're too close to the weld, your view will be blocked by the gas nozzle, and you won't be able to make an accurate weld. Also, with some welding time, the contact tip and gas nozzle can deform owing to heat buildup. One-eighth of an inch is about as close as you'll ever want the contact tip from the weld area.

TIP: When you finish a weld and release the trigger, take a look at the end of your MIG gun. The amount of welding wire extending past the contact tip shows exactly how much stick-out you were using when you finished the last weld.

To help gauge the distance between the contact tip and weld area, welders always view their MIG gun from the side while welding, as shown in Figure 11.5. The protection offered by the welding helmet will help you to get in close without fear of heat or sparks. Practice finding a position for each weld where you can comfortably hold the gun and position your face off to one side but within 8 to 12 in of the weld area.

Speed

The speed at which you move the weld gun is another major factor in determining weld quality. Moving at the proper speed will allow the base metal to heat up enough to melt thoroughly but won't add so much heat that it distorts or burns through. Just as when you learned about stick-out, if you travel too fast, the weld wire will pop as it touches the surface, and no weld pool will be formed. The best way to tell if you have the right travel speed is to get feedback from the weld as you go and inspect the bead afterwards. If as you weld (of course, keeping proper distance from the surface) you can move along a line and keep a continuous arc, you know that your speed is somewhere between too slow and just right. If instead you get popping, you know that you are moving too fast. Adjust your speed to be slow enough so as not to pop, thereby creating a successful weld pool. When you stop your weld, take a look at the height and width of the weld bead and area affected by the heat. Figure 11.6 shows two weld beads, the top of each is made at

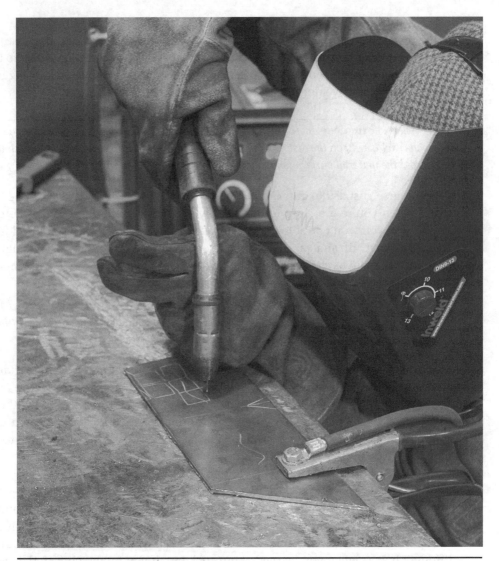

Figure 11.5 A welder watching the weld area.

a slow speed, and as they go down the speed was increased. Notice the height of the weld in relationship to its width and the total amount of weld volume.

If you take a look at the back of the material, you'll notice that where the speed was too slow, more heat penetrated the steel. This is illustrated in Figure 11.7, and you can tell which area is affected by heat because it will turn a blue to gold color. While heat is our friend when welding, too much heat can unfavorably distort the steel.

Figure 11.6 How travel speed affects the weld bead.

Figure 11.7 Heat penetration on the back of a weld.

Angle

The angle of your MIG gun to the surface, or surfaces, you are welding also is something that will greatly affect your weld. For welding on a flat surface, you want to keep the gun angle perpendicular to the steel. This directs all your heat and shielding gas directly into the weld area. If you are welding a tee or a corner weld, hold the gun at a 45-degree angle between the two surfaces to evenly direct the heat toward each surface. If you are welding a lap joint, hold the gun at a 60-degree angle from the surface to evenly share the heat between both materials. Figure 11.8 provides example of this.

Another angle to consider is the angle of your gun relative to the direction of travel. Holding the gun 10 to 15 degrees out of perpendicular from your travel direction can give you a couple of different results. This is also known as *pushing* or *pulling* your weld pool. The key difference is how much penetration the weld area has, so the effects of pushing or pulling are much more noticeable when using higher voltage. For sculptural welding, you can use whatever feels more comfortable. I typically switch between both depending on what is most convenient, but more than anything, weld in a fairly straight or perpendicular orientation.

Push

Pushing your weld means that the angle of your gun points in the direction of travel. Pushing generally yields lower penetration because the arc is formed slightly on top of the last bit of weld bead created owing to the filler wire traveling over the preformed bead. However, pushing the weld toward you can give you an increased amount of visibility over the weld area.

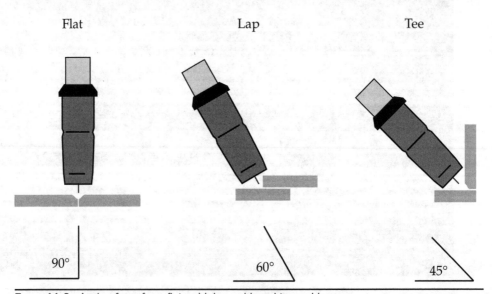

Flat Lap Tee

90° 60° 45°

FIGURE 11.8 Angle of gun for a flat weld, lap weld, and tee weld.

Pull

Pulling your weld means that the direction of the gun angles away from the direction of travel. This can give you increased penetration because the bead is forming on the rear of the molten pool. Both pushing and pulling are shown in Figure 11.9.

Straight

Holding the gun perpendicular to the direction of travel does not give you a pushing or pulling effect. One advantage is that you can more easily change direction, and you'll have good visibility on either side of the MIG gun.

Pattern of Motion or Weave

In order to join two pieces of steel successfully, each piece must be heated to the point of melting. For this to happen, the MIG gun needs to be moved back and forth from each piece, creating one shared molten pool and weld area. There are many different types of weaving motions people use for MIG welding; some of them include zigzags, crescent shapes, and various cursive letters. The total width of motion should be about as wide as the weld pool to maximize weld efficiency, so imagine that for joining ¼-in-thick plate the small arcs are only about ¼ in wide. Whichever technique you choose to use, imagine it as "stitching" along a weld seam. Graphic examples of some of these weave patterns, with arrows indicating direction of motion, are shown in Figure 11.10.

Steadiness

Linking all the rules together is your own steadiness. Any wavering in your motion, whether its height, speed, or an abrupt jerk, will break the arc. To help keep the MIG gun steady, find a position where your arm is braced against the table or your workpiece that also allows you enough range of motion to complete the weld. Just

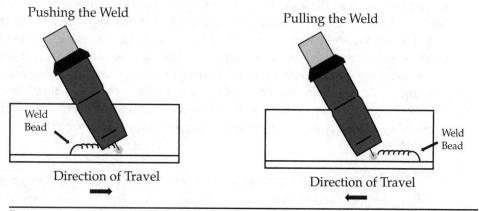

FIGURE 11.9 Pushing and pulling a weld.

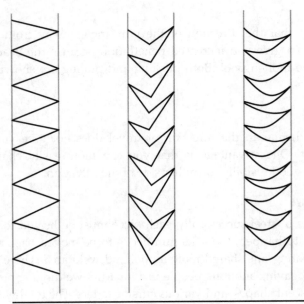

Figure 11.10 Welding motions: zigzag, triangle, and crescent.

as with torch welding and cutting, before you begin the process, find a comfortable position that puts your face near the action and prevents any sudden movements. Using your nonfavored hand to steady the MIG gun is an important trick in making a steady weld. Figure 11.11 shows a welder properly braced and ready to start welding.

Weld Vision

When all the preceding rules come together, you'll be creating a continuous arc. To get an accurate weld, you need this arc to cast enough light around the weld area so that you can see where to travel. Any arc popping that happens causes the arc light to flicker off and on, making it much more difficult to judge your distance from the surface, direction, and speed of travel. Getting accustomed to the dark welding environment is one of the biggest hurdles new welders face (as if sparks and plasma weren't enough of a shock). I always have first-time welders start welding on a flat surface and move only when the arc is constant enough to light the way. Anytime a pop occurs, the welder must hold his or her position until the arc steadies, never releasing the trigger. When a steady arc is achieved, the welder may continue on.

TIP: Use soapstone to mark your intended weld line. Since it burns away clean, it won't affect your weld, and the light color will help you keep on track even when looking through a dark shade.

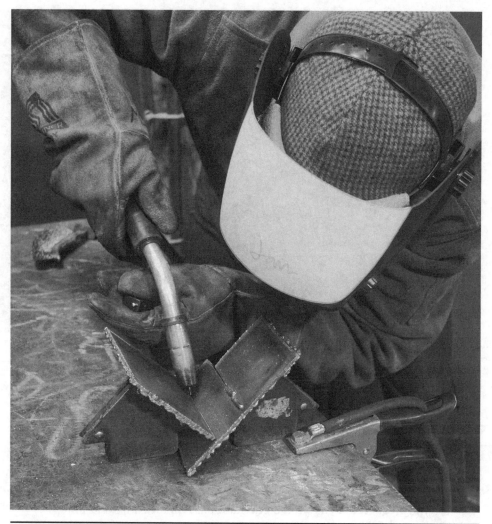

FIGURE 11.11 Braced position.

Weld Orientation

Although for hobbyist projects of our scale it is usually possible to weld with the weld area facing up, you will definitely find times when it makes more sense to weld in other positions. One of the great things about MIG welding is that it allows you to weld in any orientation.

Flat

Most commonly, you'll be welding in the flat position. Here the weld area is facing up, and your MIG gun is facing down (or angled slightly depending on the material

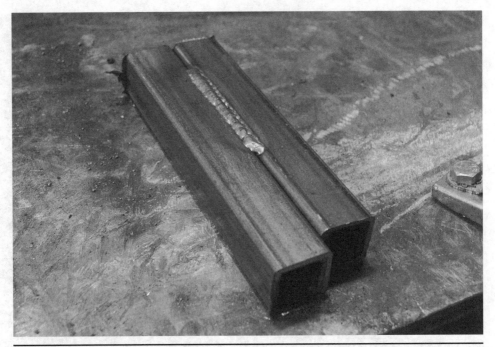

FIGURE 11.12 Flat-position weld.

or travel direction). The weld is supported by the parent material directly below it, as shown in Figure 11.12.

Horizontal

In horizontal-position welding, the parent material is in a vertical position, but the weld seam is horizontal, as shown in Figure 11.13. Here the weld area and bead are mostly unsupported by gravity. To weld horizontally, point the gun up slightly around 10 degrees to avoid the gravitational pull on your weld pool.

Vertical

Welding a seam that is oriented vertically is vertical-position welding. It can be the most challenging of the welding positions because you are working against gravity and your own weld bead. Welding down requires the welder to increase the travel speed slightly to keep the weld arc just ahead of the weld pool. It is relatively easy because gravity helps to pull the weld pool down as you go. However, because you have to weld slightly faster, getting enough penetration for the materials you are welding is a big problem with the down technique. A vertical-position weld can be seen in Figure 11.14.

The other option, welding up, can be more useful for thicker materials where deeper penetration is necessary. When welding up, it is not necessary to speed up, but the angle of the MIG gun should be pointed up about 10 degrees. It may be

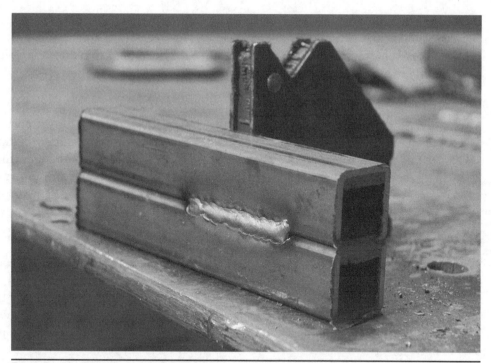

FIGURE 11.13 Horizontal-position weld.

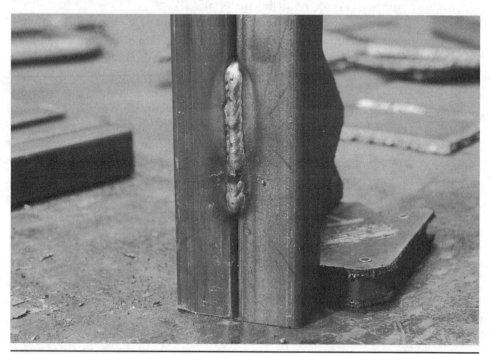

FIGURE 11.14 Vertical-position weld.

harder to pull off an attractive bead using this technique, but with some practice, you will be able to find the right balance.

For both vertical welding techniques, it may be helpful to reduce the voltage slightly to avoid burning away excess material.

Overhead

In overhead welding, there is no material below the weld area for support (the opposite of the flat position). It is much like flat-position welding, but the travel speed must be adjusted so that no material is lost along the weld seam. If too much time is spent in one area, it is likely that molten steel will drip away, resulting in a loss of material. When doing an overhead weld, make sure to light the weld area properly, and watch out for dripping steel.

Safety

- Welding produces *extreme* heat of over 10,000°F. Do not handle recently welded material without gloves, and keep all skin covered at all times.
- Welding produces *extreme* ultraviolet (UV) light that is more intense than the sun. Never look directly at a welding arc, even from a distance. Always wear a welding mask of the proper shade, and keep all skin covered at all times.
- Welding produces sparks that can travel great distances. Keep your welding area free from combustible materials.
- The electricity required for welding is enough to stop a full-grown adult's heart. For this reason, use caution when plugging in and unplugging a welder and when the welder's side panel is open. Never weld in wet conditions or near standing water.
- Always inspect your equipment before use, including the welding lead, wire spool, and gas regulator. Replace damaged equipment if necessary.
- Always weld in a well-lit environment. As well as improving your chances of creating a good weld, this may help you to avoid causing bodily harm from bumping into material or tripping.
- Know your tools. If you have any questions about the MIG welder, gas setup, or *anything*, refer to the tool's user's manual or ask the shop technician.

Personal Protective Equipment

- Always wear a welding mask (shade nos. 9 to 14).
- Under your welding mask, wear clear safety glasses.
- When welding for extended periods, wear an N95 or N99 dust mask.
- A welding cap or bandana worn under your welding mask is recommended.
- Insulated welding gloves should be worn at all times.
- Wear heavy, nonflammable boots, uncuffed pants, and long sleeves.
- Protect your neck by wearing a wool scarf or collared shirt.

- Wear clothing made of natural fibers (cotton or wool) or leather, never synthetics.
- A welding jacket worn over long sleeves is recommended.
- Surround your work area with welding screens to minimize spark travel and to prevent flashing bystanders.

Operation

Before you start welding, let's go over how to set up the welder, find a comfortable position, and properly shut the welder down.

Setting Up Your Work Area and Welder

Work Area

1. Make sure that your workspace is clean of any flammable materials and that you are wearing all the required personal protective equipment (see earlier list).
2. Parts to be welded should be on your worktable and free of coatings or contaminants. Any chamfers or bevels should already be added.
3. Inspect your welding lead and regulator for damage and your filler-wire supply.
4. Make sure that the regulator turns counterclockwise freely and that the gas cylinder knob is fully closed.
5. You should have all personal protective equipment on or located nearby.
6. Layout magnets, wire cutters, and any other hand tools you will use should be on the table.
7. If necessary, clean the tip of the gas nozzle and/or replace the contact tip.
8. Gently uncoil the welder lead and negative clamp from the machine.
9. Clamp to your worktable or work, and return the MIG gun to the machine with the lead gently coiled on the ground near your work area.

Gas

1. Turn the MIG welder on. (If it is unplugged, plug it in now.)
2. Turn the wire-feed speed to 0 and the voltage setting all the way down. This is to help you preserve filler wire and prevent accidental arcing.
3. Slowly open the gas cylinder valve two to three full turns. If you hear a leak, close it and check your equipment. Do not open the valve all the way because it could become jammed.
4. As soon as the cylinder valve is open, a reading should appear on the tank pressure gauge while the line flow-rate gauge remains stationary. It is okay to use an argon-CO_2 tank until it runs out of gas, but there will be unsatisfactory flow toward the end.

5. With gas in the tank, you now want to adjust the line flow rate to the desired setting, most likely 25 ft³/min. To get an accurate reading, you'll need to begin the flow of gas through the line, so with one hand pull the trigger on the MIG gun and with the other turn the flow-rate knob clockwise to increase flow. Be mindful of where your filler is going so as not to accidently arc on something.

NOTE: *Two types of flowmeters are common, a regulator and a meter style (Figure 11.15).*

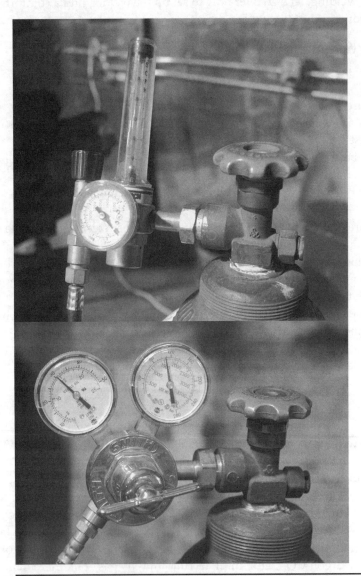

FIGURE 11.15 Flowmeters.

6. When the flow rate reaches the desired amount, release the trigger, and trim the feed wire back to the proper stick-out (¼ in in most cases).
7. Rest the MIG gun on the welder.

Weld Settings

1. Using the weld settings chart that accompanies your welder, find the recommended settings for the material under the "MIG Welder Adjustments" section earlier in this chapter. Turn each knob until the proper setting is established, and remember to make sure that the voltage dial is not between settings.
2. As mentioned earlier under "Weld Orientation," consider whether you need to reduce the recommended voltage setting at this time, and make that change.

Get Comfortable

The last thing you need to do before pulling the trigger and starting to weld is to find a good position. The proper position will depend a lot on whether you are making flat, horizontal, or vertical welds and whether or not your work can be clamped to the worktable or needs to rest on the ground. For now, I'll assume that you can perform the weld with your material sitting flat on the worktable. The things you are looking for in this position are a well-braced MIG gun, the ability to travel along the weld seam, having your welding mask about 10 in away from the weld area, and no parts of your body too close to the weld area besides your gloves.

You can stand or sit when welding, but I find that standing allows me to move more freely along the weld seam and slide my elbows on the worktable if needed. Also, when you are seated, your lap provides a great landing zone for sparks. It doesn't take long for a spark to burn through cotton or wool if it sits directly on top for long. For this reason, I suggest standing for most welding.

At this point, your work area is ready, the gas flow rate is dialed in, the welder settings match your material thickness for good penetration, and you've found a stable position where you can complete your weld. You are ready to weld! As long as the variables don't change—material thickness and weld orientation—you can continue to weld until you need a break or run out of consumables (i.e., wire or gas). As you work, you can make changes to the voltage and wire feed as needed, all on the fly, although it is usually recommended that you change these when the trigger is not depressed.

When taking a break, it is up to you how far you take the shutdown process. If you need to take a short break to use a grinder or other hand tool, I'd suggest leaving the welder as is for that time (5 to 10 minutes). If you need to take a phone call or do some other more in-depth work that will take longer than 10 minutes, go ahead and shut the machine down by using the on/off switch, but you may leave

the gas flow set and gas tank open. For time spent away from the welder longer than half an hour, I would suggest fully shutting down the machine and gas.

Shutting Off the Welder and Gas

1. When you've completed your last weld, rest the MIG gun in its cradle or draped over the MIG machine.
2. Remove the negative clamp from your work, and gently coil its wire lead around the MIG welder handle.
3. Turn the wire-feed and voltage settings all the way down.
4. Turn the tank valve knob clockwise until it stops to fully close the gas tank.
5. With the welder still on, pull the trigger on the gun until the flow-rate gauge goes to zero. Remember to watch where the wire goes; you don't want it to touch the negative clamp. You can leave this length of weld wire extending past your normal stick-out or trim it off.
6. Gently coil the gun lead around the handle of the MIG welder, and turn the MIG machine off using the on/off switch.

Practice

When learning to weld, practice really does make perfect. Below we'll go through a number of different welding practice scenarios to help bring your skill and comfort levels up.

Flat-Position Bead Making

For this practice session, cut a piece of sheet metal that is about a foot on each side or larger using the torch or plasma cutter. Clamp it directly to the worktable using the negative clamp. Your goal is to practice starting and stopping your welder and making straight and decorative beads that are consistent in quality. For this session, you'll use 10-gauge sheet steel.

Practice 1: Small Circles

1. Clamp the sheet metal directly to the worktable using the negative clamp.
2. Find your preferred welding position that allows you to hold the gun nearly perpendicular to the material and view where the wire will come into contact with the surface, as shown in Figure 11.16.
3. When you're ready, hold the trigger on the MIG gun. Do not move the gun at first. When the arc is formed, move the arc *very* slowly in a $\frac{1}{8}$-in-diameter circle.
4. Hold the trigger down for about 3 or 4 seconds while you make the circle, and carefully watch the weld area. Take note of the distance your gas nozzle is from the surface and the sound the welder makes.

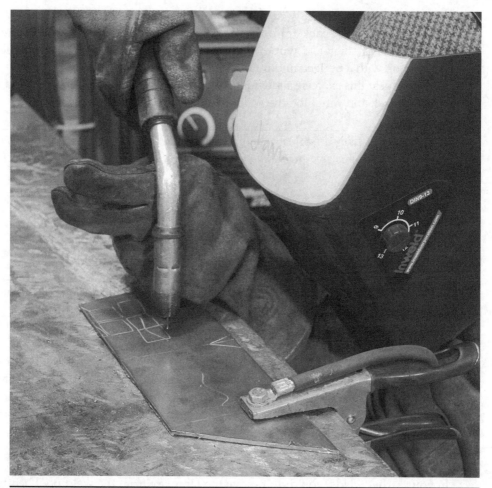

FIGURE 11.16 Getting into position.

TIP: If you're unsuccessful at creating a constant arc, double-check your welder settings and stick-out. If these both are correct, another possible culprit is a bad electrical connection. Wire brush or grind a bit of the mill scale off from the spot where you placed the negative clamp, and try again.

5. The best way to think of this sound is that of sizzling bacon.
 a. If you hear a more distinct popping noise, this suggests that the welder settings are incorrect (voltage or wire speed too low), the gun is too far from the weld area, or there is a poor flow of electricity.
 b. If the sound is more of a hiss, this may mean that the voltage is turned up too high.

6. When you are ready to stop the weld process, just release the trigger and pull the gun back from the weld area. If the wire-speed settings are set properly, the weld wire should not stick to the weld pool but rather leave you with a perfect amount of stick-out for the next weld.

7. Repeat this exercise a few more times, focusing on the sound, a slow rate of travel, and watching the weld area.

TIP: If you're having a hard time with visibility here, try slanting your sheet metal on magnets at a 45-degree angle and putting the negative clamp directly on your work.

Practice 2: Mandatory Mistakes, Part 1

Here you are going to repeat the last exercise but try to make a bad arc.

1. Start by getting into position to make another small circular weld.
2. Pull the trigger to get a nice arc going.
3. With a good arc, slowly pull the gun away from the surface of the metal. Watch this distance carefully.
4. Quickly, you should start to get a lot of popping, stray pieces of welding wire, and extremely poor lighting conditions.
5. To get a good weld again, slowly push the welding gun back to the proper distance, and the welding process should continue much more smoothly.
6. Repeat this a few times to experience the sound of a poor weld and to get used to bringing the gun back to the right distance if faced with this problem in the future.

Practice 3: Stringer Bead

In your earlier welds, you didn't move too far away from the weld pool because I wanted to focus on maintaining a proper distance from the surface. For this exercise, you will now make a weld bead along a straight line, called a *stringer bead*, to get a feel for the rate of travel. At this point, you don't need to worry about pushing or pulling the bead or making zigzags, just how to make a weld bead along a line. Don't worry about getting to the finish line here; just go nice and slow and keep a steady arc.

1. Start by drawing a 2-in line on the surface of the steel with soapstone.
2. Position yourself just like in the preceding practice with the gun perpendicular to the steel.
3. Pull the trigger, and when the arc is created, move *very* slowly and steadily along the line. If popping occurs, it is most likely due to one of two things— either your rate of travel is too fast or you have drifted away from the surface.

FIGURE **11.17** Slow and steady bead.

4. Continue along the line, trying to maintain a steady arc the whole time. At the end of the line, release the trigger and inspect your bead. Figure 11.17 shows a bead I made going extra slow and steady.
5. Practice with more lines, varying the distance of each up to about 5 in.
6. Practice angling your MIG gun up to 10 degrees along the direction of travel to try pulling and pushing techniques.

Practice 4: Mandatory Mistakes, Part 2
Again, you are going to create a bad bead intentionally. This time you'll maintain a constant height but vary your speed.

1. Draw a 3-in line on the sheet metal.
2. Using what you've learned, start your welding process on this line, and move slowly along it.
3. After a nice arc is going, speed up your rate of travel until you get more popping and an inconsistent arc.
4. Slow back down until an even arc is created again, and release the trigger.

5. Does your weld arc look something like the one on the left in Figure 11.18? Notice how the bead is intermittent during the fast section. Clearly, there wasn't enough heat during the making of this bead to create a strong bond.

6. Your ideal welding speed is somewhere between the fast section of this weld and the slow speed at which you started in step 1 of Practice 3.

7. Experiment with your own rate of speed by drawing more lines and following along them at different rates. The bead on the right in Figure 11.18 is straight and has a great height-to-width profile.

Repeat these exercises until you are comfortable enough with the heat, sparks, and darkness that you can focus solely on the factors that affect the quality of your weld bead.

TIP: Make changes to the voltage and wire-speed settings between practices so that you can start to identify the sound and feeling of a properly set up welder.

Flat-Position Weaving

Now that you are able to maintain a good height and speed of your MIG gun, you need to take your skills to the next level and learn how to join pieces of steel. To do

FIGURE 11.18 A slow-fast-slow bead on the left with a good bead on the right.

so, you need to learn how to make a weave bead—thereby heating up pieces on either side of your weld seam. Earlier in this chapter you learned about three weave types—zigzag, crescent-shaped, and triangular. Practice each in the following steps to find out which one feels best and gives an even bead.

For this practice session, cut a bunch of 4- to 6-in lengths of flat stock, and grind a small bevel on each of the long edges to help you get a good joint. You'll need clamps or magnets to hold your work together when you weld it, so make sure to have yours handy.

Practice 1: Weaving

1. Arrange two pieces of flat stock with their long edges butting up together as close as possible. Clamp them to the worktable, or hold them together with magnets.
2. To help with visibility, draw along the weld seam with soapstone.
3. First, you want to secure your material together using a weld technique known as a *tack weld*.
4. Get in position to make a weld, and make a ⅛-in-long bead that starts on one piece of flat stock and moves perpendicularly over the weld seam and onto the other piece of flat stock. Repeat this at the other end of the flat stock, as shown in Figure 11.19.

FIGURE 11.19 Tack welds.

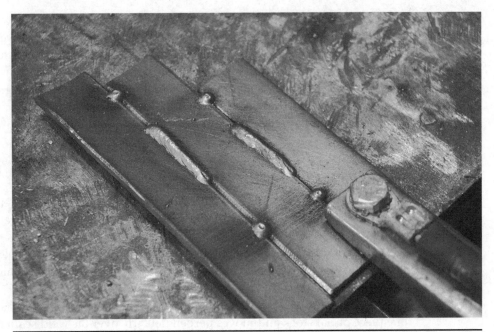

Figure 11.20 Tacking and stitching practice.

5. With your material tacked, you now want to stich it together using a weave pattern. As mentioned earlier, the weave pattern only needs to be about as wide as the chamfer you are welding.
6. Stitch three or more pieces of flat stock together (tacking each beforehand), as shown in Figure 11.20.

Flat-Position Tee Joint

Welding a tee joint is in many ways the same as welding a butt joint, except now you want to hold your gun at approximately 45 degrees from the corner along the weld seam rather than perpendicular to the surface. Another difference is that with the added height of the material, it is more challenging to get in close to the weld seam.

Using magnets, place two pieces of flat stock in the corners with their seams lined up as closely as possible. The magnets can be rotated so that you can access the seam from a variety of angles. For the first attempt, let's turn the magnets so that you can access the seam from directly above, as in Figure 11.21.

Practice 1: Tee Joint

1. Position yourself in such a way that you can see into the V-groove created by the flat stock, and hold the MIG gun steady.

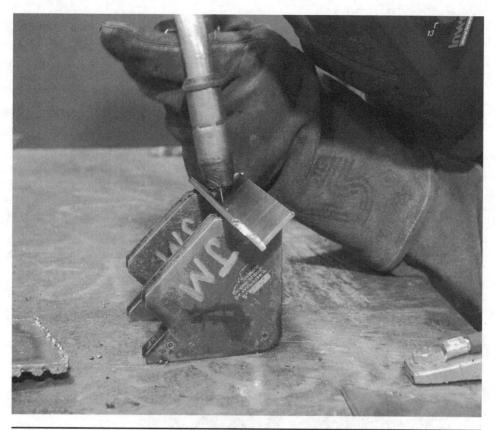

Figure 11.21 Magnets holding the workpieces.

2. Tack either end as in the preceding practice, and then run a full bead down the seam using the weave pattern of your choice.

Note: *The shiny brown pools you will see on your MIG weld bead are bits of the copper coating and other impurities collecting on the surface. Take a wire brush or sandpaper to these spots to clean them off.*

Making a Tee Corner

One connection you'll make a lot of if you are making furniture or frameworks is a corner joint using tubing or solid stock. For this exercise, you are going to use tack welds and tee welds to weld a piece of tubing perpendicular to a section of sheet metal. For this you'll need layout magnets and some sort of square tool, such as a carpenter's speed square or right angle.

Practice 1: Tee Corner

1. Clamp your sheet metal directly to the worktable.
2. Using a layout instrument, set a short length of tubing perpendicularly near the middle of your sheet metal, as shown in Figure 11.22, and check for plumb.
3. If it is square, put a solid tack in one of the corners. After this cools, check for plumb again. Given the rapid heating and cooling, the weld may have pulled the work out of square, as shown in Figure 11.23.
4. Before you put in another tack, you need to remedy this. Bend the piece of tubing back to square with your hand or using a hammer. If your tack was made properly, it shouldn't break, but if it didn't penetrate either of the materials sufficiently, the tubing most likely will pop off. If it does break, just start back at step 3.
5. With your tubing realigned, go ahead and make another tack opposite the first one.

FIGURE 11.22 Perpendicular tubing.

FIGURE 11.23 Not square anymore.

6. After this tack cools off, your piece should be held perfectly plumb, as in Figure 11.24, and you can start stitch welding around the seam until you have a solid connection.

These basic skills will take you a long way in sculptural and artistic welding. But how do you know if your weld quality is acceptable? Without having your work x-rayed, there are three good ways to judge your welds: (1) try to break them, (2) cut one apart, or (3) visually inspect the weld bead.

Breaking a Weld

Clamp any of your practice welds into a vice or directly on the table, and try your best to break the connection. Use leverage if needed, but really give it everything you've got. If your welds don't break even when the material around it deforms, you've got a great weld. Figure 11.25 shows my using leverage to break a weld and the resulting weld failure. Most commonly, one side of your weld will tear off the

FIGURE 11.24 Perpendicular again and tacked in place.

base material. What this suggests is that not enough time (or heat) was used on this side of the seam. To remedy this, go back and focus on making a slower, slightly exaggerated stitching motion along the weld seam until you get a bead that doesn't break.

Cutting Your Weld

For this, chamfer and weld a couple of ¼-in pieces of flat stock using tee and butt welds. Cut each one apart to inspect for voids or cracks. Figure 11.26 shows a tee weld with a very small void right at the weld root, and Figure 11.27 shows a void-free double-bevel weld. For structural purposes, many welds are x-rayed to look for imperfections and voids because they are often smaller than we can see with the naked eye.

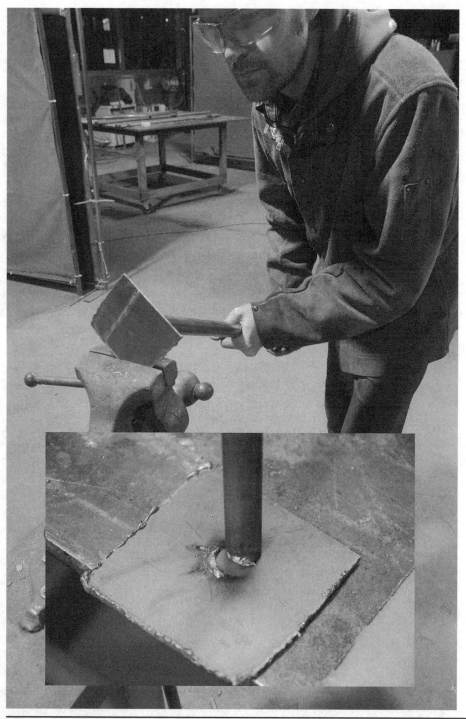

Figure 11.25 Bending and breaking a weld.

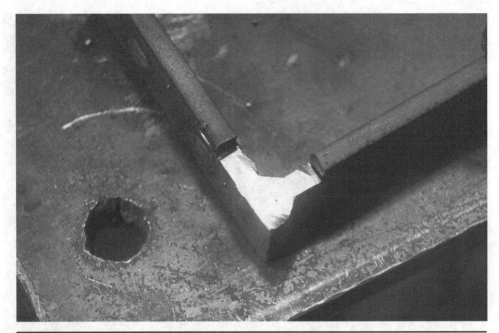

Figure 11.26 Tee cross section with two small voids.

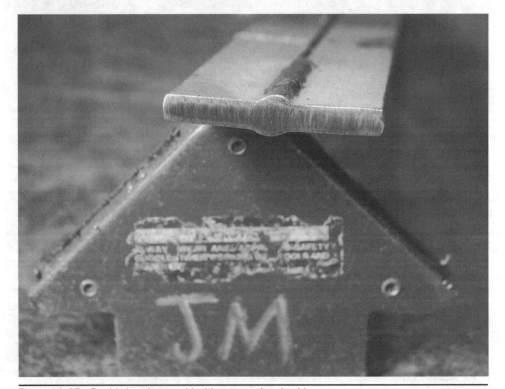

Figure 11.27 Double-bevel tee weld without any visual voids.

Visual Inspection

Below is a list of some common problems that lead to poor welds as well as how to identify them and what to do to fix them. When troubleshooting this kind of thing, you may want to use a stringer (straight) weld bead to rule out any effect your own weave pattern may have on the weld quality. Figure 11.28 shows an example of each common weld problem.

- *Poor gas flow (2)*. This is an easy problem to identify because your weld will look like Swiss cheese or the surface of the moon. This bead is characterized by the large holes and uneven consistency. To fix this weld, just make sure that you have a full tank of the right gas and that nothing is preventing it from reaching your weld area, such as a closed regulator, a damaged welding lead, a clogged nozzle, or wind.
- *Too little heat (3)*. When too little heat is used, the weld area doesn't get the penetration it needs, and the weld bead will sit high on top of the material. Also, there may be inconsistencies with the bead because it is harder to

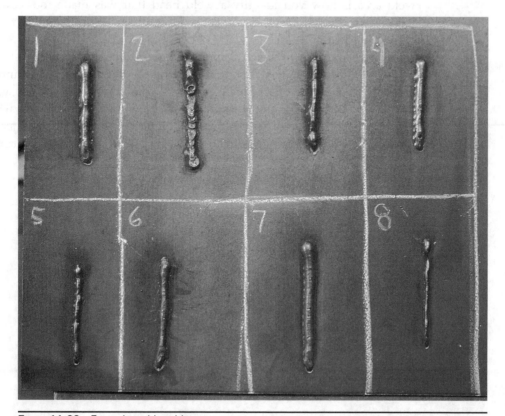

Figure 11.28 Example weld problems.

maintain an arc when the voltage is too low. To fix this problem, turn the voltage higher on your welder.

- *Too much heat (4).* When welding at a voltage that is higher than what you need for your material, you will start to deform the material more than desired. Along either side of the weld you will notice small pits or cavities, and the weld bead itself may lie very flat or even burn through the material. To fix this, just turn down the voltage slightly.

- *Too little wire (5).* Welding with too little wire will give you a similar bead to when you weld with too little heat. You should notice a very small weld bead without much spatter that is slightly more consistent than when too little heat is used. Turn up the wire feed to fix this problem.

- *Too much wire (6).* When using more than the recommended amount of wire, you may notice a bead that is larger than needed, and extra spatter is produced. Usually the bead will build up rather than out because the heat isn't enough to let the excess wire penetrate the base material. To fix this, turn the wire-feed knob to a lower setting.

- *Travel speed too slow (7).* Hopefully, this weld bead looks like your first beads from this chapter. A fat, wide bead with excess heat buildup around the weld area is how you identify a weld bead that was made too slowly. Increase your travel speed as you get more comfortable until you can form a desirable bead.

- *Travel speed too fast (8).* When traveling too quickly, you are left with a short, inconsistent bead that has very poor penetration. Remember, for beginner welders, start slow and gradually increase your travel speed when you have a good handle on gun height and keeping steady. Frequently, with new welders, the rate of speed can vary quite a bit owing to small jerky motions that deviate from the direction of travel. Practice, practice, practice!

Finishing

As with all materials that are left to nature, steel will deteriorate over time. To combat this process, you must apply a coating or finish to help repel the natural degradation that occurs. Earlier in this book you learned about the oxidizing process called *rust* that naturally happens to mild steel. You also learned that rust is porous so that it continues to oxidize and break down steel until no more material remains. In a dry environment, this could take hundreds of years, but if uncoated steel is left in a humid and salty environment, it occurs much, much faster. This means that if you want a rusted surface and don't care about the longevity of the piece, you don't need to apply any finish at all. For the rest of your work, there are a few pretty simple finishing techniques that you can apply at home or in your shop.

Most finishing processes should be performed in a well-ventilated and breeze- and dust-free environment. Another major factor in getting a good finish is adequate lighting. If you have a finished or unfinished basement, you might want to try setting up a small finishing area there. To prevent excess dust, hang a sheet or cardboard from the exposed floor joists to catch any falling debris. The addition of a few clip lights or shop lighting will prove to be a big help. In terms of ventilation, it may be enough to put some small ventilation fans in the basement windows, but remember that anytime you're in an enclosed space using finishes, be sure to wear a respirator or an adequate dust mask.

Steel Preparation

For all of your finishing techniques, you should prepare your work by following these steps:

1. Make sure that your piece is actually done! This sounds silly, but it's a bummer when after nicely painting some metal work you realize that you for-

got to weld something to it. If you do make this mistake, it just means that you have to scrape off an area of paint and bring the piece back into the studio while trying not to damage any of the other finished areas and make your repair. Then refinish the area, as well as any other damaged or spark-spattered parts of the piece. This is not a huge problem, but still, it is certainly a headache.

2. If your work is done, inspect your weld areas for stray bits of welding wire and excess spatter. You may want to wear gloves to avoid getting poked. Using a wire wheel or flap disk, clean these areas so that they are smooth to the touch. Also be sure to inspect any open ends of tubing or corners for sharp burrs. Remove these with a file, angle grinder, or reamer.

3. Next, lightly sand the surface of your work with medium-grit sandpaper or an aluminum oxide hand-sanding pad to give it a smooth finish and knock off any loose bits of scale.

4. The preceding step will create dust, so next you need to remove it. First, wipe the entire work off from top to bottom using a clean, dry cloth or rag. Next, using either a tack cloth or lightly solvent-soaked rag, repeat the process. After that, wipe the surface down one more time with a lint-free rag to check for more dust. Repeat if needed. For your safety, wear latex gloves during both these steps.

5. When the surface is free of any solvents and dust, you can use any of the finishing processes listed below.

CAUTION: Many finish materials are flammable during various stages of their application. Never use near heat sources, open flames, or enclosed spaces. Always read all safety instructions that come with your selected finishing material.

Muriatic Acid

Let's say that you like the look of rust and want to finish a project with an evenly rusted surface. The best way to start is with the cleanest steel material possible, and the easiest way to clean mill scale and other contaminates from steel is by using muriatic acid. Once you get your material down to its cleanest form, the rusting process will happen quite quickly and very evenly.

CAUTION: Muriatic acid is a toxic chemical. Follow these tips to avoid injury and accidents:

- *Follow all instructions included with the muriatic acid.*
- *Keep it locked in a safe place away from children and pets*
- *When using muriatic acid, keep all skin covered, and wear a respirator, safety glasses, heavy rubber gloves, and closed-toed shoes.*

- *Muriatic acid can be washed away with water, so have fresh water handy in the event of exposure.*

Application

To clean and promote rust on steel, you need a few basics:

- Spray bottle
- Muriatic acid (available online or at specialty stores)
- Saltwater

1. Follow the preceding steps to clean and degrease your project.
2. Use muriatic acid only in an extremely well-ventilated area, and follow all safety labels on the product.
3. Place a plastic drop cloth beneath your work to collect any excess acid.
4. Follow the instructions on the muriatic acid label to dilute it with water, and pour the mixture into your spray bottle. Spray your work liberally, and let sit until the scale is removed. Repeat if necessary.
5. When the workpiece is clean, rinse it down thoroughly with clean water.
6. Make a salt-and-water mixture, and pour it into another spray bottle, or clean the bottle you used in step 4 and use that.
7. For the next few hours, spray the work lightly with the salt-and-water mixture, and let it sit for a few days, repeating the salt spray process if needed.
8. When an even coating of rust is created, you can stop there or seal the rust if desired.
9. To seal the rust, follow the steps below to wax-finish or clear-finish your project.

NOTE: *Rusting will continue slowly even under the finish, so occasional applications of the finish may be needed.*

Paint

Possibly the most common do-it-yourself (DIY) finish, paint gives you a wide range of colors and finishes. For those of you without an ideal environment for finishing, brushing a steel project with latex paint will give you a decent and affordable finish without any of the fumes other chemical finishes contain, so you could even finish your project in your living room. The possibilities when it comes to painting mild steel are endless because clean steel accepts just about all forms of paint. Brands such as Krylon, Rust-Oleum, Montana, Valspar, and Sherwin-Williams all work and/or are designed specifically for steel. If in doubt whether a specific paint product will work on steel, you can always try a test piece before you go for the

whole project. After coating a test piece to the manufacturer's specifications, try to scrape the paint off or leave the piece outside for a period of time to see how it fares.

Before painting, it's always a good idea to follow the cleaning steps listed earlier and put your work on a large drop cloth to catch the inevitable drips and overspray. Follow all safety instructions included with the paint of your choice—and get creative.

Brush Paint

Brush painting is the most basic way to apply a paint finish. It is great for applying a heavy coat, but in most cases it will leave you with an imperfect surface. I tend to use brush painting when touching up small details or if the temperature in my unheated studio does not permit me to use spray paint.

Most paints adhere best to a primed surface. A *primer* is paint that adheres to a variety of materials and helps to hide small blemishes on the surface. For example, a nice coat of primer is a great way to fill in minor grinder marks. Primers are made for specific applications, and two that I frequently use for brush painting are Rust-Oleum Clean Metal Primer and Rusty Metal Primer. These both have great adhesion and coverage and are available at nearly any home-improvement store. They are oil-based, so make sure to use either one in a well-ventilated area. Primer usually can be applied as a one-coat process. Get an even coat over all your work, and try not to build up so much paint that you are left with drips.

Endless varieties of brushable paints are available. If you're looking for options, try your local paint store or welding supply shop for advice. Generally, paint should be applied in at least two coats to get the smoothest, most even finish. Don't worry about areas where primer shows through on your first coat, just use even brushstrokes that are more or less all in the same direction.

TIP: You can paint a latex paint over an oil-based primer such as the two Rust-Oleum options mentioned earlier. However, you can't paint an oil-based paint over latex primer.

Application

Follow these steps for primer and paint both:

1. Clean the surface using the instructions at the beginning of this chapter. When handling your work, wear latex gloves to avoid getting body oils on it.
2. Support your work slightly off the drop cloth or floor by using pieces of scrap wood, cardboard, or other stationary objects. This will keep any paint that gets on the bottom of your work from sticking to the floor.

TIP: For each coat, start with the underside, let the paint dry according to the manufacturer's recommendations, and then turn the piece over and paint the top and sides again. Repeat this method for each coat desired.

3. For the first coat, start with your work upside-down resting on your support pieces.

4. Start painting in the small areas and corners. Make sure that all details have an even coat before working large areas.

5. Start painting larger areas using long, even brush strokes, and watch for drips around the edges and corners.

6. Once an even first coat is applied, let the work dry for the manufacturer's recommended drying time before turning the piece over or applying another coat.

7. Repeat this process for each coat of primer and paint.

TIP: For the smoothest finish, you can lightly sand between each coat using extra-fine-grit sandpaper. After sanding, make sure to wipe down any dust with a tack cloth or lightly damp solvent rag.

Spray Paint

Spray paint is often easier to apply than brush paint but usually doesn't have the same high coverage you can get with a brush. To allow the paint to be atomized and sprayed, it must be thinned down significantly and therefor drips easier and has less opacity by volume. However, when spray paint is applied properly, the results are a perfectly smooth and even coat. Figure 12.1 shows a project being spray painted in a home shop.

A downside to using spray paint is the overspray it generates. Overspray is all the paint that ends up not on your work, and it's usually quite a bit. This also means that spray painting isn't as materially efficient and therefore costs more to get the same coverage. With all the atomized paint molecules in the air, it's even more important that you wear a respirator and follow all safety instructions included with your brand of spray paint.

Just as with brush paint, spray paint adheres best to a primer. I use the same Rust-Oleum brand primer but in spray-can form. Usually I have a small inventory of spray can primer at my shop because it's what I use for 99 percent of priming.

One of my favorite types of paint is made by Montana. The company has hundreds of colors in its different product lines of Gold, Black, and White. The coverage of Montana paints is excellent, and the paints hold up very well. The company also makes different caps, or tips, which can help to cover a variety of surfaces with improved efficiency. With so many colors available, you can be sure that your projects will always stand out. Montana paints are available at most art supply stores or online.

Spray paint can be applied using the same techniques explained earlier in the brush paint section but with some extra care. Below are a few tips to keep in mind when spray painting:

Figure 12.1 Spray painting.

- Always hold your spray can about the same distance from your material, usually between 6 and 10 in.
- Hold the spray can at the proper orientation and never upside-down.
- Move along the material at a constant speed.
- Start the flow of spray paint off to the side of the material before the paint pass is made. When the pass is completed, release the spray paint beyond the end of the material, as illustrated in Figure 12.2.
- A well-lit environment is crucial to watch the paint *flash*, meaning that enough paint is on the surface to form an even coat. To best view the flash point, use the reflection of nearby lighting, and look for the first hint of a glossy finish. In Figure 12.3, I'm standing just above the workpiece to use the reflection of an overhead light.
- For the first coat, less is more, meaning that you do not need to get complete coverage on the first try.

Application

If space permits, a great way to spray paint a small metalworking project is to hang it. Hanging your work allows you to coat all sides at once, resulting in the most

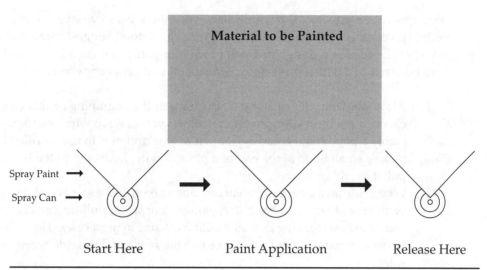

FIGURE 12.2 Spray-paint pass.

FIGURE 12.3 Spray-paint flash.

even application possible. If possible, hang your work near eye level to help with visibility. Because spray paint generates overspray, I don't suggest spray painting anywhere besides in a designated paint area or a garage where all surroundings have been covered with a drop cloth. Spray paint will get everywhere!

1. After following the cleaning instructions at the beginning of this chapter, choose a point on your project that allows you to wrap wire or string, preferably a point that is hidden from view. One option is to use a drilled hole, make a small hoop at the end of a piece of wire, insert it into the hole, and pull it to add resistance.
2. When you have a hanging point on your project, find a sturdy point in your paint area at which to hang it. A garage door track, pull-up bar, coat rack, and an exposed ceiling joist all would work fine in most cases. There should be enough room for the workpiece to hang freely and provide access on all sides.
3. Wrap the other end of your wire or string around the point from which your work will hang. Because the work can swing, this type of setup is not ideal for brush painting.
4. Start by spray painting the inside of corners, nooks, and hard-to-reach areas. Go all the way around the work until these all have a decent amount of coverage, but don't worry about making full coverage with the first coat.
5. Go over all the larger surfaces of the project with another light coat. When applying the second coat, watch for the flash point of the paint very carefully to add better coverage.
6. Since you don't have to reposition your work, you can get away with more frequent coats. Refer to the instructions that come with your paint to find out what the proper recoat time is.
7. After you let your work dry for the proper amount of time, remove your piece by untying the wire or pulling it out of the hole.

TIP: Drips in paint are a bummer, but they can be repaired. When you notice a drip, let it dry, and use fine-grit sandpaper to smooth it out. Touch up the sanded area with another coat of paint. Always fix drips before recoating with more paint; otherwise, it will be much harder to make them disappear.

Clear Finish

Paint-based clear finish is a great way to seal your work permanently but keep the natural look of steel while not hiding your connections and welds. Unlike a wax coating, clear finish doesn't need to be touched up frequently, and unlike paint, it does not need a primed surface.

Clear finish is available in a number of sheens, such as matte, satin, and glossy, and can be applied using spray or a brush. To apply clear finish, use the instructions for brush painting or spray painting but do not apply primer.

Wax

Wax is a great coating for steel because it doesn't take away from the natural look of the metal. It also is one of the few finishes that can be applied to a moving steel part such as a hinge. A steel surface finished with wax has a satin luster and is safe for handling and appropriate for indoor or outdoor use. If the piece is left outside, however, the wax coating will need to be reapplied every so often as needed, possibly every year. Figure 12.4 shows a coat of wax being applied to my log-holder project.

A number of types of wax are available on the market from hardware or specialty stores, such as bee's wax, floor wax, and butcher's wax. Wax is one of the most affordable ways to block rust from your projects. Also common among artistic finishes are colored waxes. They are usually more expensive but provide unique finishes that can be used with different types of metals.

FIGURE 12.4 Wax being applied.

Application

To wax finish steel, you only need a few items:

- Wax of your choice
- Heating instrument such as a propane torch or oxygen-acetylene torch
- Natural-fiber brush or rag

1. Clean the surface using the instructions at the beginning of this chapter.
2. Use your heat source to raise the temperature of your work slightly. This helps any captured moisture in the steel to evaporate and makes spreading the wax easier. You only need to get the surface hot enough to melt the wax, so just over 100°F should do the trick. Work in small areas so that you don't lose too much heat.
3. When you get a workable area heated, using either a natural-fiber brush or a rag, start to rub the piece down with wax. You want to get a fairly even finish and avoid large chunks of unmelted wax. You also can rub the wax directly onto the metal's surface and then spread it out using a rag or brush.
4. Repeat this process for the entire piece, and let sit until the wax dries to a haze.
5. With the surface dry and hazy, start to buff the wax using a clean cloth. The streaking caused by your wax application technique should go away, leaving you with an even luster.

Powder Coating

Powder coating is a finish process that involves electrically charging metalwork and applying dry paint particles that are oppositely charged. The application method for powder coating is usually a low-pressure gun with a hopper full of the dry paint. As the dry paint exits the gun, the particles are given a charge that attracts them to the metalwork. Once this powder is evenly applied, the whole piece must be baked for a period of time in some type of oven. The resulting baked-on coating is incredibly durable, smooth, and long-lasting. For a well-powder-coated piece of steel, you could expect the finish to last 50 years without any maintenance besides minor cleaning.

Some of the great advantages to powder coating are its material efficiency because the overspray, being just powder, can be collected and reused. Also, as I mentioned earlier, the durability of the finish is second to none. I once tried to strip a bicycle frame that I didn't realize had been powder coated. Sandpaper, a paint stripper, and chemical stripper only succeeded in scuffing the surface. Since the paint base isn't suspended in a solvent, there are very few volatile organic compounds (VOCs) and almost no hazardous waste produced. Powder coating

also lets you build up a thicker coat of paint, and there is no recoating to worry about. Because the paint bakes from the outside in, drips are usually not a concern.

Contrary to popular belief, powder coating can be done on a small DIY scale with one major limitation—the size of your oven. Because the finish is *cured*, or baked on, you must have access to an oven large enough to accommodate your entire work. If your projects are small enough to fit in a regular household oven, consider purchasing a used oven and having a dedicated powder-coating oven in your shop. Many powder-coating finishes need to be cured at less than 400°F, so even a basic used oven can suffice.

Caution: Never use the same oven for powder coating as you prepare food in.

I am not going to go into detail on how to set up your own powder-coating outfit; there are other books and websites for that. However, the basics for getting started are quite simple. All you need is

- A powder-coating gun and powder
- An air compressor with an air dryer
- An electric oven large enough to fit your work

To purchase a basic powder-coating gun, expect to spend upwards of $60 plus the cost of the powder. You should be able to find a good-quality, affordable used air compressor and oven rather easily. For under $300, you could have your own DIY powder-coating setup to finish your own small projects and projects for friends. Something to consider . . .

Projects

CHAPTER 13
Project Preparation

CHAPTER 14
Start from Scratch

CHAPTER 15
Cube

CHAPTER 16
Plant Stand

CHAPTER 17
Candelabras

CHAPTER 18
End Table

CHAPTER 19
Fireplace Log Holder

CHAPTER 20
Garden Cart

CHAPTER 21
Barbecue

Project Preparation

I n the following chapters you'll be exploring each of the tools covered earlier in this book and building on the skills that will let you create your own steel sculptural projects. Hopefully, by the end, you'll feel confident to imagine and build your own creations. For the more advanced projects in this book, you should plan on having everything pictured in Figure 13.1. This is what I show up to my studio with almost every day.

FIGURE 13.1 Common metalworking tool and safety set.

Materials

Using what you learned in Chapter 3 about finding and purchasing steel, you'll need to order some materials for the upcoming chapters. Here's what you'll need:

- 1- × 1- × ⅛-in angle, hot-rolled (HR)—3 lengths at 20 ft
- ½- × ½- × 0.083-in angle, HR—1 length at 20 ft
- ⅜-in square stock, HR—2 lengths at 20 ft
- ¼-in round stock, HR—6 lengths at 20 ft
- ½-in round stock, HR—4 lengths at 20 ft
- ⅜-in round stock, HR—2 lengths at 20 ft
- ¾-in round stock, HR—1 length at 20 ft
- ⅛- × 1-in flat stock, HR—2 lengths at 20 ft
- 1- × 1- × 0.083-in square tubing, HR—4 lengths at 24 ft
- ¾-in pipe, Schedule 40—1 length at 21 ft (Remember, the ¾-in dimension is the *inside* of the pipe.)
- 10-gauge sheet, HR—48 × 96 in, sheared to 2 pieces at 48 × 48 in for ease of use

Figure 13.2 shows some of the material delivered from Mid City Steel. This material should be enough for all the projects in this book and more. There should

FIGURE 13.2 Freshly delivered steel ready for projects!

even be enough to make a few mistakes and still have what you need to complete the projects without reordering.

Studio Access

If you are looking to access a shared metal shop or other local resources, see the "Resources" section at the end of this book for a list of resources spread across the country. If the shared shop has all the tools covered in this book, you'll be able to complete any of the projects in the upcoming chapters.

Time

Whenever you plan to get in the studio to start work, I encourage you to do so with patience in mind. Sometimes things aren't going to go exactly as you expected, but don't get frustrated or impatient—just take a short break and reflect or talk to a fellow metalworker about the issues or problems. A lot can come out of simple metal shop conversations.

I've tried to provide accurate estimates on the time I think it will take a newcomer to complete the following projects, but there are so many variables that depend on the shop specifics, your work style, and countless other issues. Don't assume that if a project is taking longer that I've said that you're doing it incorrectly. Take it as a sign that you're enjoying the metalworking process and working smart and safe!

Start from Scratch

This may be the oddest project in this book, but I think it's a really fun one for newcomers to see that the metal–inert gas (MIG) welder can be an art-making machine. For this project you'll ignore most of what you've learned about welder settings and weld orientation and focus on starting and stopping the weld. All you need to create sculpture with the MIG welder is a starting surface. If you work slowly from there, you can build sculptural shapes using only welding wire. With a bit of patience, you can make some pretty impressive pieces with a really unique look. Figure 14.1 shows my MIG-welded igloo. With this project, you can make animals, structures, pots, plant forms, and more. Think of how the form you select would connect to the ground, and work up from there using layers. These small projects can make fun gifts and are a good way to get used to the low-lighting environment of MIG welding.

What You Need
- Any scrap of steel larger than a quarter
- An angle grinder with a flap disk
- A MIG welder
- Personal protective equipment for MIG welding

Instructions

1. Clean your scrap of steel using the flap disk to help promote a good arc.
2. Set your welder to the appropriate settings for your material—but turn the wire feed up slightly. By turning the wire speed up, you'll add more filler than necessary with each weld, helping you to build something from nothing.
3. Create a series of tack welds, one on top of another, to build up a three-dimensional form.

FIGURE 14.1 A hollow MIG-welded sculpture.

4. Wait for each tack weld to cool off between welds to make the most of the filler material. If you welded a solid bead for this exercise, the heat would start to burn away the base material and filler before you could build a structure. Figure 14.2 shows progress on my igloo form.

NOTE: This series of small tack welds can be used to fill small gaps in various materials. If the ratio of filler metal to heat is in favor of the filler, you can add material quickly without burning away much of the base material.

5. Figure 14.3 shows another structure made using just filler metal. Note the excess spatter around the piece. Remember that when MIG welding, and especially with excess filler, spatter will occur. Even though it's sort of messy, the workpiece is in good shape. If you notice this much spatter under normal operation, you may want to try turning down the wire feed slightly.

TIP: If you ever have trouble starting the weld arc when you pull the MIG welder trigger, try cleaning the surface of your material with a wire brush, and double-check that your ground is getting a solid connection.

FIGURE 14.2 Progress.

FIGURE 14.3 Extra filler and spatter.

Cube

T his project is going to further your practice with the metal–inert gas (MIG) welder and plasma cutter. If no plasma cutter is available, you can use an oxygen-acetylene torch. The idea here is to learn some basic layout techniques with steel and removed material in certain areas so that you are able to bend them easily. Welding in this project is minimal, but you'll get great practice with the torch and see how workable steel is when designed properly. Figure 15.1 shows a completed bent and welded cube.

FIGURE 15.1 Bent and welded cube.

What You Need

- 10-gauge steel
- Hand tools and clamps
- An angle grinder
- A plasma cutter or oxygen-acetylene torch
- A MIG welder

Instructions

1. Place a piece of 10-gauge sheet metal on your cut table or hanging over the edge of your welding table.
2. If you would like to make a cube that is 6 in on each side, make your piece of steel at least 18 × 24 in. You are going to lay out the cube in a T formation as in Figure 15.2.
3. Using a straight edge and the plasma cutter or torch, set up to cut along the outside of your T as in Figure 15.3.
4. When it's all cut out, you should have a shape like that in Figure 15.4.
5. Along the lines inside your T (the edges of each square side), cut slices approximately 1 in long, leaving short connecting bits of steel ¼ in wide.
6. When you get these cuts completed, hammer off any slag on the backside of the cut with a slag hammer as in Figure 15.5.

Figure 15.2 The 6-in square sides of the cube positioned in the form of a T. Each side is marked with an X.

FIGURE 15.3 Cutting the outside, nice and straight.

FIGURE 15.4 Cut out the T.

7. Grind along the edges of your steel to remove any sharp edges or other slag.

8. Using C-clamps or a vice, as in Figure 15.6, hold the sides of your cube, and start to form the bends by hand.

FIGURE 15.5 Cleaning the cuts.

FIGURE 15.6 Using a vice to hold the sides of the cube.

9. Because you cut away material along the bend lines, the bending should be quite easy, and you don't need to worry about them being straight.

10. Continue bending as shown in Figures 15.7 and 15.8.

FIGURE 15.7 Bending progress.

FIGURE 15.8 Bending progress.

Tip: *If you have trouble bending any part of this cube, try using an adjustable wrench to get extra leverage, as shown in Figure 15.9.*

11. When all the sides are bent close to where you want them, use C-clamps to hold the cube together for your welds, as shown in Figure 15.10.

12. Make a series of welds like those shown in Figure 15.11 that match the small material that is bent around each corner.

Figure 15.9 Adjustable wrench for leverage.

FIGURE 15.10 Clamped cube.

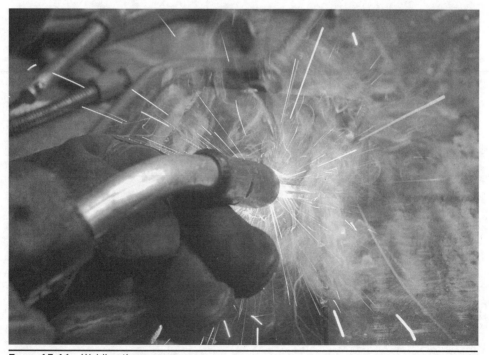

FIGURE 15.11 Welding the seams.

Plant Stand

aking a plant stand is my way of coming up with a project that starts you using a welding table as a layout tool. With soapstone, basic squares, and a flat, square steel table, you'll be able to create all kinds of projects. This is also a fun project to start using scrap metal. However, I won't assume that you can find scrap metal, so you'll cut out some pieces of 10-gauge steel using the torch or plasma cutter.

What You Need
- 10-gauge steel
- $\frac{3}{8}$-in square stock
- Hand tools
- A grinder
- A metal–inert gas (MIG) welder

Instructions

1. The main trick to this project is to lay out two parallel lines on your welding table.
2. Working with those lines and some basic squares, you can easily make paraelle forms. Figure 16.1 shows a finished plant stand layout that is nice and square. Figure 16.2 shows how I used basic squares and a simple straight line drawn on the table to make sure that the two old disk-brake rotors were parallel.
3. Use a 24-in square to draw a box or a pair of parallel lines on your welding table.
4. Arrange the top and bottom pieces perpendicular to the table and your lines with layout magnets or other square hand tools (Figure 16.3).

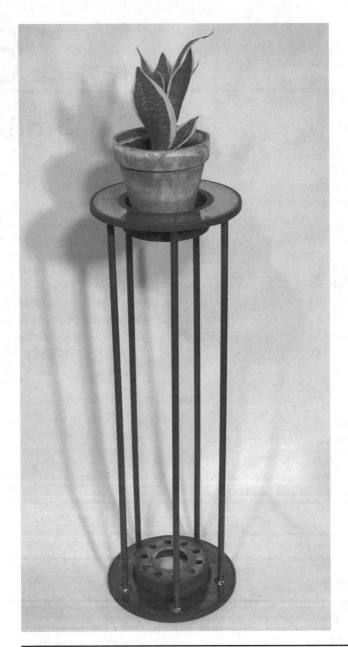

FIGURE 16.1 Squared up.

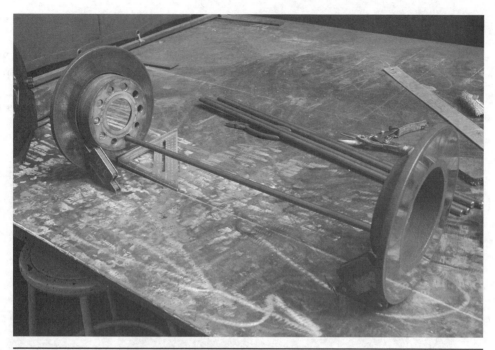

FIGURE 16.2 Rotors supported square to each other.

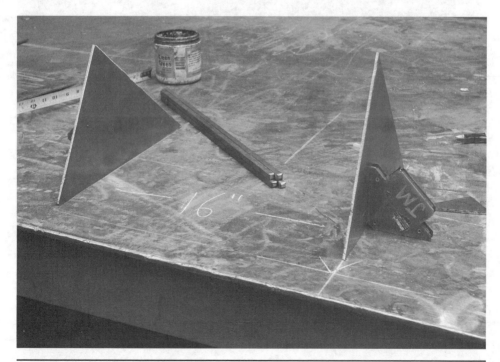

FIGURE 16.3 Work pieces held parallel.

5. Measure the distance between the insides of your material, and cut your ⅜-in stock to that measurement.
6. Without disturbing the squareness of your pieces, weld each ⅜-in support to the material, starting with tack welds and moving to full beads when the square is confirmed, as in Figure 16.4.
7. Figure 16.5 shows a completed plant stand using no right angles but assembled using very basic metalworking techniques.

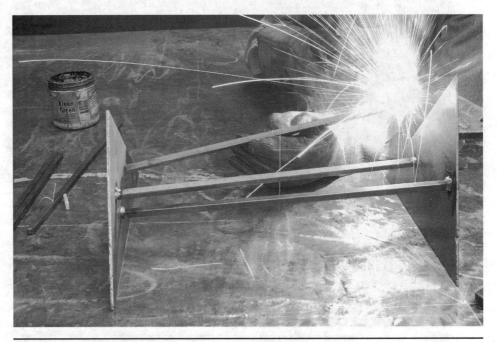

Figure 16.4 Welding supports.

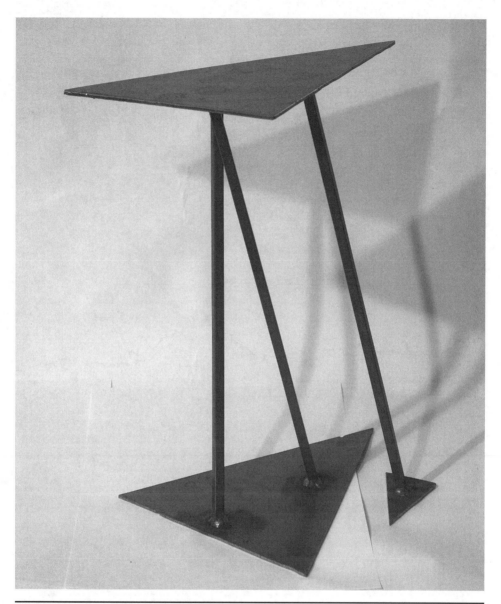

Figure 16.5 Finished triangular plant stand.

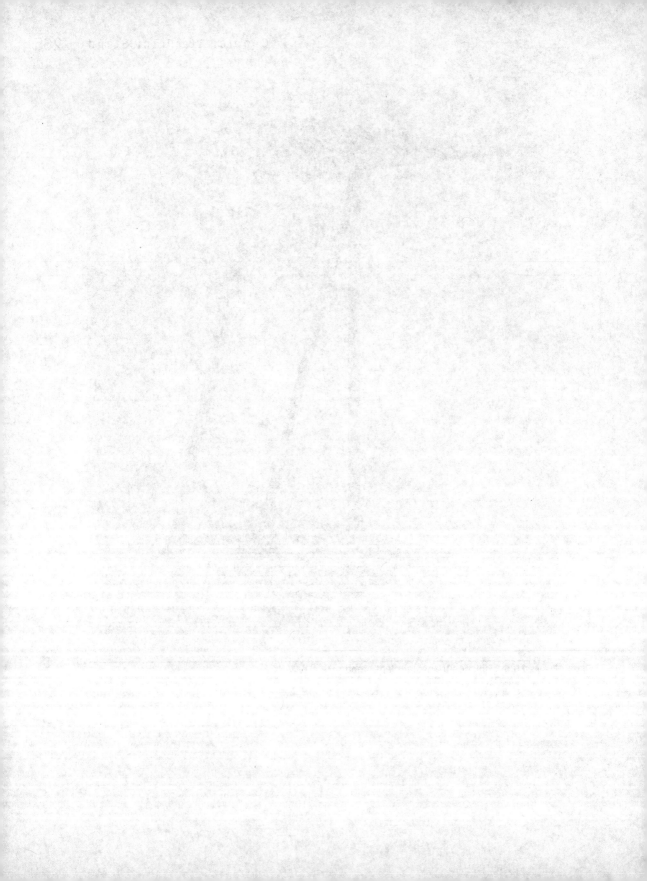

Candelabras

T his project was inspired by 1960's cast-brass candelabras I discovered recently in an antique store. The stacking three-candle stands were cast from brass, but this version you can make yourself. In this project, you'll get a little more precise with your layout and build a simple wooden jig that helps you to "mass produce" multiples of the same idea. Figure 17.1 shows a finished arrangement of stackable candelabras.

FIGURE 17.1 Candelabras.

NOTE: *Taper candles come in a variety of widths between ½ in. and ⅞ in. Using material you've already purchased for this book you'll build candelabras that can accept candles up to ¾ in.*

What You Need

- ⅜-in round stock
- ¾-in pipe, Schedule 40
- ¾-in round stock
- Scrap plywood or Medium-Density Fibreboard (MDF), ⅜ or ½ in thick
- Hand tools
- A drill press
- A bench grinder
- A metal–inert gas (MIG) welder

Instructions

1. First, cut all the material you need using a chop saw, or if that's not available, you can use an angle grinder. To make five candelabras, cut 15 pieces of each of these:
 a. ¾-in inside-diameter (ID) pipe at 1½ in long
 b. ¾-in round stock at 1 in
 c. ⅜-in round stock at 1%₁₆ in
 d. Figure 17.2 shows all the cut pieces ready to go.
2. Chamfer all the cut edges on your material, and deburr the inside of the cut tube.
3. On the ⅜-in round stock, put an extra deep chamfer on one end, as shown in Figure 17.3.
4. With the material ready, lay out a jig onto ⅜-in plywood or MDF. Draw a circle with three evenly spaced points around it where you will locate the ¾-in rod and pipe. Using the drill press, put a ¾-in hole at each of these points, as in Figure 17.4.
5. You also want to make a jig that allows you to stand the pipe ⅜ in off the ¾-in solid stock, so drill some more holes in a few scrap pieces of plywood or MDF to give the result shown in Figure 17.5.
6. Drill a ⁵⁄₁₆-in hole centered about ½ in from the edge on all your pipe, as shown in Figure 17.6. These holes will let you plug weld the ¾-in solid stock to the pipe that fits around it.
7. Slide the ¾-in stock into the jig, and place a piece of pipe over it as shown in Figure 17.5. Fill all the holes you just drilled with a hot plug weld.

FIGURE **17.2** Completed cut list.

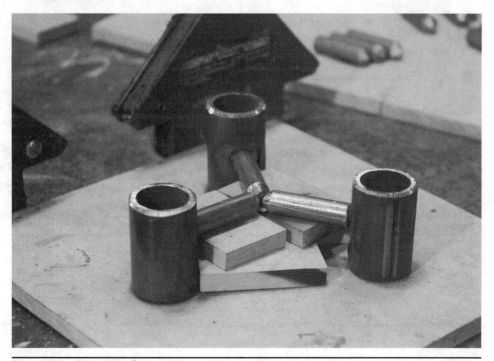

FIGURE **17.3** Chamfered $\frac{3}{8}$-in stock.

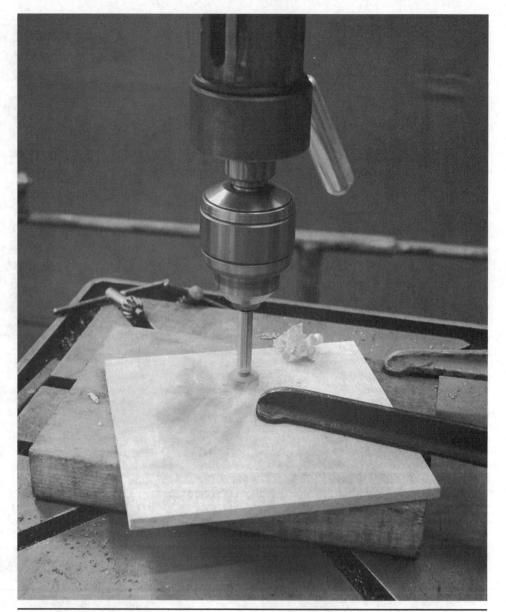

FIGURE 17.4 Creating the jig.

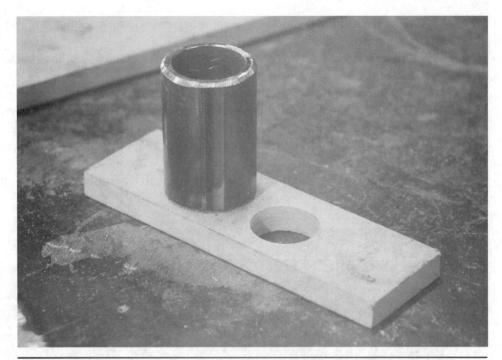

FIGURE 17.5 Standoff jig.

FIGURE 17.6 Drilling the hole to be plug-welded.

8. Now back to the layout jig. Use some scrap wood to space the ⅜-in rod off the surface of the jig, as shown in Figure 17.3.

9. Put a tack weld at each of the connection points, and slide the candelabra out of the jig.

10. Flip it over, and weld around each seam on the backside of the piece.

11. Flip it over again, and finish welding the top of each seam as shown in Figure 17.7. Try putting the candelabra back into the jig at different spots to see how accurate your work is. If needed, alter the jig to make it more consistent.

12. Repeat these steps until you have completed all five candelabras, as shown in Figure 17.8.

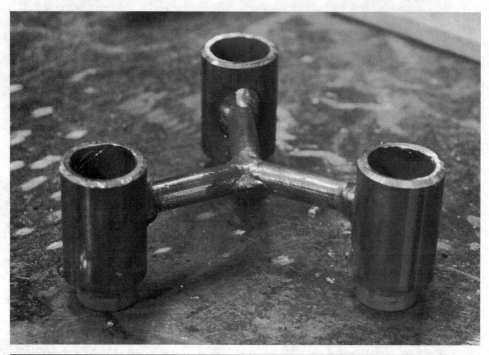

Figure 17.7 Finished unit.

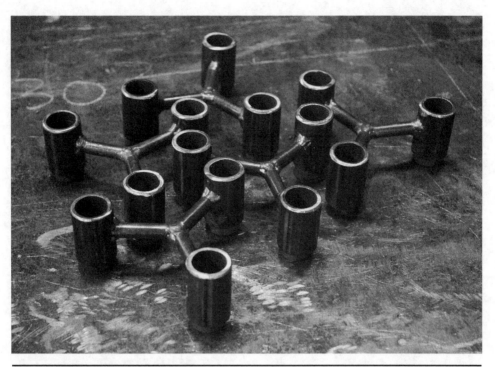

FIGURE 17.8 Completed candelabras.

End Table

For this project, you will build a small end table, but for a challenge, I won't include any right angles. Figure 18.1 shows my triangular creation. Although 10-gauge sheet metal is significantly thicker than automotive sheet metal, you still have to be careful about the amount of heat you generate when welding and grinding. A fun thing about this project is that the tabletop will give the illusion of being made out of solid $\frac{5}{8}$-in-thick steel.

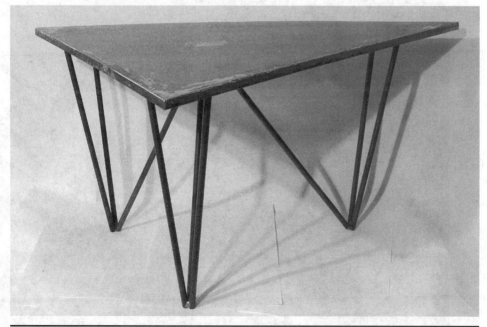

FIGURE 18.1 Triangular end table.

What You Need

- 10-gauge sheet metal
- ½- × ½- × 0.083-in angle stock
- ½-in round stock
- Hand tools
- A grinder
- A plasma cutter
- A metal–inert gas (MIG) welder

Instructions

1. Lay out the shape you want to use for your end table. I drew a triangle with sides 26, 38, and 32½ in and cut it out using the plasma cutter, as shown in Figure 18.2.

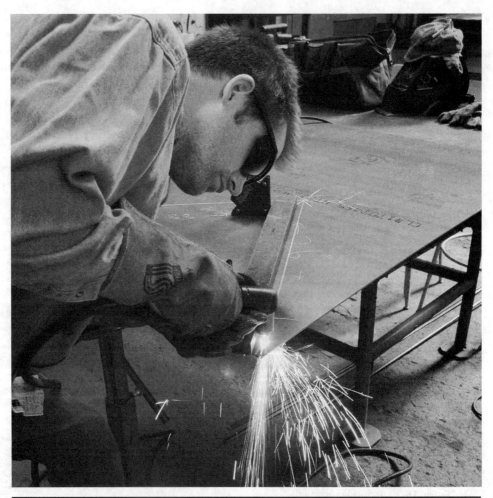

FIGURE 18.2 Cutting a triangle.

2. When you're finished cutting, grind the corners and edges to make working with the sheet metal safer and easier. My tabletop is shown in Figure 18.3, ready for the next steps.

3. Using the ½-in angle stock, lay a short length across the underside of one of the edges on your tabletop, and mark its length.

4. Using an adjustable square guide, calculate the angle of the corner, and mark half that onto the top edge of the ½-in angle stock. Cut it out using an angle grinder and cut disk, as shown in Figure 18.4.

5. Repeat this process for all three corners so that your resulting material fits nice and tight like the corner shown in Figure 18.5.

6. Use clamps to hold your pieces together, and put a series of tack weld on the inside of each length of angle stock, as shown in Figure 18.6.

7. Repeat this all the way around, and flip your tabletop over.

8. Set up your welder for the material in use, and start making short tack welds along the seam between the angle stock and 10-gauge sheet metal. Figure 18.7 shows a series of approximately 1-in tack welds that I made along the seam. You may want to start out using even smaller tack welds, say ½ in long, and alternate between ½-in tack welds and 1 or 2 in between each one. For thinner sheet metal, this minimal use of heat is even more important.

Figure 18.3 Finished tabletop.

FIGURE 18.4 Cutting the ½-in angle stock.

FIGURE 18.5 Well-made corner.

FIGURE **18.6** Corner piece tacked in place.

FIGURE **18.7** Tack welds.

9. Work your way around the tabletop in this manner, and then go back to fill in between the welds after leaving each side to cool for some time.

10. When all the sides have a continuous weld, it's time to grind the weld.

11. Figure 18.8 shows how I clamped the tabletop to the side of my grinding table for ease of grinding. This isn't necessary but is very useful if your grinding table supports this kind of work.

12. When I finish grinding the weld, I use the grinding disk to put small notches along the edge in a vertical orientation to give the illusion that the tabletop is solid steel and was cut using a torch or plasma cutter. Figure 18.9 shows this process.

13. With all the exterior welds ground, you are ready to fabricate the legs. For this, I'm going to mirror the triangular shape of the tabletop.

14. With the table upside down, bisect each corner, and mark along each line a point where it is roughly 4 in from edge to edge. Also, as shown in Figure 18.10, continue each line to the center, where you will join each leg in a later step.

FIGURE 18.8 Clamped tabletop.

FIGURE 18.9 Illusion making.

15. Cut four pieces of ½-in round stock to the desired length to match the height of your table. My legs are 18 in long.
16. Draw a simple layout pattern on the table consisting of a perpendicular line and marks to space the ends of the legs properly at 4 in apart, as shown in Figure 18.11. Use magnets to keep the legs from rolling during this step.
17. Put a nice weld on each of the legs where the two sides meet up, but be careful not to weld to the table!

FIGURE 18.10 Leg welding points marked.

FIGURE 18.11 Leg layout.

18. On the underside of your tabletop, mark 2 in along the line to the center, and place a square at that point. Leaning the legs against the square puts the center point of them 2 in off plumb, as shown in Figure 18.12. Put a nice weld around each side of the leg and tabletop.

FIGURE 18.12 Giving the legs some lean.

19. With each of the legs welded or tacked in place, measure from their tip to the center mark on the table. Cut ½-in round stock to fit as shown in Figure 18.13. Weld these in place.

20. With all the welds completed, you are left with a nice, sturdy end table, as shown in Figure 18.14.

FIGURE **18.13** Diagonal leg sections.

FIGURE 18.14 Finished product.

CHAPTER **19**

Fireplace
Log Holder

F or this project, you're going to build a heavy-duty fireplace log holder in a modern style (shown in Figure 19.1). This project again will introduce a type of jig and provide practice at making multiples of one piece.

What You Need
- 10-gauge sheet metal for the jig
- 1-in flat stock and $\frac{3}{8}$-in square stock or similar, also for the jig

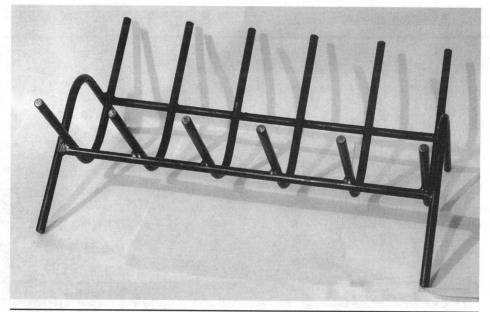

FIGURE 19.1 Fireplace log holder.

- ½-in round stock
- Hand tools
- A grinder
- A torch with a rosebud tip
- A metal–inert gas (MIG) welder

Instructions

1. There are two options for this project jig: You can weld the jig directly onto the welding table, or you can use a separate piece of sheet metal, as I've done in Figure 19.2, and clamp that to the welding table. Some shops may not want you to weld to the table, and using a separate piece means that you can hang onto the jig and make more later.
2. Lay out the jig guide as shown in Figure 19.2, and use the 4-in flat-stock hoop you rolled in Chapter 8 during one of the roller practice sessions. Weld the hoop together if you haven't already done so.
3. Weld the hoop to your guide material 2 in from the bottom and centered across the 14-in dimension.
4. Lay a length of ½-in round stock over the corner of the log holder (8 in from the bottom and 7 in from the center of the hoop) that touches the edge of the hoop. Use short pieces of square stock to locate this length on your guide, as shown in Figure 19.3.

FIGURE 19.2 Jig.

Figure 19.3 Laying out the guide.

5. Weld the square stock to the guide using well-made tack welds. There will
 be a bit of force against these pieces, so make sure that they are secure.
6. Using a length of ½-in round stock that is longer than you need, say 22 in,
 mark out where the bend will take place using soapstone, as shown in
 Figure 19.4.

Figure 19.4 Bend area marked in white soapstone on material to be bent.

7. Rest the length of solid stock above the work table or off to one side, and fire up the rosebud-tipped torch to the proper settings to heat it.

8. Work the rosebud tip back and forth over the area to be bent, as shown in Figure 19.5.

9. Using your gloved hands, bend the ½-in round stock around the guide until it matches the other side, as shown in Figure 19.6.

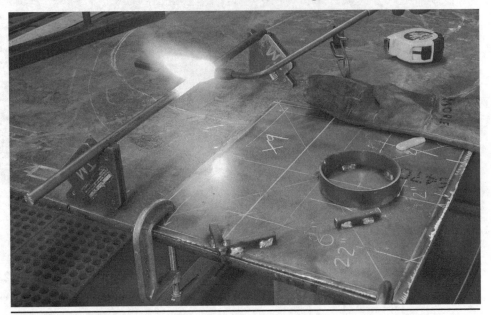

FIGURE 19.5 Heating.

FIGURE 19.6 First bend.

10. Measure the excess material on the long side, and subtract it from the initial length of 22 in. I have an extra 3⅜ in, so my total length should be 18⅝ in.

11. Cut eight lengths of ½-in round stock to 18⅝ in. (Cut an extra one, making nine, just in case you need it.)

12. Lay out all the pieces on the table, and mark where you will heat them, as shown in Figure 19.7.

13. Using the same strategy as before, heat up each length and bend it around the guide, as shown in Figure 19.8.

14. Repeat this until all the parts are bent the same amount, as shown in Figure 19.9.

15. Now you want to join the two ends of the log holder together, so get ready to MIG weld.

16. Figure 19.10 shows my jig being used to keep the ends symmetrical and other lengths of ½-in round stock used as support.

17. With the ends welded, you now want to cut and weld ½-in round stock to span the width of the log holder. For the length, I used 21½ in to evenly space the bent pieces every 4 in.

18. Using magnets and squares, arrange this piece perpendicular to the end of the log holder, as shown in Figure 19.11.

FIGURE 19.7 Soapstone marks for heating.

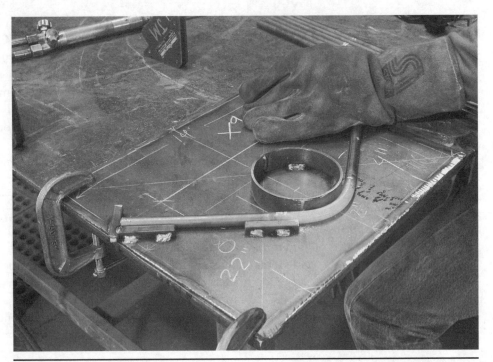

Figure 19.8 More bending.

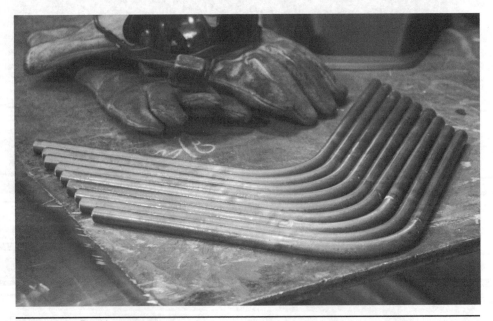

Figure 19.9 Bent log support.

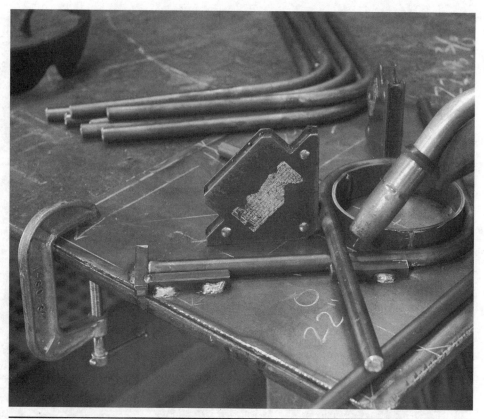

Figure 19.10 Welding the ends.

19. Flip the log holder over, and locate each support piece 4 in on center or 3½ in edge to edge. Placing the piece upside down helps to keep the top ends of the work aligned. Figure 19.12 shows this process.

20. Figure 19.13 shows all the supports in place and welded.

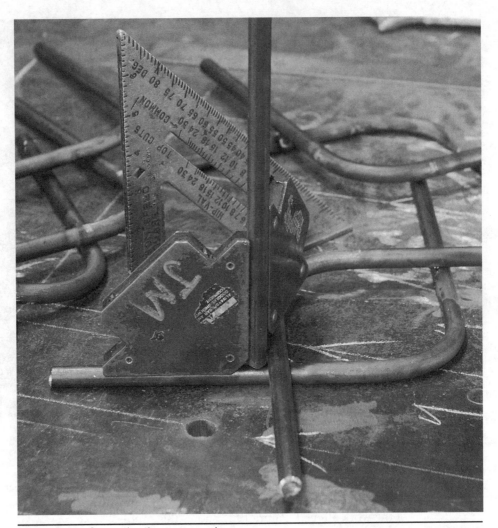

FIGURE 19.11 Supporting the cross-member.

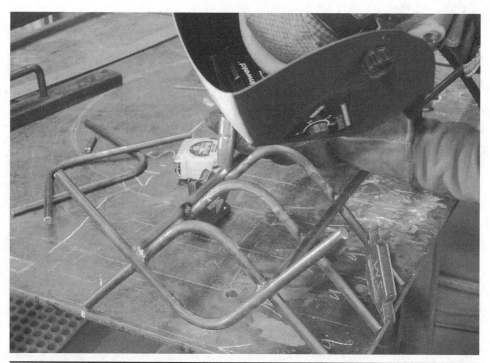

Figure 19.12 Placing the supports.

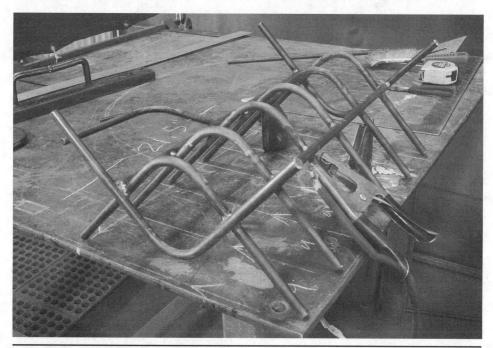

Figure 19.13 Complete, but upside down.

Finishing

Because the piece you created in this project is meant to be in direct contact with flaming logs and embers, you won't want to finish it using any material that can burn. Wax is the perfect choice for this to keep the piece from rusting between uses. Because it is inside, it shouldn't build up much rust to begin with, but if you ever notice any, just wire brush it away and reapply the wax finish.

Garden Cart

T his project is going to require using some extra pieces and parts, and introduce some extremely useful fabrication basics. The basic platform of this cart could be modified to work with a number of different-sized bicycle wheels and even could be outfitted to work as a bicycle trailer. Figure 20.1 shows the framework with wheels before adding the plywood panels.

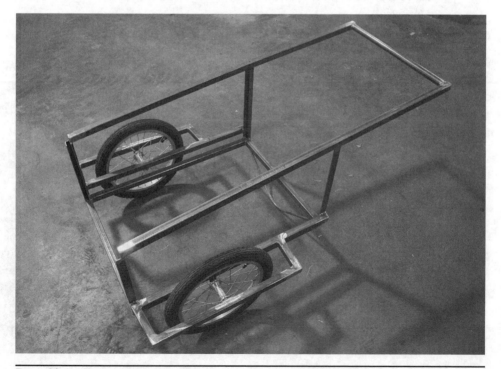

FIGURE 20.1 Garden cart.

What You Need

- 1- × 1- × ⅛-in angle stock
- 1- × 1- × 0.083-in square tubing
- ⅛- × 1-in flat stock
- ¾-in pipe
- ⅜-in round stock
- Bicycle wheels
- Hand tools
- A grinder
- A metal–inert gas (MIG) welder

Instructions

1. To start off, draw a rectangle to the dimensions of the cart platform on your welding table. My base is going to be 30 × 22 in.
2. Figure 20.2 shows square tubing cut with mitered corners at 45 degrees within my 30- × 22-in box.

NOTE: *When the square-tube frame is welded, it will be the first of your projects to have a hollow airtight space. Because welding has such high heat, it can rapidly expand air within your work, causing problems. Before you weld the frame, drill two ¼-in holes in it for safety.*

FIGURE **20.2** Square-tubing base.

3. When welding a frame such as this, it may help to reposition the piece so that you get the best weld position. Figure 20.3 shows how I've rotated the work so that I can weld in a flat/horizontal position rather than vertical.

4. Before the next steps, grind all welds smooth on your frame, leaving the inside corner welds the way they are. Inside corners are difficult to grind without special tools, and they add a lot of strength.

5. For the front of the garden cart, I want to make a sliding door. To do this, I'll use steel to make a channel to accept ⅜-in plywood that can be lifted out. I want the front height of the cart to be 10 in, so the rail can be about 9 in. Cut four sections of flat stock and angle stock to make two of the pieces, as shown in Figure 20.4. Space the material apart using ½-in rod.

6. Make short weld beads along the seam between the flat stock and angle stock.

7. With one side of the channel square, you want to put a 5-degree pitch on the other end to give the cart a sloping handle. Using an adjustable square,

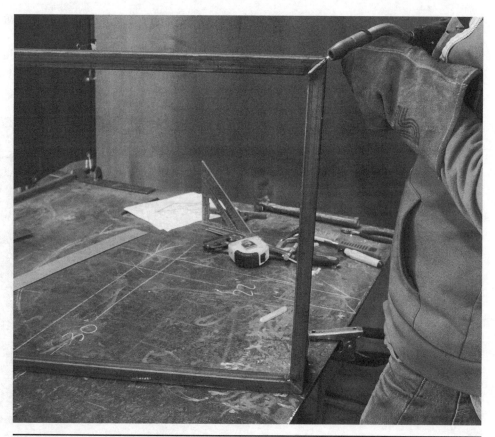

Figure 20.3 Moving the work for ease of welding.

FIGURE 20.4 Pieces of the channel.

scribe a 5-degree line 9 in away from the other end of the channel, and cut it using a cut disk on an angle grinder, as shown in Figure 20.5.

8. With both pieces of channel cut the same, arrange them on the front edge of the cart base with the channel openings facing each other, as shown in Figure 20.6. Tack weld them in place.

FIGURE 20.5 Cutting the channel.

FIGURE 20.6 Channel ends.

9. Cut two lengths of angle stock, perpendicular on one side and with a
5-degree cut on the other side to make the supports for the back of the
handle, as shown in Figure 20.7.

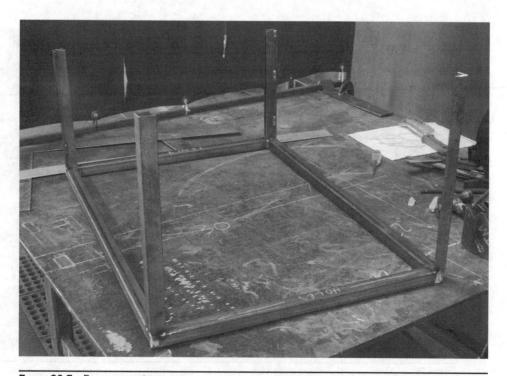

FIGURE 20.7 Rear supports.

10. Cut two lengths of square tubing to about 4 ft long to make up either side of the handle. You don't want to have exposed openings in the tubing for an outdoor project, so cut four 1-in squares of 1-in flat stock and weld them to the ends, as shown in Figure 20.8 (don't forget to drill a hole to let hot gas escape). Grind the squares smooth to give the appearance of a solid piece of steel.

11. Set the lengths of tubing on the front and rear supports of the garden cart (making sure not to cover the top of the channel), and tack weld them in place.

12. Cut a length of pipe to be used as the end of the handle. On my cart, it's 20 in long. I used magnets to position it while I tacked it in place, as shown in Figure 20.9.

13. Weld all the tacks you've made so far, taking measurements to make sure that things are staying straight, and then grind the visible welds smooth, as shown in Figure 20.10. Make sure to weld the inside corners where the square tubing meets the angle on the handle and the cart base. These corners are very strong, and the welds will be hidden from view.

14. Next, you need to make the supports for the wheels. There's quite a bit of flexibility here for different-sized wheels and to raise and lower the overall height of the cart.

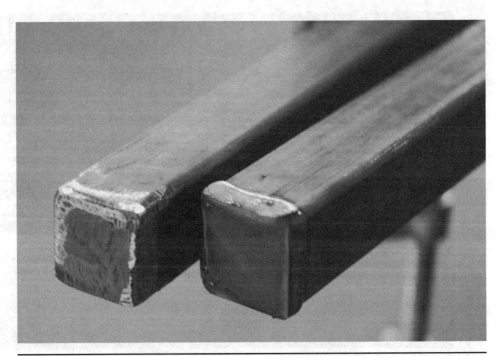

Figure 20.8 Ground and welded ends of tubing.

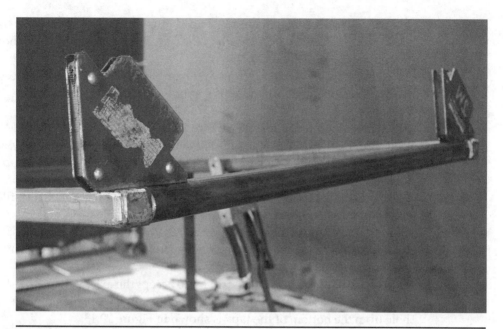

FIGURE 20.9 Ready to tack the handle in place.

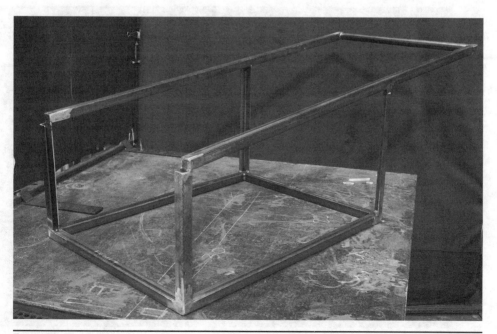

FIGURE 20.10 Progress!

15. For the wheel support, I made a P-shaped frame that supports the axle from above and spans the whole length of the cart. The P-shaped frame is shown tacked together in Figure 20.11.

16. To add some style, I cut my front and rear pieces of tubing at 5 degrees to match the slope of the handle. It's subtle, but it looks pretty nice when completed.

17. The wheels I am using for my cart are 16-in front wheels with a solid ⅜-in axle. The width between axle nuts is 3⅞ in, so the space between the wheel-support frames needs to be at least 4⅛ in to make room for the dropout tabs.

18. After making sure that the frames are square, weld all corners, and fill in the open square ends using 1-in squares of flat stock.

19. To make the dropout tabs, cut four 2-in lengths of flat stock.

20. Find the center of these tabs, and center punch ⅜ in up from one end, as shown in Figure 20.12.

21. Drill these all out using a ⅜-in drill bit to accept the axle.

22. After drilling, use a cutoff disk to cut slightly angled openings to the ⅜-in hole from the bottom of the tap, as shown in Figure 20.13.

23. Mark the center of the P-shaped wheel support frame, and clamp each dropout tap here on the inside of the frame. Align the top of the tab with the top of the frame tubing to get the same height.

FIGURE 20.11 Wheel support.

FIGURE 20.12 Center-punched tabs.

FIGURE 20.13 Angled cuts in the dropouts.

24. Use a ⅜-in rod across the whole cart to check alignment of the tabs. Figure 20.14 shows me using an adjustable square to make sure that the dropouts are perpendicular to the cart frame.
25. Weld along all the seams of the dropout tab.
26. Mount the wheels to the frame so that you can check for alignment and ground clearance. Figure 20.15 shows me measuring the height from the ground to achieve my desired cart-sitting angle. This angle slopes the handle back toward the user slightly so that when it's picked up, the support won't rub on the ground.
27. The support can be made out of any type of material, but I'm going to hand bend a length of ⅜-in round stock, as shown in Figure 20.16. I probably wouldn't be able to do this to ½-in round stock, but ⅜-in round stock is just workable enough.
28. Using magnets, position your support at the rear of the cart (Figure 20.17), and weld it to the frame.
29. Go through the frame, and double-check that all the pieces of the frame, handle, and wheel supports are welded and ground (where appropriate). Figure 20.18 shows a detail of some of these welded connections.

FIGURE 20.14 Checking for square.

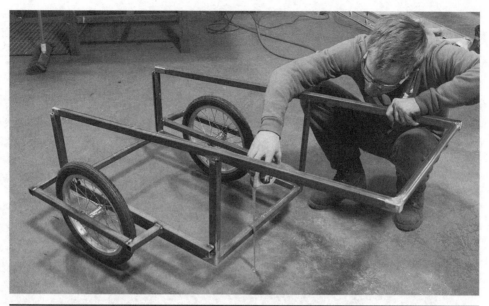

FIGURE 20.15 Measuring for the support.

FIGURE 20.16 Bending the ⅜-in round.

FIGURE 20.17 Rear support.

FIGURE 20.18 Welded connection detail.

Finishing

Because the cart created in this project is for outdoor use, I highly recommend a nice coat of outdoor-rated paint (or better yet, powder coat). Follow the instructions in Chapter 12 to thoroughly clean your metal, and give it a nice coat of primer and two or three coats of paint. Remove the wheels for these steps.

Barbecue

T he barbecue you will build in this project, based on a 55-gallon drum (Figure 21.1), is one of those quintessential do-it-yourself (DIY) projects that I thought had to be featured in this book. I used to be reluctant to use 55-gallon drums for much of anything because the thin-wall sheet metal it's made out of can

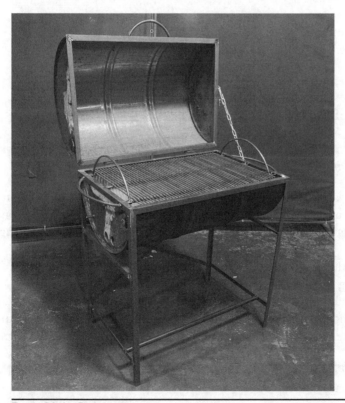

FIGURE **21.1** Barbecue.

311

be difficult to weld to, and when it is left outside, it can rust pretty quickly. The combination of elements from being left outside and frequent temperature changes when using a barbecue means that the drums frequently give way to rust rather quickly. I made a few alterations to my 55-gallon barbecue design that I think will help to make this project one that lasts quite a while.

What You Need

- 55-gallon drum (clean interior)
- 1- × 1- × ⅛-in angle stock
- ⅛- × 1-in flat stock
- ¾-in pipe
- ½-in round stock
- ⅜-in round stock
- ¼-in round stock
- 10-gauge sheet metal
- Chain
- Assorted ¼-in hardware
- Steel hinges
- Hand tools
- A grinder
- A plasma cutter
- A metal–inert gas (MIG) welder

Instructions

1. The first step is to cut the 55-gallon drum in half.

CAUTION: *Make sure that nothing flammable is inside the drum before making contact with the angle grinder or plasma cutter.*

2. Draw a box equal to the diameter of the drum (usually 22.5 in) on the worktable, and draw diagonals across each corner. Place the drum on the box with its seam lined up with one of the diagonals, as shown in Figure 21.2.
3. You'll use this seam as one of the cut lines and mark the other side of the barrel along the same diagonal line. Flip the drum over and repeat.
4. Using a straight edge, mark a line along the side of the marks you made in step 3, as shown in Figure 21.3, and along the barrel's seam. This is your cut line, and the straighter it is, the easier time you'll have welding the barrel to the frame.
5. Connect the lines on either side across the top and bottom of the barrel, and prepare to cut.

FIGURE 21.2 Lining up the barrel to cut.

FIGURE 21.3 Cut line.

6. Figure 21.4 shows me using a cutoff disk on the barrel to make a nice clean cut. Make sure to wear a respirator if you are grinding through paint.

7. After cutting both sides and the top and bottom, you should have a barrel like mine, as shown in Figure 21.5.

FIGURE 21.4 Cutting the barrel.

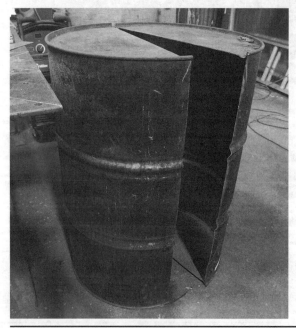

FIGURE 21.5 Neatly sliced barrel.

8. To prepare to weld the barrel to the frame, use a grinding wheel or flap disk to clean the inside edge of the bottom half (Figure 21.6) and the outside edge of the top half of the barrel.

9. Cut lengths of 1-in angle stock with a 45-degree miter on both ends to fit around the outside of the barrel bottom. Lengths for these sections are 34¾ and 23¼ in, but they may vary depending on your barrel. Figure 21.7 shows me tacking these sections using the barrel as my guide.

FIGURE 21.6 Cleaning the inside edge.

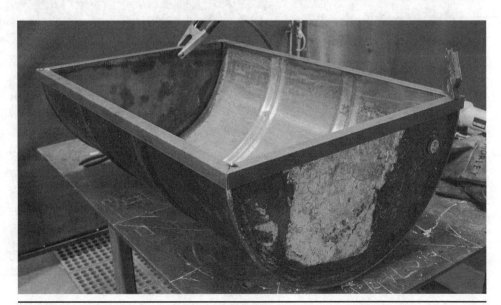

FIGURE 21.7 Tacking the frame for the bottom barrel.

10. Before you weld the frame to the barrel, weld the inside and outside of each seam along the angle iron, and grind them smooth.

11. Lower the voltage on your welder for around 22-gauge sheet metal. Put a series of tack welds along the inside of your frame where it meets the barrel, as shown in Figure 21.8. These welds will be mostly hidden from sight, but try to make them as strong as possible without burning away the sheet metal.

12. I want my grilling height to be 36 in from the ground, so I'll cut four lengths of angle stock to 35 in. Using a square, tack the legs to the frame as in Figure 21.9, checking for plumb before every tack.

13. To add reinforcement and take some of the weight off the drum, add two supporting members that rest on the bottom of the drum. A cool connection is the detail shown in Figure 21.10 to weld angle to angle by using a cutoff disk to remove one of the faces from a piece of angle. With the grill upside down, rest the length of angle on the bottom of the barrel, and weld it to the legs. The inside of the weld is shown in Figure 21.11.

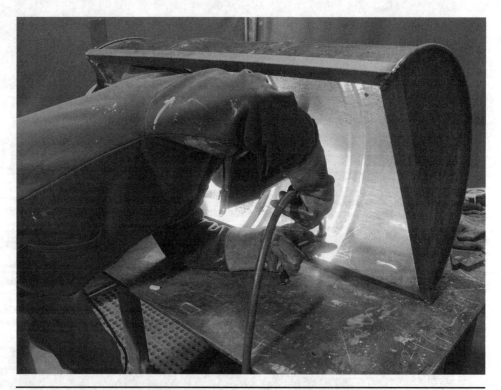

FIGURE 21.8 Welding the inside of the barrel.

FIGURE 21.9 Attaching the legs.

FIGURE 21.10 A nice way to join the angle stock.

FIGURE 21.11 A view of the welded connection.

14. For added rigidity, add diagonal bracing on the legs on the back of the barbecue, as shown in Figure 21.12. The piece of flat stock at the top of the photo is holding the legs in place while I mark, cut, and weld the flat stock for the bracing.

15. Connect the rear legs to the front legs using a length of flat stock about 6 in from the ground and welded perpendicular to both legs.

16. Weld a piece of ¾-in pipe between these two lengths of flat stock to help tie each side together. This also makes a great foot rest when you are grilling.

17. Now you can make the angle frame for the top of the grill to match the dimensions of the bottom frame. For this part I suggest turning the angle iron around to avoid creating a place where water can collect and freeze or cause rust. Figure 21.13 shows the material tacked together and in place on top of the lower frame.

18. A number of steel hinges are available that would work with this project. Figure 21.14 shows slip hinges and fixed hinges, both designed to fold at least 90 degrees. For security purposes, I'm going with the fixed hinges, but if you want to be able to remove the lid at any time, slip hinges would be a good choice.

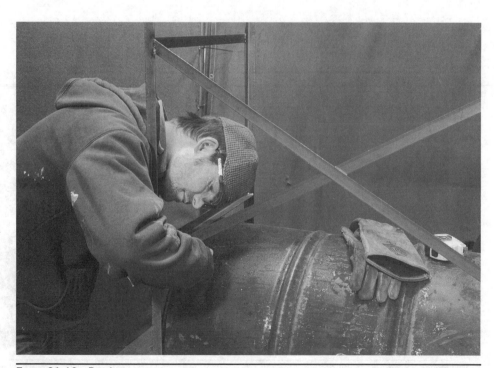

Figure 21.12 Bracing.

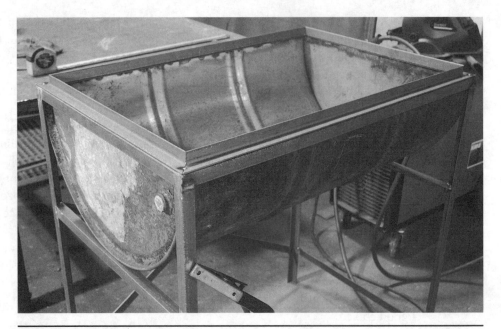

Figure 21.13 Top frame tacked together.

Figure 21.14 Steel hinges.

19. Line up your hinges about 4 in from each corner, and tack weld them in place, as shown in Figure 21.15. Test them by opening the lid a few times to check for smoothness. If they open smoothly, weld each side on permanently.

20. Before welding the other half of the barrel to the top, you now should make a handle for the lid. Roll a short length of ½-in round stock, and cut the ends to make a truncated curve such as that shown in Figure 21.16.

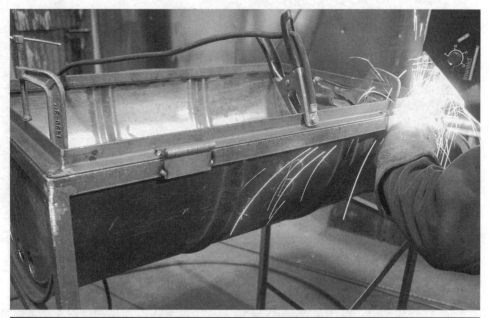

Figure 21.15 Tack welding the hinges.

Figure 21.16 Handle in progress.

21. Center it on the front of the lid as in Figure 21.17, and weld it to the top frame.

22. Rest the top half of the barrel on the grill, and mark the locations that need to be cut away for both hinges and the handle on the front, as shown in Figure 21.18. Use an angle grinder or plasma cutter to remove this material.

FIGURE 21.17 Ready to weld the handle in place.

FIGURE 21.18 Marking material to cut away.

23. With the top of the barrel sitting flush against the frame, start tack welding the barrel in place. Go all the way around using short tack welds until the whole thing has been welded.

24. At this point, you'll add handles to the sides of the grill to make it easier to move around.

25. Just like the handle on the front, roll two short lengths of ½-in round stock, and trim them using an angle grinder. Weld these onto each side of the grill, as shown in Figure 21.19, making sure that they are centered and level.

26. Mark a series of round holes on each side of the grill that will allow air into the fire chamber, as shown in Figure 21.20.

27. Plasma cut these holes, and cut one hole on top for a pivot, as shown in Figure 21.21, where you can attach the air damper.

28. Using the series of holes you laid out as a guide, mark out a wedge shape that will act as the damper. Plasma cut the wedge, including a hole through which to bolt it to the grill. Also weld on a handle of some sort, such as a short piece of round stock, to help move the damper when it's hot. Figure 21.22 shows an example. You can bolt the wedge to the side of the grill using hardware and washers to keep it from coming loose.

29. Now you want to build a heavy-duty ashtray that will help to keep the inside of the grill from decaying. Lay a large piece of 10-gauge steel on your

FIGURE **21.19** Handle in place.

FIGURE 21.20 Air holes.

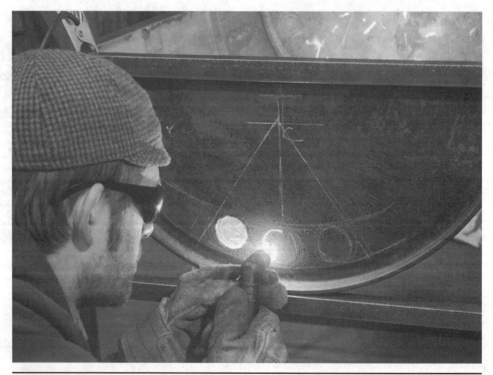

FIGURE 21.21 Cutting.

FIGURE 21.22 Damper and hardware.

worktable, and draw a 24- × 30-in rectangle. Divide the 24-in dimension into three pieces 6, 12, and then 6 in wide, as shown in Figure 21.23. Plasma cut the whole rectangle out, and make a series of plasma cuts along the secondary lines you drew to help make bends as you did earlier in this

FIGURE 21.23 Laying out the ashtray.

book. Make sure that the cuts are roughly 6 in long with a 1-in connection between them.

30. Clamp the ashtray to the table, and bend each side up to about 45 degrees, as shown in Figure 21.24. If you have trouble with the bends, try using an adjustable wrench to give you extra leverage.

31. Cut two lengths of ½-in round stock to make handles and 1-in flat stock to close in the ends, as shown in Figure 21.25. Weld these in place.

32. Cut the excess flat stock off using a cutoff disk, as shown in Figure 21.26.

33. Mark a series of X shapes on the bottom of the ashtray. These will help to let air into the fire area and let any barbecue drippings fall out of the pan. Plasma cut these using the plunge technique you learned earlier until you have something like that shown in Figure 21.27.

34. Now it's onto the grate. If you are going to have a heavy-duty barbecue, it might as well have a heavy-duty grate. To support this grate, cut short lengths of ¾-in pipe in half, as shown in Figure 21.28.

35. Weld these sections to the underside of the frame on the lower half of the 55-gallon drum. If any previous weld bead interferes, grind it away. Figure 21.29 shows a short section of pipe being positioned for a weld. For this grill, I used three supports on each side.

Figure 21.24 Bent ashtray.

FIGURE 21.25 Ends welded and handles in place.

FIGURE 21.26 Removing excess flat stock.

FIGURE 21.27 Plasma-cut X's.

FIGURE 21.28 Cutting short lengths of pipe in half.

FIGURE 21.29 Grate support ready to be welded.

36. Cut three lengths of ⅜-in round stock that fit into these support pieces. Measure across the inside of the grill to figure out how wide to make the rails. The measurement should be around 20½ in, leaving a little bit of room on either side.

37. Cut and weld the first 20½-in grate section out of ¼-in round stock onto the three supports to keep them aligned, as shown in Figure 21.30.

TIP: For this grate, you're going to need nearly 60 lengths of ¼-in stock cut to length. Figure 21.31 shows a simple stop-style arrangement you can make with scrap material and a few C-clamps so that your cuts are always on the mark without measuring every time. Just prepare your first piece, slide the stop into place and clamp it, and you're on your way.

38. Remove the grate from the barbecue, and turn it upside down on your worktable. Using short lengths of ⅜-in round stock, space each ¼-in section apart, and weld it to the ⅜-in support section of the grate. After doing this 48 times, you should have a grill that looks something like the

FIGURE 21.30 Grate under construction.

FIGURE 21.31 Simple stop setup with a chop saw.

FIGURE 21.32 Upside-down welded grate.

one in Figure 21.32. The reason I did this upside down is to keep the topside looking nice and neat.

39. Now you want to make another handle for the grate just as you did the other handles earlier. For this, I suggest matching the ⅜-in round stock used for its supports and rolling two short sections as shown in Figure 21.33.

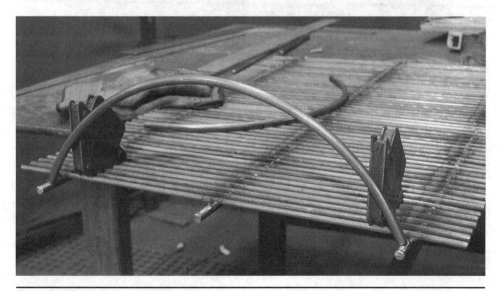

FIGURE 21.33 Handles welded to the grate.

40. On one side of the barbecue, weld a length of chain so that when the lid is open just around 90 degrees, the chain keeps it from falling too far back.
41. Figure 21.34 shows the completed barbecue, ashtray, and grate.
42. Get ready to clean, paint, and grill (Figure 21.35)!

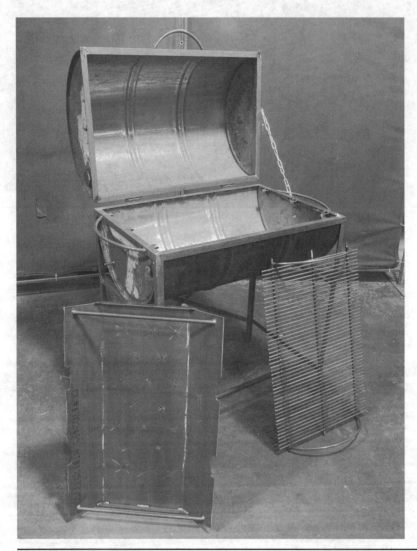

Figure 21.34 Completed grill components.

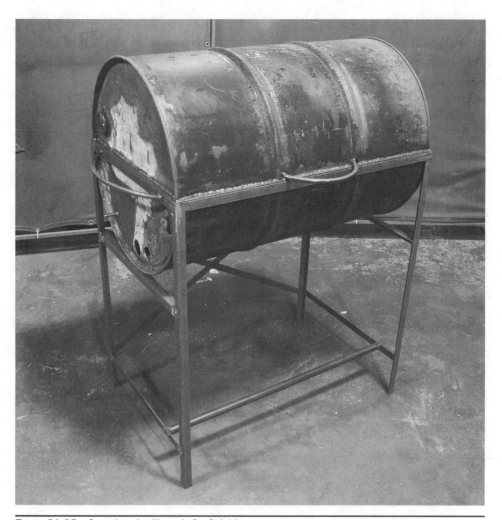

FIGURE 21.35 Completed grill ready for finishing.

Finishing

Before using or finishing this barbecue, you need to give it a thorough "burn" to remove any leftover finishes or contaminates. Do this by building a hot fire in the ash pan until no paint remains on the outside of the barrel. Use hardwood such as oak or cherry for the fire rather than pine, and make sure not to use any wood with adhesives or resins.

You don't want to finish anything on the inside of the barbecue. Let the smoke and grease take care of that, but a high-temperature finish on the whole exterior is a must to keep the grill in working order for years to come. Many paint manufacturers make high-temperature paint for barbecues or automotive engines. You should be

able to find something at your local paint store. Before painting, follow all the prefinishing steps listed in Chapter 12, and remove the hardware-fastened parts such as the chain and dampers to finish separately.

Resources

Here is a list of some artist/craft-based organizations and businesses that offer courses in welding and/or accessible shop space across the country. If you are having trouble finding a metal shop near you or I haven't listed anything in your area, I highly suggest contacting a nearby community college. Many of them offer metalworking courses, and if they don't, they may be able to help point you to someplace that does. Another route is to contact a local working metal artist or sculptor to see if he or she can offer any advice. Who knows, he or she even may be interested in helping out!

Education and Studio Resources (Listed West to East)

Oakland, CA: The Crucible, http://thecrucible.org/

Portland, OR: Shop People, http://shoppeople.org/

Portland, OR: ADX Portland, http://www.adxportland.com/

Seattle, WA: Pratt Fine Arts Center, http://www.pratt.org

Salt Lake City, UT: Salt Lake Community College, http://www.slcc.edu/

Billings, MT: Contemporary Steel, http://www.mrcustomsteel.com/

Denver, CO: Club Workshop, http://www.clubworkshop.com/

St. Paul, MN: Studio Bricolage, http://www.studiobricolage.org/

Minneapolis, MN: Chicago Avenue Fire Arts Center,
 http://www.cafac.org/

Kansas City, MO: Kansas City Art Institute, http://www.kcai.edu/

Tulsa, OK: Tulsa Community College, http://www.tulsacc.edu/

Austin, TX: Austin Metal Authority, http://www.austinmetalauthority.com/

Memphis, TN: Metal Museum, http://www.metalmuseum.org

Chicago, IL: Fire Arts of Chicago, http://www.firearts.org

Evanston, IL: Evanston Art Center, http://www.evanstonartcenter.org/

Detroit, MI: TechShop, http://www.techshop.ws/

Cincinnati, OH: Blue Hell Studio, http://www.bluehellstudio.com

Columbus, OH: Columbus Idea Foundry,
 http://www.columbusideafoundry.com/

Tampa, FL: Rustic Steel Creations, http://www.rusticsteel.com/

Penland, NC: Penland, http://penland.org/

Raleigh, NC: TechShop, http://www.techshop.ws/

Richmond, VA: Visual Arts Center, http://visarts.org

New York, NY: 3rd Ward Brooklyn, http://www.3rdward.com/

Providence, RI: The Steel Yard, http://www.thesteelyard.org/

Somerville, MA: Artisan's Asylum, http://artisansasylum.com/

Auburn, ME: New England School of Metalwork,
 http://www.newenglandschoolofmetalwork.com

Deer Isle, ME: Haystack, http://www.haystack-mtn.org/

General Welding and Online Resources

King Architectural Metals, http://www.kingmetals.com/

Miller Welds, http://www.millerwelds.com/

Lincoln Electric, http://www.lincolnelectric.com

Hobart Welders, http://www.hobartwelders.com/

BOC, http://www.bocworldofwelding.com/

Engineering Toolbox, http://www.engineeringtoolbox.com/

Metals Depot, http://www.metalsdepot.com/

Key to Metals, http://www.keytometals.com

American Welding Society, http://www.aws.org

American Iron and Steel Institute, http://www.steel.org/

Index

A

accidental flashing, preventing, 6
acetylene gas. *See also* oxygen-acetylene
 torches
 handling safely, 7–8
 history of, 35
 rotten eggs scent of, 148
adhesives, welding vs., 28
adjustable guide rollers, 125
adjustable square, layout tool
 defined, 67
 making end table with, 277
 making garden cart with, 299–300,
 306
adjustable vice, for drill press, 113–114,
 119–121
aesthetic design, 26
air blast, plasma cutter, 177
air compressor. *See* compressed air,
 plasma cutters
air damper, making barbecue, 323, 325
American Welding Society (AWS), 35
amperage, plasma cutter, 183–184, 186
angle grinders
 bench grinders vs., 94–95
 chamfering, 87–88
 changing disks, 73–75
 chop saw vs., 99–100
 cutoff disks, 77–78
 cutting/grinding area for, 59, 81

cutting sheet, 90–91
cutting stock, 89–90
flap-disk polishing, 92–93
flap disks, 79
grinding disks, 75–77
making art from scratch with,
 249–251
making candelabra with, 268
making multiple cuts, 92
overview of, 71
parts, 71–73
removing blemish weld with, 86–87
safety, 81–82
safety gear/tools for, 20–21, 71
surface grind practice, 82–85
surface preparation, 85
wire cup and wheel brushes, 80–81
wire-cup cleaning, 93–94
angle, MIG gun, 206–207
angle stock
 cutting with chop saw, 109–110
 joining, 316, 318
 making barbecue with, 312,
 315–316
 making end table with, 276–278
 making garden cart with, 298–301
arc eye, 6
arc popping, MIG welders, 203, 208
argon, for MIG welders, 198–199
arm protection, 15–16

art project, making from scratch, 249–251
ashtray, barbecue project, 323, 325–327
auto-darkening welding helmets, 11–12
automatic center finder, drill press, 114
automatic welding, history of, 35
AWS (American Welding Society), 35

B

backfire, oxy-acetylene torch, 154
bar clamps, 63
barbecue project, 311–333
bead making, flat-position, 216–220
beads, weld, 33
bench grinders
 chamfering, 98–99
 creating cutting/grinding area
 for, 59
 overview of, 94–96
 parts, 96
 safety, 97
 safety gear/tools for, 20–21
bench vise
 chamfering with angle grinder,
 87–88
 grinding surface of steel, 82–83
 removing blemish weld, 86–87
 setting up to grind, 81
bending, torch
 making cube with, 257–258
 making fireplace log holder with,
 290–295
 making garden cart with, 306, 308
 operation of, 170–172
 practicing, 172–175
 with rosebud tip, 168–171
bicycle wheels, garden cart, 298, 302,
 304–309
bits, drill press, 114–116, 117–123
blacksmiths, 50
blade guard, chop saw, 101
boots, 16
box tubes, steel, 45–46
brazing, welding vs., 28
breaking welds, 225–226
breeze, inferior welds caused by, 19
Bronze Age, welding in, 35

brush paint, finishing steel with, 234–235
butt joints, 33–34
buying
 steel. *See* steel, buying
 tools, 60

C

C channel stock, 48
C-clamps, 63–64
candelabras project, 267–273
carbon dioxide (CO_2), shielding gas for
 MIG welders, 198–199
carburizing flame, oxy-acetylene torch,
 150, 164
cast iron, determining, 54
casting, decorative/ornamental steel, 50
center drill bits, drill press, 115
center punch, drill presses
 defined, 113
 drilling $\frac{1}{2}$ inch hole in flat stock,
 118
 drilling $\frac{1}{8}$ inch hole in $\frac{1}{2}$ inch
 square stock, 119–120
 drilling $\frac{3}{8}$ inch hole in sheet metal,
 122
 making garden cart with, 304–305
chamfering
 with angle grinder, 87–88
 with bench grinder, 98–99
 defined, 87
 making candelabra with, 268–269
channel stock, 48–49
chemicals, as shop hazard, 6–7
chop saws
 creating cutting/grinding area
 for, 59
 cutting angle stock, 109–110
 cutting flat bar, 106–107
 cutting multiple items, 108–109
 cutting round tube at 30 degrees,
 105–106
 cutting square stock at 90 degrees,
 102–104
 making candelabra with, 268
 making garden cart with, 304–305
 overview of, 99–101

parts of, 101
safety gear/tools for, 20–21
simple stop setup with, 329–330
types of disks, 102
chuck, drill press, 113
circle-cutting guide, plasma cutter, 181–182
clamps
 drill press. *See* drill presses
 grinding surface of steel, 82–83
 making cube, 258–259
 preparing to grind surface of steel, 85
 removing blemish weld, 86–87
classification, of steels, 39–40
cleaning
 of metalworking studio tools, 60–61
 steel, for finishing, 233
clear finish, 238–239
clear safety glasses, 8
clothing items, 5
CO_2 (carbon dioxide), shielding gas for MIG welders, 198–199
cold-rolled steel, 50–52
compressed air, plasma cutters
 overview of, 177–178
 preparing, 185
 safety, 183
compressed-gas cylinders, safety, 7–8
concrete
 avoid welding directly on, 56
 floors for metalworking studios, 55–56
conductivity, of mild steel, 41
consumable electrode, 31–32, 35
consumables
 angle grinder disks as, 71, 78
 bench grinder disks as, 95
 buying in specialty welding stores, 60
 chop saw disks as, 99, 110
 MIG welder, 196–199
 safety for grinding, 81
contact tip
 filler wire for MIG welders and, 199

gauging distance from weld area to, 203
 MIG gun, 196–197
contraction, of mild steel, 41
corner joints, 33–34
corners, well-made, 277–279
corrosion (rust)
 blocking with finishes. *See* finishing
 mild steel susceptibility to, 41
 preventing on 55-gallon drum, 311–312
 preventing on fireplace log holder, 296
 promoting with muriatic acid, 232–233
crescent weave, MIG welder, 207–208, 221–222
cube project, 253–259
cutoff disk, chop saw, 99
cutoff disks, angle grinder
 cutting sheet, 90–91
 cutting stock, 89–90
 high torque when using, 73
 making barbecue with, 314, 316, 331
 making multiple cuts, 92
cutting
 area in metalworking studio for, 59
 with chop saw. *See* chop saws
 making barbecue using, 312–314, 323–324
 making candelabra using, 268–269
 making cube using, 254–256
 making end table using, 276–278
 with oxy-acetylene torch. *See* oxygen-acetylene torches, cutting
 with plasma cutter. *See* plasma cutters
 sheet, with angle grinder, 90–91
 stock, with angle grinder, 89–90
 welds, with MIG welders, 226–228
cutting table, metalworking studio, 58

D

deburring tool, drill press, 113, 119
decorative steel, obtaining, 50

diamond plate sheet metal, 50
dirt floors, for metalworking studios, 55–56
disks, angle grinder
 changing, 73–75
 cutoff disks, 77–78
 flap disks, 79
 grinding disks, 75–77
disks, chop saw, 102–109
drag tip, plasma cutter, 180–181
drill bits, drill press, 114–123
drill presses
 accessories, 112–114
 drill bits, 114–116
 drilling ½ inch hole in flat stock, 117–119
 drilling ¼ inch hole in 1 inch round tube, 120–122
 drilling ⅛ inch hole in 1/2 inch square stock, 119–120
 drilling ⅜ inch hole in sheet metal, 122–123
 overview of, 111–112
 parts, 112–113
 safety gear/tools for, 20–21
 speeds, 116–117
dust
 preparing steel for muriatic acid by removing, 232
 as shop hazard, 4
dust masks, 16–18, 71

E

earmuffs, 17–18
edge joints, 33–34
education resources, 335–336
electrical-arc welding processes
 GMAW. *See* gas-metal arc welding (GMAW)
 history of, 35
 MIG. *See* metal–inert gas (MIG) welders
 of MIG welders, 193
 of plasma cutters, 177–178
 stick welding, 32–33

electrical shock
 safety gear/tools for, 21
 as shop hazard, 6
electricity
 connections inside MIG welder, 197–198
 metalwork studio safety, 56
electrode/filler, MIG gun, 197
electromagnetic angles, 65–67
emergency plan, 4
end table project, 275–285
equal leg angle stock, 48–49
expanded sheet metal, 50
expansion, mild steel, 41
eyewash area
 flushing out eyes with, 4
 for shop safety, 19

F

face shields
 clear safety glasses and, 8
 for plasma cutters, 181, 183
 shaded glasses and, 12–13
feed rollers
 defined, 125
 inside MIG welder, 197–198
 operating, 127–128
 rolling flat stock into circle, 128–132
 rolling hoop from round stock, 133–135
55-gallon drum, barbecue project, 312–333
files, as basic tools, 68–69
filler material
 adding in torch welding, 30–31
 making art with, 250–251
 in MIG welding, 31
 in soldering or brazing, 28
 in TIG welding, 31
 in torch welding, 159
 as weld bead, 33
 in welding process, 23, 29
filler wire, MIG welders, 192–202
filters (shades)
 number guide for MIG welding, 11

number guide for plasma cutting, 12–13

welding helmet ratings for, 9–10

finishing

barbecue project, 331–332

clear finishes, 238–239

muriatic acid, 232–233

overview of, 231

paint, 233–238

powder coating, 240–241

preparation, 231–232

preventing corrosion on steel with, 42

wax, 239–240

fire

metalwork studio safety, 55–56

as shop hazard, 4–5

fire extinguishers, 19

fireplace log holder project, 287–296

first aid kits, 4, 19

fixed-shade filter shields, 12

fixed-shade welding helmets, 10–11

flame, oxy-acetylene torches

bending with, 168, 170–171

cutting with, 142–143, 149–154, 156–157

electric arc of MIG welders vs., 31

lighting with sparker, 142

preventing chemicals from contacting, 7

preventing UV injury with face shields, 13

preventing UV injury with welding helmets, 9–10

shutting down, 155, 166–167

temperature of, 30–31

as UV radiation hazard, 5–6

welding with, 158–159, 162–166, 168–169

flame, plasma cutter, 178, 183–184

flanges, I-beam, 49

flap disk, angle grinder

overview of, 79

polishing cut pieces, 92–93

welding barbecue to frame, 315

flashing, risk of accidental, 6

flat bar

cutting multiple items with chop saw, 108–109

cutting with chop saw, 106–107

drilling $\frac{1}{2}$ inch hole in, 117–119

obtaining steel as, 47

flat-position weld, MIG welder

making bead with, 216–220

making garden cart with, 299

making tee joints with, 222–223

operation of, 215–216

overview of, 209–210

weaving with, 220–222

flat stock

creating chamfer with bench grinder on, 98

cutting weld, 226–228

cutting with chop saw, 106–109

drilling $\frac{1}{2}$ inch hole in, 117–119

making barbecue with, 312, 319, 326–327

making fireplace log holder with, 287–289

making garden cart with, 298–299, 302–306

overview of, 47

removing blemish weld from, 86–87

rolling into circle, 128–132

weaving, 221–222

welding tee joint, 222–223

flip-down welding helmets, 10–11

floor-mounted drill presses, 111–112

flux-cored wire

MIG welders, 199

for windy environments, 19

flux, torch welding, 159

flying particulates, safety gear/tools for, 20–21

foam earplugs, 17–18

forge welding, 35

forging, decorative/ornamental steel, 50

G

garden cart project, 297–309
gas
 compressed-gas cylinder safety,
 7–8, 56
 fixing MIG welds with poor flow
 of, 229
 operating MIG welders, 213–215
 shielding gas for MIG welders,
 198–199
gas cylinders. *See* oxygen-acetylene
 torches
gas diffuser, MIG gun, 196
gas line, MIG gun, 197
gas-metal arc welding (GMAW)
 defined, 24
 history of, 35–36
 overview of, 31
gas nozzle, MIG welders, 196–197
gas-tungsten arc welding (GTAW),
 31–32, 35–36
gauge, sheet metal, 49
glasses
 clear safety, 8
 shaded, 12–13
gloves, 13–15
GMAW (gas-metal arc welding)
 defined, 24
 history of, 35–36
 overview of, 31
grinding
 with angle grinders. *See* angle
 grinders
 area in metalworking studio for, 59
 with bench grinder, 94–98
grinding disks, angle grinders
 changing, 73–75
 cutoff disks vs., 77
 making end table with, 280–281
 overview of, 75–77
grinding wheels
 angle grinders, 72–73
 bench grinders, 95–96
 shop hazards for friction of, 4–5
 welding barbecue to frame with,
 315

grip-style clamps/pliers, 63–64
grit/grime, and safety, 21
grounding clamp, MIG welders, 194–195
GTAW (gas-tungsten arc welding),
 31–32, 35–36
guard, angle grinder, 71–73
guide rollers
 operating, 127–128
 overview of, 125
 rolling flat stock into circle, 128–132
 rolling hoop from round stock,
 133–134
gun, MIG
 angle of, 206–207
 distance from weld area, 202–203
 parts of, 195–196
 pattern of motion or weave, 207
 speed of, 203–205
 welding lead and, 195

H

H-beams, 46
H-beams, buying steel as, 49
half-round stock, buying steel as, 46, 49
hand tools
 clamps, 63–64
 files, 68–69
 magnetic angles, 65–67
 making barbecue with, 312
 making end table with, 276
 making garden cart with, 298
 measuring tape, 65
 other layout tools, 67
 scribe, 68–69
 slag hammer, 67–68
 soapstone, 70
 Vice-Grips, 63–64
 wire cutters, 65–66
handheld drill, 111
handles
 angle grinder, 71–73
 chop saw, 101
 making for barbecue, 321–323, 331
 oxy-acetylene torch welder, 158–159
hazards, shop, 4–6
head protection, 15–16

hearing protection, 16–17
heat
 fixing MIG welds with too little/
 too much, 229–230
 removing blemish weld, 87
 safety gear/tools for, 20
 as shop hazard, 4–5
heat source
 development of welding
 technology and, 35
 most direct in torch welding, 30–31
 in TIG welding, 31
 in welding process, 23
heated tube, cooling, 5
hexagon stock (bar), obtaining steel as,
 46, 48
high-carbon steel, 39
history
 of oxy-acetylene torch, 137
 of welding, 35–36
horizontal position weld, MIG welders
 making garden cart, 299
 operation of, 215
 overview of, 210–211
hoses, oxy-acetylene torch, 140–141
hot-rolled steel, 50–52
I
I-beams, obtaining steel as, 46, 49
insulated welding gloves, 14–15
iron, as main ingredient of steel, 37

■ **J** ■

J. Broomfield & Sons Scrap Metal, 44
jig
 building to make candelabras, 268,
 270–272
 making fireplace log holder, 287–296
joining techniques
 angle stock, 316, 318
 mechanical connections, 28
 welding vs. other, 24–27
joints, types of welds and, 33–35

■ **L** ■

labels, grinding disk, 76
lap joints, 33–34

layout
 magnetic angles for, 65–67
 metalworking studio safety
 concerns, 55–56
 other tools for, 67
levels, using for layout, 67
light
 reducing risk of accidental flashing,
 5–6
 safety glasses not offering
 protection from extreme, 8
lighters, metalworking safety, 5
lighting
 in metalworking studio, 56
 oxy-acetylene torches, 149–151,
 162–165
low-carbon steel, 38, 40–42

■ **M** ■

magnet test, determining steel, 53
magnetic angles, 65–67
maintenance, shop tool, 60–61
manganese, avoiding inhalation of,
 17–18
materials, project preparation, 246–247
measuring tapes, 65
mechanical connections, welding vs., 28
medium-carbon steel, 38
Metabo welding tools, 60
metal–inert gas (MIG) welders
 adjustments, 200–202
 angle, 206–207
 breaking weld, 225–226
 consumables of, 198–199
 cutting weld, 226–228
 distance from weld area (stick-out),
 202–203
 electrical hazards of, 6
 flat-position bead making with,
 216–220
 flat-position tee joint with, 222–223
 flat-position weaving with,
 220–222
 gun parts, 195–197
 history of, 35–36
 inside, 197–198

metal–inert gas (MIG) welders (*cont.*)
 making art from scratch with,
 249–251
 making barbecue with, 312
 making cube with, 253–259
 making end table with, 276
 making garden cart with, 298
 making plant stand with, 261–265
 operation of, 213–216
 overhead welding, 212
 overview of, 31
 parts, 193–195
 pattern of motion or weave, 207
 principles of, 24
 removing rust before using, 41
 safety, 212–213
 shop hazards for, 4–5
 speed, 203–205
 steadiness, 207–208
 steel's response to oxy-acetylene
 vs., 137–138
 tee corner, 223–225
 thick steel on welding table for, 57
 using weld chart, 200–202
 UV radiation hazard of, 5–6
 visual inspection, 229–230
 weld orientation, 209–212
 weld vision and, 208–209
 welding helmet protection, 8–12
metalworking studio
 access for project preparation, 247
 area for angle grinder, 81
 buying tools, 60
 cleaning/maintenance, 60–61
 cutting/grinding area, 59
 cutting table, 58
 layout safety, 55–56
 lighting, 56
 online resources for, 335–336
 paint area, 59
 steel storage, 59
 welding table, 57
Mid City Steel, 44
mild steel
 determining with spark test, 54
 as low-carbon steel, 38

 paint finishes for, 233–234
 properties of, 40–42
mill scale
 cleaning off before finishing, 42
 cleaning with muriatic acid, 232–233
 flat-position bead making and, 217
 hot rolling steel to form, 52
 overview of, 42
 removing with angle grinder, 85
 removing with flat disks, 79
 removing with wire-cup cleaning,
 94
 torch bending and, 169, 172
mill scale, removing before welding, 42
Miller Welding tools, 60
miter saws, 99
multiple cuts
 with chop saw, 108–109
 with cutoff disk on angle grinder, 92
muriatic acid, promoting rust on steel,
 232–233

N

neck protection, 15–16
negative clamp, MIG welders, 194–195
neutral flame
 oxy-acetylene torch cutting,
 150–151, 156
 oxy-acetylene torch welding, 164
nominal pipe size (NPS) pipe, buying,
 47–48
non-auto-darkening welding helmets,
 10–11
North Safety welding tools, 60
NPS (nominal pipe size) pipe, buying,
 47–48

O

Occupational Safety and Health
 Administration (OSHA), 3–4
on/off switch
 drill press, 113
 MIG gun, 195
 MIG welder, 193–194
 MIG welder shutdown process,
 215–216

online resources
 decorative and ornamental steel, 50
 on education and studios, 335–336
orientations, MIG welders, 209–212, 215–217
ornamental steel, obtaining, 50
outdoor home studios, layout safety, 56
outside diameter (OD), measuring round tube via, 47
oven, for powder coating, 241
overhead weld, MIG welder, 212
oxidizing flame, oxy-acetylene torches, 150, 164
oxygen-acetylene torches
 bending, 168–175
 history of, 35, 137
 making cube with, 253–259
 UV radiation hazard of, 5–6
oxygen-acetylene torches, cutting
 lighting and mixing flame, 149–151
 making cut, 151–154
 overview of, 137–139, 142–144
 parts detail, 141
 plasma cutters vs., 177–179
 round stock, 156–158
 safety, 20, 142
 sheet metal, 156–157
 shutting down gases, 155–156
 shutting down torch, 155
 torch and tank setup, 139–140
 torch-head details, 141–142
 work area/gas cylinders set up, 144–148
oxygen-acetylene torches, welding
 filler, 159
 flux, 159
 heating wax for finishing steel with, 240
 how it works, 24, 29–31
 lighting and mixing flame, 162–165
 making weld, 165–166
 overview of, 158–159
 practicing, 167–168
 shutting down gases, 167
 shutting down torch, 166–167
 work area/gas cylinders set up, 160–162

P

paint area, networking studios, 59
paint finishes
 barbecue project, 331–332
 brush, 234–235
 garden cart project, 309
 overview of, 233–234
 spray, 235–238
pants, protective, 16
Parkinson's disease, from manganese, 17–18
pattern of motion, MIG gun, 207
perforated sheet metal, 50
personal protective equipment (PPE)
 arm, neck, and head protection, 15–16
 boots, 16
 clear safety glasses and face shields, 8
 dust masks, 16–18
 gloves, 13–15
 hearing protection, 16–17
 long pants, 16
 shaded glasses and face shields, 12–13
 shop safety equipment, 18–19
 welding helmet, 8–12
personal protective equipment (PPE), for specific tools
 angle grinders, 82
 bench grinders, 97
 chop saws, 102
 defined, 3
 drill presses, 117
 MIG welders, 212–213
 overview of, 19–21
 oxy-acetylene torches, 142
 roll bending, 128
personal respirator systems, 18
pierce cuts, plasma cutters, 189
pipe
 bending, 172–175
 clamps, 63

pipe (*cont.*)
 making barbecue with, 319, 326, 328
 making candelabra with, 268
 making garden cart with, 298,
 302–303
 never cooling heated tube with
 water, 5
 obtaining, 44
 round tube vs., 47
 steel, 47–48
plain-carbon steels, 38–40
plant stand project, 261–265
plasma arc, 4–6
plasma cutters
 accessories, 180–182
 amperage, 183–184
 angle of torch, 184
 cutting straight line, 190–192
 making barbecue with, 312, 323,
 326, 328
 making cube with, 253–259
 making cut, 188–189
 making end table with, 276
 overview of, 177–179
 parts, 180
 plunge or pierce cutting, 189–190
 preparing to cut, 185–187
 safety, 181, 183
 safety gear/tools for, 20
 shaded glasses and face shields
 (shade nos. 4-12) for, 12–13
 shutting down, 189
 soapstone markings for, 67
 standoff, 185
 torch, 181
 travel rate, 184
plate steel, obtaining, 50
plunge cut, plasma cutter, 189–190
pound-force per square inch (lbf/in),
 oxy-acetylene torches, 138–139
powder coating finish, 240–241, 309
power source, MIG welders, 193–194
pressure regulators, oxy-acetylene
 torches
 overview of, 138–139
 safety procedures, 142

setup, 140–141
 welding setup, 160–162
 work area/gas cylinders setup,
 146–148
primer, 234–236
projects
 art from scratch, 249–251
 barbecue, 311–333
 candelabras, 267–273
 cube, 253–259
 end table, 275–285
 fireplace log holder, 281
 garden cart, 297–309
 plant stand, 261–265
 preparation for, 245–247
pulling weld, angle of MIG gun for, 207
pushing weld, angle of MIG gun for,
 206–207

Q

quenching steel, 37
quill feed, drill press, 113, 117–118

R

rectangular tube, obtaining steel as,
 46–47
regulators, MIG welders, 195
resources, online, 335–336
ring rollers. *See* rollers
roll bending
 overview of, 125–127
 parts, 127–128
 rolling flat stock into circle,
 128–132
 rolling hoop from round stock,
 132–135
 safety, 128
roller guide, plasma cutters, 180, 182
rollers
 overview of, 125–127
 parts, 127–128
 rolling flat stock into circle,
 128–132
 rolling hoop from round stock,
 132–135
 safety, 21, 128

rosebud tip
 making fireplace log holder, 290
 oxy-acetylene torch bending with,
 169–175
rotational tools, safety, 15, 20
round stock
 cutting with oxy-acetylene torch,
 156–158
 making barbecue, 312, 321, 326–327,
 331
 making candelabra, 268–273
 making fireplace log holder,
 287–289, 291
 making garden cart, 298, 306–307
 making legs for end table, 281
 obtaining steel as, 47
 rolling hoop from, 132–135
round tube
 cutting with chop saw at 30
 degrees, 105–106
 drilling 1/4 inch hole in 1 inch,
 120–122
 multiple cuts in, 92
 obtaining steel as, 47–48
rust. See corrosion (rust)
Rust-Oleum Clean Metal Primer, 234–235
Rusty Metal Primer, 234

S

safety. See also personal protective
 equipment (PPE)
 angle grinder, 81–82
 bench grinder, 97
 chop saw, 102
 drill press, 116
 electrical roller, 126
 general shop, 3–4
 grinding consumables, 81
 metalworking studio layout, 55–56
 MIG welder, 212–213
 muriatic acid and, 232–233
 oxy-acetylene torch, 142
 plasma cutter, 181, 183
 roll bending, 128
 shop equipment, 18–19
 shop hazards, 4–8

sandpaper
 cleaning weld bead surface, 223
 flap disks constructed of, 79
 preparing steel for finishing, 232
 smoothing paint finish, 235, 238
scale. See mill scale
schedule number (SCH), steel pipe
 thickness, 47
scrap yards, buying steel from, 44, 52
scribes, marking steel with, 68–69
shaded glasses, and face shields, 12–13,
 181
shades (filters)
 number guide for MIG welding, 11
 number guide for plasma cutting,
 12–13
 welding helmet ratings for, 9–10
shapes, of steel, 45–50
sharp edges, safety gear/tools for, 21
sheet metal
 cutting with cutoff disk, 90–91
 cutting with oxy-acetylene torch,
 156
 drawing straight line with plasma
 cutter, 190–192
 drilling 3/8 inch hole in, 122–123
 making barbecue with, 312, 316
 making cube with, 253–259
 making end table with, 275–285
 making fireplace log holder with,
 287–296
 obtaining, 49–50
 plasma cutting for thin materials,
 177
 slip rollers used for, 125
shielded metal arc (stick) welding, 32–33
shielding gas
 angle of MIG gun and, 206
 MIG welders, 195, 198–199
shutdown
 of MIG welder and gas, 215–216
 of oxy-acetylene torch for cutting,
 155–156
 of oxy-acetylene torch for welding,
 166–167
 of plasma cutter, 189

slag
 cleaning up before torch welding,
 168
 as disadvantage of stick welding,
 33
 finding correct amperage for
 plasma cutting, 186–187
slag hammer, 67–68, 168
slip rollers. *See* rollers
soapstone
 marking cutting lines, 92, 102,
 156–157
 marking for bending, 173
 marking for rolling, 128
 marking intended weld lines, 208
 overview of, 70
soldering, welding vs., 28
solid stock
 bending. *See* roll bending
 chamfering, 98
 grinding surface of, 82–85
 making candelabra, 268–273
 making tee corner, 223–225
 slip rollers used for, 125
 torch bending of, 171–172
solid wire, MIG welders, 199
solvents, preparing steel for muriatic
 acid, 232
spark test, 53–54
sparks, safety gear/tools for, 20
speed, drill press, 116–123
speed squares, 67
speed, travel
 adjusting MIG welders for, 203–205
 adjusting wire on MIG welders for,
 200–202
 fixing MIG welds with too slow/
 too fast, 230
 for flat-position bead making,
 218–220
 for overhead welding, 212
 for vertical-position welding,
 210–211
spindle, drill press, 113
spindle lock, angle grinders, 73
spray paint finish, 235–238

spray-paint flash, 236–237
spray-paint pass, 236–237
square stock
 cutting with chop saw, 102–104
 cutting with cutoff disk, 89–90
 drilling $\frac{1}{8}$ inch hole in $\frac{1}{2}$ inch,
 119–120
 making fireplace log holder,
 287–288
 obtaining steel as, 45
square tube
 making garden cart, 298, 302
 multiple cuts in, 92
 obtaining steel as, 45–47
standoff, in plasma cutting, 185
Stay-Clean Paste Flux, 159
steadiness, MIG gun, 207–209
steel
 determining if something is, 52–53
 obtaining, 42–43, 52
 overview of, 37–38
 plain-carbon, 38–40
 properties of mild, 40–42
steel, buying
 channel stock, 48–49
 decorative and ornamental, 50
 flat bar, 47
 half-round stock, 49
 hexagon stock, 48
 hot-rolled vs. cold-rolled, 50–52
 I-beams, 49
 overview of, 44
 plate, 50
 rectangular tube, 47
 round stock, 47
 round tube, 47–48
 sheet metal, 49–50
 square stock, 45
 square tube, 45–47
steel hinges, 319–321
steel pipe, buying, 47–48
steel yards (suppliers), 44–45
stick-out, MIG welders
 in flat-position bead making,
 217–218
 overview of, 202–203

setting up gas, 215
shutting off gas, 216
stick (shielded metal arc) welding, 32–33
storage, metalworking studio, 56, 59
straight line, cutting with plasma cutter, 190–192
strength, of mild steel, 40
stringer beads, making flat-position, 218–219
studio. *See* metalworking studio
surface grind, angle grinder, 82–85
surface preparation, angle grinder, 85
surface welds, 33

▬ T ▬

table crank, drill presses, 113
table, drill press, 111–113
table lock, drill presses, 113
tack welds
 defined, 221
 making art from scratch with, 249–250
 making barbecue with, 316, 321, 323
 making candelabra with, 272
 making end table with, 277–280
 making fireplace log holder with, 289
 making garden cart with, 300, 302
 making plant stand with, 264
 making tee corner using, 223–224
 securing material together with, 221
tanks, oxy-acetylene torches, 140–141
tee joints
 flat-position, 222–223
 making with MIG welders, 223–225
 overview of, 33–34
testing for steel, 52–53
thick stock, cutting with oxy-acetylene torch, 156–158
thickness
 plate steel, 50
 of steel top on welding table, 57
time estimates, project preparation, 247

tips, oxy-acetylene torch
 bending with, 169–175
 cutting with, 143
 welding with, 158–160
tool steel, testing for, 54
tools
 buying, 60
 cleaning/maintenance of, 60–61
 hand. *See* hand tools
 protective equipment worn for. *See* personal protective equipment (PPE), for specific tools
tools, hand. *See* tools, hand
torch
 oxy-acetylene, 141, 143
 plasma cutting, 180–181, 184, 188–189
 welding, 29–31
torque
 cutoff disk increasing, 73
 preparing to grind surface of steel, 85
transformers, MIG welders, 193–194
trashcans, covering for safety, 19
travel rate, plasma cutter, 184
triangular weave, MIG welders, 208, 221–222
trigger, MIG gun, 195–196
tungsten-inert gas (TIG) welding, 31–32, 35–36
twist bits, drill press, 115

▬ U ▬

U channel stock, buying, 48
ultraviolet (UV) radiation hazard
 plasma cutters, 181
 as shop hazard, 5–6
 welding helmet protection, 9–12
unequal leg angle stock, 48–49
unibits, drill press, 116
used tools, buying, 60

▬ V ▬

ventilation
 metalwork studio safety, 19, 56
 wearing dust masks, 17–18

vertical-position weld, MIG welders, 210–212, 215
very high-carbon steel, 39
Vice-Grips, 63–64, 277, 279
vision, MIG welder, 208
visual inspection
 determining steel via, 53
 of welds made with MIG welders, 229–230
voltage, MIG welders
 adjusting, 200–202
 flat-position bead making and, 217
 making barbecue, 316
 reducing for vertical welding, 212
 and wire-feed settings, 194

W

warping, mild steel and, 41
water, quenching steel in, 5
wax, coating steel with, 239–240, 296
weaving
 flat-position, 220–222
 patterns, 207–208
weld chart, MIG welders
 defined, 195
 how it works, 200–202
 settings, 215
welder cutting, safety gear/tools for, 20
welding
 brief history of, 35–36
 education and studio resources for, 335–336

gas-metal arc welding, 31
gas-tungsten arc welding, 31–32
general resources on, 336
how it works, 29
metal–inert gas, 31
stick, 32–33
torch, 29–31
tungsten-inert gas, 31–32
types of welds and joints, 33–35
understanding, 23–26
what it is not, 27–28
welding helmet, 8–12
welding lead, MIG welders, 195
welding screens, shop safety, 6, 18–19
welding table, 57
welding wire, 197–198
welds
 breaking, 225–226
 cutting, 226–228
 making with oxy-acetylene torch, 165
 removing blemish with angle grinder, 86–87
 types of joints and, 33–35
wheel brushes, angle grinders, 80–81
wire cups, 80–81, 93–94
wire cutters, 65–66
wire, fixing MIG welds, 230

Z

zigzag weave, MIG welders, 207–208, 221–222